The Social Context of Art

The Contributors

JEAN CREEDY Head of Department of Art History and Complementary Studies, Brighton College of Art

Z. BARBU Professorial Fellow in Sociology, University of Sussex

EDWARD LUCIE-SMITH Art critic of *The Times*

DENNIS GABOR Formerly Professor of Applied Electron Physics, Department of Electrical Engineering, Imperial College of Science and Technology

GYORGY KEPES Professor of Visual Design, School of Architecture and Planning, Massachusetts Institute of Technology

RALPH BERRY Senior Lecturer in Complementary Studies, Brighton College of Art

MICHAEL TREE Head of Information Division, Council of Industrial Design

STANLEY REED Director, British Film Institute

EDWARD ADAMSON Director of Art Department, Netherne and Fairdene Hospitals

H. R. KEDWARD Lecturer in History, University of Sussex

CHRISTOPHER CORNFORD Dean of Department of General Studies, Royal College of Art

The Social Context of Art

edited by
JEAN CREEDY

TAVISTOCK PUBLICATIONS
London · New York · Sydney · Toronto · Wellington

First published in 1970
by Tavistock Publications Limited
11 New Fetter Lane, London E.C.4
Printed in Great Britain
in 11 point Ehrhardt 2 points leaded
by W & J Mackay & Co Ltd, Chatham

SBN 422 72730 X

Distributed in the USA
by Barnes & Noble Inc.

Contents

Contents

JEAN CREEDY

Introduction

In providing something in the nature of a *mise en scène* for this publication, I have tried to resist the temptation to comment, other than indirectly, upon the situation in Art Education at this moment. I make my contribution here from direct experience of the new developments in Art Education in a situation where it is my responsibility, in a developing college, to extend opportunities for cross-fertilization between disciplines and approaches now considered to be broadly, and in a vocational sense, 'relevant' to the education of young artists.

It seems appropriate first to look at the current situation in this field since, at the time these contributions were being made ready for the publisher, we were overtaken by the dynamic events of the summer term of 1968 when, in a number of major colleges of art, students made consistent demands on a number of points in the general system. Ideas of reform rapidly became widespread, extending to some thirty colleges. To a varying extent up and down the country the whole system, with its built-in assumptions, has been challenged. Revised thinking was at this time taking place in all Diploma colleges on the re-submission of planned courses to the Summerson Council, prior to the Quinquennial Review following the establishment of the new Diploma in Art and Design in 1963.

The developing situation of change, as it affects all levels of Art Education, will no doubt continue, taking into account recent findings and new psychological approaches relevant to the disciplines and assessments involved in the teaching and learning processes generally. It is clear that many new theories concerning

psychology and the learning process strike at the root of existing methods of measuring intelligence and perceptual ability.

Nationally and internationally, there is a new emphasis on the significance of the twentieth century, with its immediate roots and new concepts. This must henceforth constitute a major study in its own right. Radical new approaches to the study of our own century were evident in the informal discussions at the International Congress of Aesthetics in Uppsala in August 1968. There was much discussion on new lines of thinking concerning twentieth-century studies in Art and Aesthetics, laying little or no emphasis on continuity with the past and seeking to understand the recent trend in experimentation as a series of events, rather than as part of a historical continuum. Methods of approach in the teaching of the History of Art, and the selection for essential study in depth of 'significant periods of time' are currently debated.

Complementary Studies were initially seen by the Summerson Council in the following terms: 'By these we mean any non-studio subjects, in addition to the History of Art, which may strengthen or give breadth to the students' training.' In November 1965 at the Brighton Conference on Art Education, Professor Quentin Bell spoke of the essential need for the student to look away from his own time. In Britain, Design History, long neglected as a study in its own right, is coming into its own in the new schemes, which must extend beyond the specialized art training institutions and colleges of art into the universities, the colleges of education, and the schools. If we are to believe in a new power to develop intelligence and perceptual ability, we must also take into account the young artist's additional innate gifts of perception and extrapolation together with his ability to develop communicative skills.

In consequence of the unrest in the art schools that erupted in 1968, I invited Christopher Cornford to make, off the cuff, as it were, a contribution on the current situation in Art Education. This he has chosen to do, appropriately enough, in the form of a letter, which appears as Chapter 11. We share the belief that these events arose from a basically healthy, forward-looking movement. Mr Cornford's contribution provides rather more than a factual

2

statement of recent events. It offers a sympathetic clarification of the more valuable thinking to be extracted from the wide range of staff and student opinion over the eventful weeks during the summer term of 1968, together with a brief summary of the immediate historical background in art education relevant to this present situation.

The idea that the Foundation Courses should become the responsibility of the secondary schools, or even of the sixth-form colleges, is fiercely and rightly challenged up and down the country from within these vital diagnostic courses themselves. Essentially circumambient in character, they now draw many older students and are often closely involved with technology, offering essential breadth of experience, specialist teaching, and a chance to discover skills beyond those possible in the schools. The position of vocational courses is a matter currently under review. At the same time the departments of educational studies continue to press their major role within the ambience of the university, while maintaining a firm foothold in the Diploma colleges.

The realization of a need to shift the initiative to a greater extent in the direction of students and those staff directly engaged in teaching, and the new plans for students participation at all levels of planning, have been keynotes in the new thinking. The question remains: in what ways can responsibility be more widely shared, and what safeguards should be provided for valuable traditions and inherited disciplines? In my view, the roots of twentieth-century Art Education in Britain go back further than is indicated in Mr Cornford's historical résumé. Few would deny that from the Bicentenary Exhibition of the Royal Academy, Reynolds emerges as a great figure; his influence is far-reaching. The pattern of change even in the Academy schools is not without the element of revolt – witness the throwing of bread used for rubbing out, a symptom of boredom no doubt. The prohibition of the use of bread for erasure resulted in a significant effort in the searching out of line, though this development later deteriorated into the conventions commented upon by Mr Cornford in his letter.

The significance of developments in Art Education, going back

3

to the establishment of the Diploma in Art and Design six years ago, should not, however, be overshadowed by the current situation of revolt and change. We should not lose the impact of the initial redirection in Art Education, a vital attempt to raise status and standards, giving greater breadth in course work and assuming parity with the University First Degree. A valuable opportunity lay in the freedom accorded to the DipAD Colleges for the organization of Art History and Complementary Studies as a new departure, which allowed 15 per cent of Diploma course time to be devoted to these studies which were deliberately left undefined in the Commission's report.

This volume has to do primarily with the role of the *visual* artist in society, and it is outside its scope specifically to examine relevances concerning music, poetry, and the drama; though it is clear from the breadth and experience of its contributors that a wider context is often implied.

Analogies must constantly be drawn between the arts at this time when the interrelation of the arts is very much the concern of forward-looking artists, historians, educationists, and critics. This is not to forget that the visual artist and designer is still a dramatic and interpretative being, playing from time to time the role of philosopher, poet, prophet, or social satirist. Today the one prerequisite of any work of art is that we should respond to it, not that we should necessarily judge it well or ill. There are few social or moral prohibitions as to how the artist or designer may fulfil his function. 'Response' suggests that the work of art is in any case a social act; a distinction may, however, be drawn here regarding the art of the psychopath.

Every work of art – primitive, sophisticated, analytical – proves to be, nevertheless, a synthesis, an organized whole, reflecting the artist in relation to society or group. From time to time one hears a work described as 'highly personal'. Investigation reveals that it is the language that is personal; the message is more often than not universal. A visit to the Fourth International Exhibition of Contemporary Art (Documenta IV) in Kassel revealed a new awareness on the part of the artist and his role in society. Painter,

sculptor, designer develop a unique visual language which has to be sufficiently arresting to break through a certain acknowledged apathy in an already over-stimulated society, bombarded by every sort of verbal and visual message that man and technology can devise. Society today may be said to be constantly under threat of emotional exploitation. In the current scene the *act* of producing the art form is in itself of fundamental importance. In some cases the act is understood to be the end-product, rather like the dance-drama in primitive society. Professor Gombrich has demonstrated that change works out in 'counter-movement'. Contemporary art is essentially challenging to accepted ways of thinking; there is a constant pattern of reaction and antithesis. This is in itself a reflection of the mood of society and a symbol of intellectual growth allied to the protest against, and movement away from, authority. At the same time in the current scene there would seem to be a general movement towards anonymity, in line with the identification of the individual with the group, particularly where young artists are concerned.

The sculptor James Tower describes the artist today as feeling his way towards forms which express the psychology of his time. This is particularly appropriate in the case of the young sculptor, but is equally applicable to the graphic designer. Professor Barbu, who contributes to this volume, has lectured to DipAD students over three years on aspects of social psychology and the sociology of art. He comments upon the ability of the young artist to grasp this subject academically as well as perceptually; out of the enthusiasm which this study engenders will undoubtedly come specific contributions to the problems of sociology, in relation to the practice of art and design. A deliberately cultivated socio-historical sense may provide a sound basis for any rediscovery of the significance of the visual world, particularly when reinforced by some knowledge of the psychology behind contemporary and historical use of image and symbol. This is a new era of understanding by the artist and the art student of the significance of symbol by which he reads and transmits what is fundamentally significant. Awareness of the power of symbol has sometimes led

5

esoteric arts to become further removed from the common eye and mind, rendering them less comprehensible to the masses outside the society or group from which they stem. A study of the universality of image and symbol not only is relevant, but today offers some assurance of the success of certain graphic work, for example.

It is the purpose of this book to comment on the visual arts as they concern the social scene. Its purpose is also to cultivate understanding and exchange by perceptual and intellectual means, promoting wider exchange between social groups. It is hoped thereby to clarify in some measure the function and aims of the artist in relation to his own society and those of future generations.

Even though many current individual art forms are nonpermanent in structure and execution, the action, the function, is living, and on record. The direction of thought and purpose is altered, new interests and concepts are engendered. It is this common understanding and exchange between differing social environments and their organic components that makes the new art forms lasting and purposeful.

Pop art, kinetic art, and environmental art, for example, contribute to establishing greater awareness by their strong element of social participation; the feed-in and the feed-back from society.

In the past, preoccupation with social problems and political consciousness on the part of the few, the perceptual élite one may say, has produced new and vital art widely different in purpose and kind. At the root of this dynamic social awareness is a deep humanity, as evidenced by Grunewald's Isenheim altar piece, Goya's etching sequences 'The Horrors of War' and the Van Gogh drawings of peasants in the fields bent in toil, and the miners of the Borinage. Contemporary art forms produce social awareness very different in kind. Through his own participation in social experience the artist engages his public by irresistable new means and by associations deliberately employed; the work of Chryssa in neon-lighting sculpture is a case in point.

We are now asked to look inside, walk in and around, feel and engage, being forced by new dynamic approaches to have positive

6

'look and feel' reactions in company with others. We are deliberately arrested, and occasionally repelled for a positive, specific purpose: the purpose of increased awareness of total environment. Moreover the simple possibilities and opportunities presented by the contemporary artist are dramatized for society itself to exploit as a continuing process. Such action is promoted, for example, through the work of Anthony Caro, Erich Hauser, Robert Morris, Eduardo Paolozzi, and William Turnbull in sculptural form. Through such work, social groups understand and enjoy the nature of their own environment and participate in understanding qualities, functional entities, tools, and surroundings of other groups. By such means Man may come to realize the great sculptural possibilities of functional form in architecture, industry, town-and-country planning, for example. Who can fail to note the sculptural qualities of the new concrete breakwater for the harbour at Dubai, a photograph of which appeared in *The Times* on 3 March 1969?

Technology, particularly now with opportunities provided through new polytechnics, could offer not merely means for the artist to create new forms and to employ new techniques in the handling of new materials, but the means for technology to discover its own endemic functional forms. This development is actively advanced if at the aesthetic level society moves towards a positive understanding of this great potential. A new-type industrial revolution is envisaged within the next decade bringing a dynamic impact and leaving in its wake a powerful aesthetic legacy very different from that of the nineteenth-century industrial revolution.

On the question of increased awareness in design, new elements, new dynamic force, and new subtlety of perceptual experience are explored, particularly through the development and popularity of the print. Briget Riley, Burgoyne Diller, Rupprecht Geiger, Kenneth Noland, and Al Held are engaged in such analysis and in the dramatization of simple design elements to this end. Through their work they open new lines of communication. A far greater segment of society is now exposed to such experience.

7

To return for a moment to the more controversial type of sculptural form. This is 'foisted' upon Society; the man in the street protests. In reply one may rightly argue, if the layman can come away from an exhibition of contemporary sculpture and say of a configuration of drain-pipes he sees rising from the pavement, 'There is a far better piece of sculpture than what I have just seen on the Pavilion lawns', then the exhibition will not have been in vain. The finer appreciation of spatial subtleties and the exploitation of surface and material textures and qualities in environment will be, through this foisting, ultimately an enrichment, as form and character of industrial material is carried abroad into all areas of society. Through the unique power of the artist to explore and identify himself, in the manner in which Van Gogh identified himself with the peasant population, we have the new environmental experience passed on.

Today we are all concerned in the visual arts with what is endemic, functional, and appropriate in space form, surface, colour, and design; in general mood moving away from the 'precious', aesthetic experience of the real or imagined world of the artist as individual, to the wider context of society. Debated now is a new philosophy of Design; to some extent clarified at the NCSID Congress in London, August 1969; laying strong emphasis on breadth of design education notwithstanding the new technologies and their claims. Almost as a *raison d'être* now, the Fine Artist, inasmuch as he sees himself as distinct from the Designer, currently advances the claim to independence of mind, purpose, and action, and the preservation of *individual* freedom in every respect.

Much has been said in this introduction of the role of the young artist and of his aims. Art students, however, form a very small part numerically of the larger group actively engaged in the study of society, and it is to this larger audience that this work is also addressed.

© Jean Creedy 1970.

Z. BARBU

Sociological perspectives in art and literature

Whenever a student of society, be he an historian or a sociologist, yields to the temptation to use evidence derived from literature, or works of art in general, he implicitly assumes a certain degree of correspondence between two kinds of phenomena belonging to two levels of human activity – the real and the imaginary. For, needless to say, he is concerned with literary and artistic representations only to the extent to which this enables him to increase, or clarify, his knowledge of social events. Thus, while a literary or art critic may become genuinely interested in the 'society' of Jane Austen's novels, or of Chardin's painting, the historian or sociologist does so only to the extent to which this tells him something about the society in which Jane Austen or Chardin lived.

But does such a correspondence exist?

The question has seldom been examined, and even less frequently explicitly answered. An historian such as J. Burckhardt – to start with one of the best-known names in this field of inquiry – creates the impression that the relationship between art and society is simple, direct, and almost as obvious and natural as if it were a matter of sense perception. Thus, he 'sees' a sort of identity between the social and cultural trends or aspects of a period, that is, between the individualism of Leonardo's art, Machiavelli's

9

political thought, and the economic practices of a Florentine merchant of the time.

Such an approach can, admittedly, be considered and even dismissed as old-fashioned. But before doing so, it would be advisable to note that, in this matter, the difference between Burckhardt and a contemporary and, at the same time, much more sociologically minded historian, such as Marc Bloch, is one of degree rather than one of substance. Marc Bloch (1961) is more aware of the complex and subtle character of this correspondence, consequently he uses evidence drawn from the analysis of literary works for a twofold reason: first, to throw additional light on particular historical events; second, to bring into relief a series of background features of a period or of a society that would otherwise have remained imperceptible. Consequently, his work makes us aware of a sort of polyphonic and carefully counterpointed correspondence between the artistic and social events of a period.

Burckhardt and Bloch certainly assume too much with regard to the positive relationship between art and society. On the other hand many, if not most, historians are in this respect far more cautious than necessary. A typical example is A. J. P. Taylor, who after dealing rather imaginatively with the literary image of the 'thirties', in England, writes:

> It would, however, be rash, indeed mistaken, to assume that literary taste and popularity indicate what ordinary people are thinking. The assumption perhaps works in earlier periods, when history deals only with the upper, cultivated classes, and great works therefore can be regarded as the mirror of the age. Even this assumes that works which have survived or are rated highly by posterity were necessarily the most influential or the most representative in their own time. At any rate, literature tells us little when we deal, as we must in the twentieth century, with the people of England. The novels of Virginia Woolf, for example, were greatly esteemed by a small intellectual group, and their destruction of the tight narrative frame has influenced later writers. They are irrelevant for the historian. Again, the

10

thirties produced a school of poets deeply concerned with social and political questions, and it is tempting to regard their leader, W. H. Auden, as the characteristic voice of his time, in the way that, say, Tennyson had once been. Maybe Auden expressed in poetic form what many Englishmen were thinking. This does not mean that they read his poems or had even heard of him. The decade was indeed short of literary pundits. No one took the place of Bernard Shaw or Arnold Bennett, men who pronounced without hesitation on every great question (Taylor, 1965, p. 311).

So much for historians. It would, however, be rash to assume that the sociologists have so far dealt more systematically with a question of a kind that should after all occupy a central place in the methodology of their discipline. Admittedly most of them regard art as a social fact but few, if any, have examined critically the implications of such a view – no more than did Burckhardt a century ago. Max Weber, for instance, takes almost for granted that the ancient Indian art reveals a series of basic features of the ancient Indian religion and society. Now, this may be true, but the problem is to demonstrate it, that is, to identify some basic processes that regulate the relationship between art and society, and above all, to formulate the main conceptual tools by which such a relationship can be interpreted. This is, in itself, a difficult task, and one made even more so by the lack of agreement among those who have been concerned with this kind of inquiry. It is, nevertheless, possible to derive from their work some basic approaches and working hypotheses, and thus to outline the theoretical framework of the sociology of art and literature. What follows is an attempt in this direction.

To start with, anyone concerned with the relationship between art and society, and the term 'art' is used here in a comprehensive sense to include literature, has to analyse the works of art that form the subject of his inquiry in terms of (a) *social structure*, (b) *culture*, (c) *personality*. The meaning of these terms will become apparent from what follows, for the moment it would be enough

to emphasize that they are the basic conceptual tools and units of analysis in any systematic sociological investigation of art.

ART AND SOCIAL STRUCTURE

The first task of the sociology of art is to locate a work of art in the structure of its society. One of the most usual ways of doing this is by relating it to the social class of its author. This need not necessarily imply the acceptance *in toto*, or even in part, of the Marxist conception of society, according to which art, together with other cultural manifestations, such as religion, science, and philosophy are reflections in human consciousness of economically determined class relationships. The reference of a work of art to the social class of its author should, in principle, imply no more than the conviction that a comparative analysis of two phenomena belonging to the same social structure increases our understanding of their nature and, naturally, of their specific relation to each other. After all, this is one of the most common procedures in sociological research. It is only that, in this case, the two phenomena under consideration, i.e. social classes and works of art, are in themselves very complex and different socio-psychological structures, and consequently their comparison has to be carried out by an imaginative interpretation ranging from subtle analogies of meaning to more precise convergencies and correlations of specific traits. A most common example of this consists of an analogy between the mental structure, the dominant attitudes, feelings, and values of the main character of a literary work, and the behavioural and cultural patterns of a specific social class. In this way one can speak about the middle-class character of the post-Restoration novel and drama in England, or of the working-class character of D. H. Lawrence's novels.

One should, however, specify that such a procedure applies more readily to literary works, and that it has, even within this context, a relatively limited value. First of all, the mental and behavioural structure of a series of imaginary characters, such as those depicted by James Joyce, Virginia Woolf, or Alain Robbe-

Grillet, to mention only a few examples, cannot always be analysed in terms of social class. Secondly – and this is often overlooked by many sociologically minded literary critics – the so-called hero or heroes express only one, and often not the most significant, aspect of the class character of a literary work. This makes it often necessary to consider a series of more general and diffuse traits of a work of art with a view to revealing its class character. Thus, in one of his well-known sociological studies of literature, Georg Lucács arrives at the conclusion that the historical novel of the nineteenth century was as a whole the expression of social class, the continental bourgeoisie, in the process of losing its power and vigour and consequently taking refuge in the past. Similarly, Flaubert's realism, his preoccupation with the (insignificant) details of the individual's life, was, according to him, a symptom of petty bourgeois escapism.

The social class or the class consciousness of a group of people expresses itself, therefore, not only in the characters depicted by a work of art, but also in a series of formal and stylistic traits, as well as in a series of other traits referring to the general conception and style of life suggested by such a work. In this broad sense, the concept of social class can also be applied to non-literary works of art. This is an important point and will be taken up at a later stage. For the time being it is necessary to look more closely at the more general question of the relationship between social class and art.

As just mentioned, this form of social analysis is based on the relatively simple idea that the social class of the artist is reflected in his work. It can be little doubted that in principle this is true; contemporary social psychology has produced enough empirical evidence to prove that the behaviour and the personality of the individual is to a considerable extent influenced by his social class. But to establish the social class of an artist is not as easy a matter as writers of Marxist orientation, such as Lucács (1962) or Goldmann, would like us to believe. To start with, it is necessary to discriminate between the class-belongingness and the class-identification of the artist, that is, between the social class in which he was brought up and to which in some respect he may

still belong, and the social class with which he identifies himself in his thoughts, feelings, and aspirations. One can think in this context of relatively simple cases, such as D. H. Lawrence or Maxim Gorki, for whom class-belongingness and class-identification coincide; consequently the class character of their novels is clearly conveyed not only by the character structure of their heroes but also by the whole emotional and intellectual climate of their work. No one felt the same about the English working class after reading D. H. Lawrence. But such cases are rare, and consequently, it is necessary to regard the social significance of works of art in terms of their authors' personal feelings and conceptions about social stratification, irrespective of their class-belongingness. In this sense, one can speak about the class consciousness conveyed by Diderot's literary writings or by Courbet's and Goya's paintings. There are, furthermore, other cases in which the class identity, or the class consciousness of the artist is either a confusing or a completely irrelevant element in respect of the social significance of his art. A typical example is Picasso, whose art has hardly anything to do with feelings, perceptions, and attitudes characteristic of the working class with whom he has identified himself throughout his life. This remains true even if one makes abstraction of the narrow and dogmatic manner in which his art has been interpreted and consequently rejected by Soviet critics.[1]

The case of Picasso leads us to another point regarding the relationship between social class and art. In dealing with this problem it is often necessary to draw a clear distinction between the conscious and deliberate class orientation of the artist and the class significance of his work; between the intentions and conceptions of the artist as a social and political agent, and the social meaning of his art. In his study of Balzac's novels, Georg Lucács makes this point very clearly. Balzac, as a person, was a royalist and hence identified with the interests and political aspirations of the French upper classes, while in his novels, or at least in some of them, he reveals a deep understanding and sympathy for the lower classes, and for the peasants in particular. Lucács goes as far

[1] For a suggestive Marxian view of his work, see Garaudy (1963).

14

as to maintain that the political vision of his novels is radically different from his personal (political) views. As I have just mentioned, Picasso presents the same problem in different terms: while at the conscious level he is identified with working-class attitudes and values, his art expresses highly urbanized middle-class attitudes and values.

One cannot, therefore, take for granted that the person of the artist, his social class, his social status and role, constitute the basic frame of reference for the sociological analysis of his art. Sometimes the analysis has to be focused entirely on his work. All this points to the conclusion that the relationship between the artist and his society is so complex and diffuse that it can be expressed in various ways and at various levels. Consciously the artist can perceive and conceptualize some aspects of his society, while unconsciously he may be aware of some other and completely different aspects of the same society.

Before ending this section, it is necessary to make two points of a more general nature. First, the analysis of works of art in terms of social class constitutes only one way of establishing their social significance. Other aspects or components of social life, such as religious, political, and economic groups or institutions, can sometimes be more relevant in this respect. Examples of works of art influenced by the religious or political affiliation of their authors are so common that they should not detain us here. Secondly, the sociologist of art and literature has often to deal with societies in which social classes do not exist. Primitive societies may be instanced as an example of this. In this case, the social analysis of primitive art has to be carried out within the frame of reference of primitive society, or primitive culture in general.

ART AND CULTURE

The term 'culture' defies any brief and, indeed, any commonly accepted definition. For the present purpose it would, however, be enough to mention that the term normally refers to the beliefs,

opinions, concepts, values, and norms held in common by the members of a society. 'Common' is a key word here, for it is often assumed that the elements of a culture form a shared frame of reference, an organized structure that moulds the behaviour of each individual member of a society. Thus, culture, or culture pattern, constitutes a basic interpretative tool in sociological research; the institutions and activities, the dominant patterns of behaviour and personality structure of a community cannot properly be understood until they are referred to their cultural background, i.e. to dominant beliefs, conceptions, and norms.

Here are a few points of method regarding this field of inquiry. To start with, there is a problem of choice, namely, the selection of those components of a culture that have more direct relevance for the works of art under consideration. This requires a detailed knowledge both of the culture and of the art of a period. But it requires also special sensibility for, and insight into, the many and subtle ways in which the contents of a culture find their expression in a work of art, or in a group of works of art. Though various attempts have been made to formalize this particular stage of inquiry, and to label it somewhat pretentiously as 'content analysis', or 'projective analysis', the enterprise as a whole involves a considerable element of subjectivity. For this reason it is difficult to prescribe specific rules of procedure. It may, however, be relevant to mention that many workers in this field stress the idea – and this can hardly be simple coincidence – that some of the most important cultural determinants of art are closely related to general beliefs and conceptions about God, or supernatural forces, about nature, and about society and man in general. Primitive and medieval art are often given as illustrations of this point.

Though widely different in content and form, the primitive and medieval works of art have at least three essential characteristics in common. First, they are not representational within the usual acceptance of the term. One should, however, specify that this cannot be taken to mean that the primitive or the medieval painter is never preoccupied with representational techniques,

with the technique of drawing, for instance. It is only that his intention, and the whole purpose of his activities as an artist, go beyond *verisimilitude*, beyond perceptual resemblance between artistic and natural objects and situations. On the contrary, most of primitive and medieval painting creates the impression that the artist's conscious or unconscious intention is to simplify and even to 'distort' the perceptive represensorial element of his art, and thus to render it transparent and open to trans-sensorial meanings and values. As has often been said, his art has a parabolic significance. Secondly – and this follows directly from what has just been said – neither the primitive, nor the medieval artist is inspired by specific and autonomous motives; he seldom paints or carves in order to arouse aesthetic pleasure, or to produce aesthetic values. Both primitive and medieval art are closely integrated with the totality of social life, or to put it differently and perhaps more cautiously, they are to a greater extent (socially) functional than modern European art normally is. Thirdly, primitive and medieval art are less individualized than modern European art, and the art of the Renaissance in particular. Despite the effort made by some anthropologists to distinguish between individual styles in primitive art, this seems to be true in more than one sense.

First of all, the primitive and the medieval artist have comparatively little freedom for choosing and treating their subject. Secondly, they are less inclined, and perhaps less able than the Renaissance artist, to express in their work personal experiences and individualized states of mind. This should not, however, imply that the term self-expression could on no account be applied to the primitive and medieval artist. It is only that the content of their minds is dominated by inter-individual, hence social, experiences, by common beliefs, conceptions, and attitudes. Finally – and, psychologically speaking, this is a corollary of the previous point – the primary concern of the primitive and medieval artist is not with the individuality of the objects and situations that form the content of their art, but rather with symbolic significance or, to use more technical language, with their participation in a super-individual and often trans-sensorial structure

17

of meanings. Consequently they aim at archetypal and stereo-typical forms.

At this stage, one can go back to the central question of this section. Most of what has been said above leads to the conclusion that the main point of similarity between primitive and medieval art consists in their relative lack of what one may call individual or individualizing traits. This can obviously be regarded as an aspect of some basic features of primitive and medieval societies. Both societies are highly and rigidly integrated, and for this very reason they hinder, and moreover counter-stimulate the development of self-awareness in their individual members. In this sense, the medieval, and even to a greater extent the primitive, artists are neither inclined nor able to egotize their world, and consequently, to express in their work what they themselves, as individuals, perceive, feel, or think. Even in their roles of artists, as indeed in all their roles, they are mainly participants.

But our main concern is not with the relationship between the primitive artist and his society but rather with the manner in which this is reflected in his art. What does he, in fact, express in his work; in other words, what is the specific social significance of his art? Now, needless to say, much of the significance of primitive art would remain inaccessible without making a conscious and systematic effort to perceive and interpret it within the cultural context, within the specific beliefs, conceptions, and attitudes of a primitive community, in other words, without using the concept of culture as an interpretative tool. Only in this way can one establish a meaningful and, to a certain extent, an aesthetic contact with the art of the Aborigines of Arnheim Land, to give a well-known example. The tall, thin-bodied human figures, as well as the X-ray painting characteristic of this art are in fact visual forms of basic beliefs and conceptions of the world. Furthermore, Aborigine art is intrinsically connected with an act of participation, and even with a re-enactment of a specific myth of creation.[1] In this particular sense, it would not be completely inadequate to call it representational; it is only that it represents a cultural

[1] For detail see Smith (1961).

object. For example, the tall thin-bodied human shapes are mythical creatures, more precisely *mimi* (spirits), who in the primeval dreamtime of the world rose from the ground and, wandering over the featureless earth, made it as we know it now. This explains a great deal of the significance of this primitive art as well as of its particular form.

Similar interpretative tools have been applied to medieval art; E. Mâle (1945), for instance, sees a close connection between the anonymous and iconographical (as opposed to the individualizing) character of this art, and the medieval sacramental conception of the world, and particularly the conception of man as a receiver of faith. On this point he writes:

> All human tender, or simply picturesque side of the Gospel does not seem to have touched the medieval artist. He evidently did not see in the New Testament the things which appealed to a Veronese, or to a Rembrandt. Those aspects of Christ's life which are illustrated are not the most humanly moving, but those connected with the great feasts of the liturgical year; it is the sacramental not the human aspects of Christ which are stressed. The thirteenth century artist saw in the Gospel not a collection of picturesque or affecting scenes, but a succession of mysteries.

This, obviously, throws light not only on the cultural inspiration of the medieval artist but also, and particularly, on the cultural source of some of the most outstanding formal characteristics of his art. And, needless to say, this is not confined to visual art; the same cultural cluster, namely, man in a sacramental world, shapes the main literary works of the period, such as Dante's *Divina Commedia* or Langland's *Piers Plowman*, to mention only two outstanding examples.

Concluding this section, one can say that anyone concerned with a cultural interpretation of art has to bear in mind the intimate and complex interrelation between culture and society, between dominant beliefs and concepts on the one hand, and dominant social events and institutions on the other. As an

19

illustration one may mention the development that took place in the later medieval religious art of Southern France and Northern Spain, and particularly in the visual representation of Christ. While in the thirteenth century the dominant image was that of Christ in Majesty (Pantacratos), in the fourteenth century this became that of Christ in Passion. Now the point is that this stylistic development cannot be interpreted in cultural terms alone. Since there is no reason for believing that the theocentric sacramental conception of the world had not remained dominant throughout this period, we have to broaden considerably our search for possible causes. And indeed, this is precisely what Mâle does; he relates this important artistic development to a series of extra-cultural events, such as wars, internal social conflicts, plagues, natural disasters, that shook the confidence of the late medieval man in the stability of his society and the security of human existence in general. All this was bound to change man's perception of, and feelings about, God expressed at a cultural level in the conventional representation of Christ.

ART AND PERSONALITY STRUCTURE

The concept of personality structure is an important interpretative tool in any sociological inquiry, and an indispensable one when the inquiry is about the social significance of art. In such cases it may be as necessary as the concepts of social structure and culture. It would, however, be relevant to state from the very outset that the sociology of art is not directly concerned with the personality of the artist. This remains on the whole the domain of the psychology of art, whose main task is to interpret a work of art in terms of the specific motivational and behavioural structure of its author. The psychoanalytical interpretation of art is an outstanding and, at the same time, extreme example of this.

This cannot be taken to mean that the personality of the artist is not an important determinant of his art. For example, no one will understand adequately the difference between the drama of Aeschylus and Euripides without taking into account the differ-

ence between their personalities; for even when they deal with the same subjects – war, for instance – they perceive, evaluate, and dramatize it in a completely different way. But the point is that the sociologist could hardly leave the matter here. While he would admit and record the difference in their personality structure, he would be inclined to account for this difference, or at least for part of it, in social terms. Thus, he would emphasize the fact that, though both Athenians, the two artists belonged to different social classes – the former to the upper, the latter to the lower classes. This class difference may account for the fact that, although almost contemporary, the two writers identified themselves with two generations separated not so much by age as by cultural and political orientations. Euripides belonged, or at least sympathized with the angry young men of his time. In conclusion, the sociologist would be inclined to interpret the difference between their conceptions of the drama in terms of their specific cultural climates.

What has just been said throws light on the specific manner in which the concept of personality structure is employed in sociological research. In this context, the concept normally connotes a pattern of mental organization characteristic of a community, of a culture, or of a historical period. Thus defined, the term comes very near what some psychologically minded anthropologists, such as A. Kardiner and R. Linton (1945) have called 'basic personality', i.e. a specific motivational structure determined by a culture.

Now, it is rather in this specific sense that the term personality structure can be used as an interpretative tool in the sociology of art and of literature. The personality of the artist is, in this context, relevant to the extent to which he reflects patterns of mental organization dominant in his society or, to put it more precisely, to the extent to which his art expresses these patterns of mental organization. To illustrate this point it is necessary to mention again the work of those anthropologists who belong to the so-called 'Culture and Personality' school. Ruth Benedict, for instance, perceives such a close connection between culture

and personality structure, on the one hand, and personality structure and dominant modes of artistic expression, on the other, that she feels justified in applying one term to these three aspects of social life. Thus, she speaks about the 'Dionysian', or about the 'Apollonian' culture, personality structure and, naturally, art of two primitive communities. We say 'naturally' because both terms have strong aesthetic overtones; this is certainly obvious in the work of Nietzsche from whom the terms were borrowed. Moreover, it may well be that Ruth Benedict herself began her study of the two communities with an insight into their art and inferred from this the basic features of their cultures, societies, and personality structures. This deserves to be mentioned because it throws light on what has been said at an earlier stage with regard to the role played by intuition and personal insight in this type of research.

For further elucidation of the question that concerns us here we should discuss briefly some ideas put forward by a well-known art historian, Worringer, in his studies of the origins of art forms, and of Baroque art in particular (1908, 1912). The fact that Worringer does not normally use the term personality structure should for the time being be regarded as a matter of terminology. The important point is that his central aim is to correlate, and moreover to establish, causal links between specific art forms and styles, and specific mental structures, that is, feelings and conceptions about the world and even specific motivational and behavioural structures. Primitive art can be taken as an illustration. What form, according to Worringer, the main characteristics of the primitive man – and he always considers the concept of man as the starting point and the main frame of reference of his investigation – is an attitude of fear and mistrust toward nature and the world in general. This is generally due to a low degree of intellectual and technical development, and consequently to the failure of the primitive man to understand and master his environment. Because of this, his basic reaction is one of diffidence, and of withdrawal from nature. Worringer calls this type of relation to nature *abstraction*, meaning both the primitive's inability to

22

experience, and his (unconscious) avoidance of experiencing, nature directly and concretely through his sense organs. Moreover, the primitive seems to be possessed by a compulsive need to schematize and abstract his physical environment. He achieves this by religious and artistic activities, that is, by putting between himself and nature a web of spiritual images and abstract forms. His religion and art are therefore two basic ways in which he escapes from the *natural* and *sensorial* into the magic and abstract. In conclusion, Worringer derives the social function as well as the formal traits of primitive art from the concept of primitive man.

Worringer's concept of personality structure is, admittedly, ill defined. On the other hand, it is not difficult to realize that the concept has a strong socio-cultural connotation. This can be inferred from Worringer's basic terms, such as the primitive, the medieval, and the Renaissance man. This remains true even if one is inclined to believe that Worringer has never freed himself completely from such general notions as *Zeitgeist* and *Volksgeist* which suggest either unstructurized and almost free-floating collective states of mind, or concrete collective individualities; in other words, either too much or too little for the specific purposes of the sociologist of art and of literature.

The difficulty involved in Worringer's position is not untypical. On the contrary, most sociologists are reluctant to work with the concept of personality structure; they are inclined to think that their task is more or less finished when they succeed in describing and interpreting social phenomena in terms of social structure, or culture, when they succeed, for instance, in interpreting delinquency or political affiliation in terms of social class, family structure, age, and occupational groups or in terms of dominant beliefs and values. Though this is not the place to discuss basic problems of approach and method, it is important to emphasize that such an attitude is much less adequate and even more damaging in the sociology of art and literature than in any other field of sociological inquiry. This is not only because art phenomena are more complex, but also because they are more intimately related to mental processes and structures than most

23

other social phenomena. Putting it very simply, there is a much smaller distance between a mental image and a painting, than between a mental process, however complex, and, say a political party or a professional organization. This makes it all the more necessary for the sociologist of art and literature to regard personality structure, as defined above, as an important conceptual tool in his field of research. That this has not been fully realized can be seen from the following example: according to a well-known thesis the rise and the development of the novel and of lyric poetry as specific literary forms were closely associated with a certain stage in the rise of modern individualism. Now the point is that, however relevant in itself, such a thesis cannot be adequately demonstrated as long as individualism is defined only in terms of social structure, or culture, or more precisely in terms of a rising middle class and of their individualistic values. At least as relevant would be to consider in this context the rise of a new personality structure, a self-centred and inner-directed, as opposed to a group-centred and tradition-directed personality structure. The rise and particularly the consolidation of the novel would hardly have been possible without this socio-psychological development. For does not the modern novel, starting with John Cleland, Diderot, Laclos, Richardson, not to mention de Sade, express in so many ways the story of an individual endeavouring to live his life according to his own wishes and aspirations, endeavouring to assert, and moreover to publicize, the value of his interiority?

REFERENCES

BLOCH, MARC. 1961. *Feudal Society*. Trans. by L. A. Manyon. London: Routledge & Kegan Paul.

GARAUDY, J. 1963. *Réalisme sans rivages*. Paris: Plon.

KARDINER, A. & LINTON, R. 1945. *The Psychological Frontiers of Society*. New York: Columbia University Press.

LUKÁCS, GEORGE. 1962. *The Historical Novel*. London: Merlin Press.

MÂLE, E. 1945. *L'Art religieux du XIIe au XVIIIe siècle*. Paris: Colin.

SMITH, MARION W. (ed.) 1961. *The Artist in Tribal Society*. London: Routledge & Kegan Paul.

TAYLOR, A. J. P. 1965. *English History, 1914–1945*. London: Oxford University Press.

WORRINGER, W. 1908. *Abstraction and Empathy*. Trans. by Bullock. London: Routledge & Kegan Paul, 1953.

— 1912. *Form in Gothic*. London: Tiranti, 1957; New York: Shocken, 1964.

EDWARD LUCIE-SMITH

Manifestations of current social trends in contemporary art

One of the phenomena of the twentieth century has been the conscious attempt to bring the visual arts into line with what was happening in society as a whole – or, at least, with what the artist felt *should* be happening. At the same time, twentieth-century artists have often appeared to feel an instinctive need to dissociate themselves from their surroundings, to make an assertion of their own creative autonomy, regardless of social bonds. The result has been to create a confused and confusing attitude towards the social role of the arts. As the pioneers of modernism, the visual arts have been particularly subject to this. On the one hand, there is the intellectual effort to conform, to make a contribution which will benefit society as a whole; and, on the other, there is an instinctive revulsion from this, a frenzied assertion of personal identity. The old way of labelling these two sets of attitudes would, I suppose, have been to call them the Apollonian and the Dionysian. It would perhaps be more fruitful to adopt the terminology of a psychological study of social relationships (Berne, 1966), and to say that the artist's 'Adult' has often seemed to be in conflict with his 'Child'.

'Adult' attitudes in the arts are sane, intelligent, and curiously passionless. 'Childish' ones are passionate, irrational, playful, and occasionally destructive. They are also – and this is an important

27

point – connected with the demand for some kind of special status in society to be given to the artist. So far as modern art is concerned, society traditionally plays the role of the stern, sometimes wrathful, sometimes forgiving parent, who responds to the caprices of the creative man. Though this stereotype is, as I hope to show, a distinctly inadequate one, at least it introduces us to the idea that some kind of reaction is involved. Modern art has never existed in isolation from the rest of society.

The development of the visual arts in the postwar period is so deeply rooted in the history of what has gone before that it is impossible to discuss the subject without some reference to the development of modernism as a whole. When we look at the most significant and influential trends in postwar painting and sculpture, we find that these are very closely linked to things that took place at the very start of the history of modernism. The most interesting of the sources are Constructivism and Dada, not only because they show us the kind of antithesis I've just been talking about, but because their respective influences on the painting and sculpture of the present moment are particularly obvious.

Constructivism, which had its origins in the Russia of the revolutionary period, was, of all the modern movements in art, the one which laid the most stress upon the social role of the artist, and upon his relationship to industry. We catch the note very clearly in Alexei Gan's Constructivist manifesto, which dates from 1920: 'If up till now economic relationships have developed of themselves', says Gan, 'passing us by and not requiring us to interfere in them, now our consciousness will not be lulled with such a conception . . . We are innovators of intellectual-material production . . .' Gan goes on to assert that the task of the artist is 'not to reflect, not to represent and not to interpret reality, but really to build and express the systematic tasks of the new class, the proletariat' (quoted in Gray, 1962). It is easy enough to see in this way of thinking the source of many of the ideas which, with suitable modifications to fit changed times and circumstances, are being explored by artists today. We have here, for example, the first glimpse of a new

28

aesthetic in which everything in the visual arts will be assimilated to architecture. And this has implications that I hope to explore at a later stage.

But let me turn a moment to what seems to be the direct opposite of Constructivism, although its contemporary – I mean the Dada movement, which sprang up in Zürich in 1917, and later transferred its activities to Berlin and to Paris. In a recent history of the movement, Hans Richter (1966), who was one of its founder members, gives a vivid description of the principal Dada manifestations. The greater the uproar caused by these performances, the better pleased were their perpetrators. The Dada movement was, however, much more complex philosophically than might at first glance appear. We get a glimpse of this in the definition given by Hugo Ball, the German poet who, perhaps more than anyone, was responsible for setting Dada in motion. 'What we call Dada is foolery', Ball wrote, 'foolery extracted from the emptiness in which all the higher problems are wrapped, a game played with the social remnants . . . a public execution of false morality.' To this statement of Ball's we may add Tristan Tzara's dictum from the Dada manifesto of 1918: 'Thought is produced in the mouth', and a comment from Richter himself:

> Dada's propaganda for the total repudiation of art was in itself a factor in the advance of art. Our feeling of freedom from rules, precepts, money and critical praise, a freedom for which we paid the price of an excessive distaste and contempt for the public, was a major stimulus. The freedom not to care a damn about anything, the absence of any kind of opportunism, which in any case would have served no purpose, brought us all the closer to the source of all art, the voice within ourselves.

It is perhaps worth making the point that these various statements, correctly analysed, do not imply a withdrawal from society, any more than does the history of Dada itself. Otherwise, what was the reason for staging so many demonstrations; and,

29

later, for the quarrels and struggles for primacy which broke out within the movement? What Ball, Tzara, and Richter mean is that the Dadaists were trying to exchange one kind of social relationship for another, and in this at least they resembled the Constructivists. And both, I think it fair to add, did something characteristically modern – they shifted the focus of their attention from the object itself, the thing which the artist makes, to the response produced by the object.

In one case – Constructivism – the objects were to symbolize a change in social relationships quite directly and simply. The work of art as a bourgeois possession was to be abolished, and in place of it was to be put something from which the taint of property had been removed, something which belonged by its very nature to the public sphere. The interest displayed by Russian Constructivists in public projects and monuments of various kinds was the practical expression of this. And the corollary was that art was no longer to be the subject of individual, private (and therefore selfish) emotions, but was to evoke some kind of collective response.

In the case of Dada, things were different, the 'excessive distaste and contempt for the public', of which Richter speaks, was a typical Dada paradox – the child's demand to be loved in spite of his misdeeds. What was important was the Dada trust in spontaneity, which seemed to look forward to a more liberal kind of social relationship, and to be constructive criticism of the state of society as it then stood. Here, too, the work of art was to play a new role, and, once more, this role was one which minimized its status as a possession, as something owned. It was, instead, an instrument through which states of feeling could be explored. The way in which all this returns us to ideas about society is a trifle oblique, but is nevertheless there to be traced. The notion was that society was only as healthy (or as free) as the individuals within it, and that the kind of self-awareness that Dada aimed to promote was the precondition of social health as well as of individual happiness.

With Dada – though not, I think, with Constructivism – I may

perhaps be accused of projecting into the movement ideas which existed only in embryo, which the Dadaists themselves never fully worked out. I am, however, encouraged to find these ideas in Dada very largely because of its influence on the painting of recent years. Dada's healthy qualities, just as much as it unhealthy ones, are very clearly present in the movement now generally known as 'Pop Art' – a term which, like most similar labels, misleads while it describes.

Though Pop has not been a 'universal' art, as the name might suggest, the degree of acceptance which it has attained is very striking. By a typical paradox, acceptance has not always been the same as respectability. From the point of view of the art historian, Pop is not only a revival of Dada, it also represents a reaction against the Abstract Expressionist style which was so dominant in both Europe and America during the late forties and early fifties. From the point of view of the sociologist it is, I suspect, more interesting and more significant still – it represents a sudden irresistible influx of urban imagery into painting, just at the time when artists seemed to have rejected both urbanism and recognizable images of any kind. It also marks the point at which high culture and low culture seemed to enter into an alliance against the middle. If we add the fact that it shows the earliest strivings towards the use of industrial techniques in art, it is possible to begin to see how crucial Pop is.

Pop art is perhaps more various than it is usually given credit for being, and it has shown important differences in its two main centres of development – New York and London. Nevertheless, the materials of Pop are basically the same, wherever it is to be found. Mario Amaya lists them in his recent book, *Pop as Art* (1965): 'movies, television, comic strips, newspapers, girlie magazines, "glossies", high fashion, "High Camp", car-styling, billboards and other advertising'. Amaya adds the claim that the use of this material shows a return to the real and the solid, but that 'reality' is viewed in a special way: 'Direct experience and primary emotion are eschewed for the manufactured, gift-wrapped feeling, shiny and new and guaranteed not to tarnish . . .

The new art is not a style so much as a shared point of view about the modern environment, sexy, sensational and saleable, which has sprung up during the last twenty-five years in Europe and particularly in America.'

The difference between American Pop artists and British ones is something that I'd better try to clear up here and now. Basically, it lies in the attitudes which the artists concerned choose to adopt towards the material that Amaya lists. British artists, I feel, are much more inclined to view this wealth of urban imagery in a nostalgic, romantic, indulgent way. David Hockney, in a series of etchings on the theme of *The Rake's Progress*, takes a bemused, wondering look at New York – the artist casts himself in the traditional role of the innocent abroad. This is characteristic – British painters have always liked the exotic, and Pop is a style that allows them to indulge this liking to the full. Peter Phillips (the most purely Pop of all British painters) gleefully uses an imagery of motor-cycles and pin-tables which we know is visible in England, but which we also recognize as being only very marginally part of our national culture. We get much the same kind of feeling from the much more rigorous work of Richard Hamilton, who was one of the originators of the Pop style, and who began exploring the whole field of popular imagery in 1952, in advance of most of the Americans.

Hamilton shares one important thing with these American rivals – one that is not usually found among British Pop painters. He has a preference for using the borrowed image 'raw' rather than 'cooked' – that is, it is fed into the work of art without significant alteration, and is allowed to assert its own personality or lack of personality. We see the same preference at work with such Americans as Roy Lichtenstein and Andy Warhol. Lichtenstein, for example, made his reputation with a series of paintings that were blown-up images borrowed from comic-strips. The paintings use this material very literally indeed – all the mannerisms of print are painstakingly reproduced, the heavy black outline bounding each shape, the mechanical screen of dots which comes from the method of reproduction. It takes prolonged

scrutiny to discover just at what point Lichtenstein has chosen to change his originals. These changes are significant, of course, but the subject-matter does remain overwhelmingly present in the painting.

Warhol refuses even this degree of compromise. His images are often screen-printed from photographs – often the artist's 'choice' in the matter lies simply in the number of times a given image – Marilyn Monroe or the electric chair – is repeated on a single canvas. Warhol has also made such things as exact stencil replicas of real Brillo crates. Or, carrying matters still further, he puts his signature on 'real' Campbell's soup-tins, thus turning them into authentic Warhols.

The shamanistic or magical side of Warhol's activity cannot be overlooked, and it is something that throws a curious sidelight on the kind of society we live in. In fact, the activities of the Pop painters seem to me to be delicately poised between several alternatives. The deeply personal shelters behind a façade of impersonality; a separation takes place between 'idea' and 'embodiment' which I hope to discuss in another context. One point I should like to make straight away, and that is about the psychological relationship between the Pop painter and the imagery he uses. This seems to me not dehumanized, but, on the contrary, very personal. What seems to attract a great many Pop artists is the notion of the hard, the tough, the resistant – the city as a parent who rejects. All of this acquires an additional interest when we look back to something I've already touched on – the relationship between modern art and its patrons, which is another version of the parent-child relationship. It occurs to me that there is a real analogy with one of the 'games' which Dr Berne analyses – the one he labels 'Schlemiel'.

The players of this game are, in the case where it assumes the most typical possible form, the clumsy guest and the forgiving host. Dr Berne calls the players White and Black, respectively.

After the cigarette burn in the tablecloth, the chair leg through the lace curtain and the gravy on the rug, White's Child is

33

exhilarated because he has enjoyed himself in carrying out these procedures, for all of which he has been forgiven, while Black has made a gratifying display of suffering self-control. Thus both of them profit from an unfortunate situation, and *Black is not necessarily anxious to terminate the friendship.*

I don't think that anyone familiar with the attitudes of *avant-garde* artists and *avant-garde* patrons could fail to feel some flicker of recognition on reading this passage. The past history of modern art – the creation of the myth of the 'inevitable' rejection of genius – has created a perfect situation for the 'extreme' artist, who seeks refusal perhaps even more eagerly than he seeks acceptance.

The relationship with the patron is not, however, the only bond between the modern artist and the society in which he lives. It is only the most obvious one. In any society where goods and services are exchanged for money, the artist needs money in order to stay alive and continue working. Money as well as acceptance is what the patron gives him, and the symbolisms tend to become very confused. How much has money become the measure of acceptance; how far has it remained simply the medium of a transaction? Whichever way we choose to answer these questions, the artist remains (among other things) a maker of commodities. Our fascination with the complexities of modern patronage sometimes tends to obscure this brutal fact. Let us, by contrast, shift the perspective a little, and try to think about works of art, and especially Pop art painting and sculpture, simply in this role – as commodities put up for sale.

One of the most striking things about modern manufactured goods is the extent to which the whole economic structure to which they belong is sustained by the concept of obsolescence. That is, even so-called 'consumer durables' turn out to have a life span whose limits have been foreseen from the very moment of their creation. An economy in which things lasted too tenaciously would, under modern industrial conditions, be an economy staggering towards bankruptcy. A regular rhythm of consumption

is needed to keep prices down to the point where most people can afford to buy what they need, or think they need. And this brings up the whole question, not so much of Pop as of the thing it springs from – Pop Culture.

Pop culture seems to me something much simpler than it is often made out to be – basically it is the result of marrying fashion to mass production, fashion being the most powerful contributor that we know towards the obsolescence of any manufactured object. If we compare the society we now live in to the society of the pre-industrial epoch, we discover that one of the things that has changed the most radically is the whole concept of fashion. Fashion which springs, true enough, from the simple human desire for change, was formerly used primarily as an instrument of social demarcation, and a fashion was something which began at the top of the social hierarchy, and spread, by a gradual process of dilution and dissemination, to the bottom. Some fashions achieved an astonishingly long half-life thanks to the protection afforded them by folk-culture. One example that occurs to me is the fashion for the Louis XV style in furniture. This began at the very beginning of the eighteenth century, and lasted, so far as 'provincial' furniture was concerned, till the first decade of the twentieth. Dated French *armoires*, still impeccably Louis XV in style, are known from the years immediately pre-ceding the First World War.

Industrialism, in its present refined and developed form, has finally brought about a violent democratization of fashion that corresponds to the process of political democratization. It has also provided the necessary prosperity. Now a new fashion is launched, reaches all sectors of society simultaneously, and is replaced by another fashion. Designers have learned to cater for the machine. Under the old dispensation, 'high fashion' carefully cherished its own elaborations – these made sure of the fact that what was fashionable would not spread too fast or too far without visible evidence of improverishment. Now designers look not for the elaborate, but for the telling – for the shape or the pattern which at once shouts 'new' and makes the previous shape or

35

pattern obsolete. This is not to say that fashion has surrendered its role as a demarcator – far from it – but it now divides and classifies in a different and subtler way. It marks off the generations, for example, and it helps to emphasize and give form to the conflicts that exist between them.

Pop art, which relies on popular imagery, and, in particular, on that department of popular imagery which is concerned with the whole business of selling – advertisements, posters, and packaging – has very naturally been deeply affected by the concept of obsolescence and disposability. Many critics have commented on the fact that Pop art seems to have very feeble impulses towards the eternal; that its creators seem to accept the fact that their products have only a limited validity; that they will be used and thrown away.

But there is another factor that ought to be mentioned, and this is the increasing 'feedback' from *avant-garde* art into the mainstream of popular culture. As I've already suggested, Pop culture makes very wasteful use of ideas, and modern art has turned out to be a fertile source of these. The relationship has therefore become a symbiotic one – modern art has something to give as well as to receive. It has been interesting to note how, once Pop artists had taken advertising images and combined them in a certain way, these combinations and rhythms of arrangement began very soon to find their way back into advertising. More than this – the whole phenomenom of 'good bad taste', which has become a characteristic part of modern fashion, has its roots in Pop art.

The argument can be carried further still. The Op (or optical) painting which was accepted as the predestined successor of Pop, immediately enjoyed an enormous success in commercial adaptations. Op, in fact, seems to represent the reassimilation of fine art by the applied arts, the breaking down of a barrier which had its origins in the Renaissance. It has all the qualities that popular culture needs: it is easily recognized, easily characterized, and easily reproduced. Many Op pictures, with their hard, definite colour areas and simple colour schemes, could be produced in

series should the demand arise, and the idea of the 'original' painting which exists in a number of identical examples has in fact been a subject of experiment among Op artists.

Op art raises a number of other questions, which I should now like to consider. The conjunction of Op and Pop is, from the historical point of view, a fascinating one, as Op is as much the child of Constructivism as Pop is of Dada. The marriage of Op art and Pop culture, as represented by recent Op art fashions in clothes and furnishing, might be thought of as representing the final marriage of two hostile traditions, a paradoxical but somehow necessary event. But before we jump to this conclusion, let us consider for a moment the nature of Op painting, and, in particular, the role played in it by the subjective element.

It would seem that the main aim of Constructivist art was to cut out the subjective factor, to create a kind of art that would be entirely constant in its effect, and would achieve this effect in a way that could be precisely analysed. Similarly, it would seem that Dada was the first assertion of the primacy of the subconscious; and that this is why Dada, from one point of view, is simply the primitive or '*ur*' phase of Surrealism. The Pop painters combined a respect for the neutral surface, with an equal respect for the irrational. In many of their works, while the images are borrowed unaltered from some popular source, the way in which they are combined reflects something intensely personal to the artist. In other works, it is the *choice* of image that is the irrational and personal act.

At first sight, Op art would seem to represent a reaction to this attitude – a rejection of capriciousness. In fact, I think the history of art since the war can be interpreted as a journey in three stages. First, the total subjectivity of Abstract Impressionism: the painter alone with his materials, putting his psyche on to the canvas with carefully unconscious gestures. Then, Pop art – a return to Dada, and an acknowledgement of the part a shared system of imagery can play in fantasies which nevertheless remain personal. Finally, Op. Here the artist resorts to new methods. Painting is to be stabilized, to become less capricious. The painting does not

37

merely comment on machine civilization, it *becomes* a machine, designed to affect the human organism in a particular way. The design is a matter of the coolest rational thought and planning – the kind of planning an engineer puts into designing a new petrol-driven engine and then making the blue-prints for it. Graphs are drawn; specifications are considered and discarded. When it comes to the final stage, the artist may not even make the work of art himself; he may simply have it executed by others according to instructions he provides.

But subjectivity, hustled through the front door, promptly returns *via* the back. We can see this clearly enough as soon as we start to consider the exact function of the aesthetic machines that are so laboriously designed for us by the Op artists. Let me take as my example a typical painting by Bridget Riley. The violent pattern kicks at the optic nerve. It may affect the spectator's sense of balance and make him feel physically giddy if he looks at it long enough. At any rate, it disturbs (as it is meant to do) his perception of space and distance. In many ways, what the picture does to the man looking at it resembles what would happen were he to be thrown into a light hypnotic trance. The physical sensations he is experiencing allow him access to a level of the mind which is not normally so easily accessible to him.

My contention is, then, that the concern for subjectivity is still present in Op art, but the emphasis has been transferred from the subjectivity of the artist to that of the spectator. The one thing we cannot say for contemporary art is that it has yet provided any kind of symbolic representation of a development towards a more rational and orderly kind of social organization. Instead, it encourages the anarchic element – it provides a safety valve for feelings and impulses which we are otherwise forced to suppress.

So far, I've been speaking as if I thought that on the whole art was the patient and society the agent – as if art was something which merely reflected social change, without initiating it. Broadly speaking, this is true. But by accepting the situation as something axiomatic, we are in danger of missing something important. What this is we can perhaps see by looking for a

moment at kinetic art – a development closely related to Op, but where the work of art usually has real instead of apparent motion. This motion can be something which happens in a fixed cycle, or something entirely random.

It is sometimes said that kinetic art represents an alliance between the visual arts and music. The work of art extends through time, as well as occupying a given volume of space. Certainly, kinetic artists are apt to refer to Scriabin, a musician who invented a colour-organ, as one of the remote ancestors of the movement. But it is unnecessary to insist on the exact parallel. More important for my present purpose is the fact that the kind of developments we see in kinetic art undoubtedly represent a kind of synthesis between various arts, a synthesis which might lead us to think that art is once again approaching a 'baroque' phase. The typical baroque art-form was the theatre, in which all the arts combine, and it seems quite clear that modern art reveals an important aspect of itself when we think of it in theatrical terms, as something which performs and acts upon an audience, which is itself the microcosm of society.

The 'happenings' which have recently formed so controversial a part of the modern art scene, are (like kinetic art) only a small part of something which is much more generally disseminated. The happening – basically a work of art made with people and objects instead of paint and canvas – is, in one sense an extension of collage. And in another it is a mime – a theatrical performance in the most literal sense. There are, however, grounds for thinking of Op painting like Miss Riley's as giving a performance too. In her case, the work of art is not something which hangs passively on the wall. Instead, it is the highly active intermediary through which the artist's intention reaches the spectator. The painting, indeed, performs certain acts which happen not outside the spectator, but within him; not on the wall, but actually inside a particular physiology, that of the man who looks at the wall. Since I have already talked of 'games' in quite another context when discussing the artist's relationship with society, let me say now that I think there is a good case for describing an Op painting

39

or a kinetic sculpture, not as an object, but simply as a game which the artist and the spectator are both engaged in; a framework for the discharge of psychic energy.

A more important question rises out of this. Just because a painting is optical or a sculpture kinetic, the cash nexus is not on that account broken. What the artist does is still, so to speak, 'in the market' – there is no escaping that. But if what he does more closely resembles a performance than a conventional act of making, how are we to classify what he offers? Does it come under the heading of 'goods' or 'services'? I am aware that this classification may sound a little ludicrous. I am also aware of its crudity. But I cannot, at least for the moment, think of a better one. To give some indication of how I mean to use the distinction here, and, at the same time, to fill in the background to my remarks, let me say something about goods and services in general, as they function in an industrial society. Unarguably, the emphasis has been slipping from one to the other. The whole concept of obsolescene and disposability, of which I talked earlier, provides us with the clue to what is happening. More and more, we tend to think of (and use) 'goods' in the old sense, as if they had become 'services'. 'Goods', I take it, are those things which we *own*, 'services' are things, or frameworks of organization, which we merely *make use of*. To take a couple of examples: the paper cup and the disposable paper napkin, technically speaking, fall into the category of 'goods', but the part they play in our lives is something much more closely resembling a 'service'. As a kind of footnote to this, one may point to such things as the hire-purchase of cars and refrigerators, and the contract hiring of television sets, as being of significance where this shift from 'goods' to 'services' is concerned.

But there is another step in my argument. The kind of development I've been talking about might be thought of as having certain general consequences, or, at any rate, general conclusions might be drawn from it. A society which has begun to replace goods by services, and to think of the goods that it uses in terms of what they job (the jobs they perform) rather than what they are (their solid and objective existence), is, it seems to me, a society

which has demonstrably moved to a much more 'abstract' level of thinking. And this impression is reinforced when we look at things which have little to do with economics. The whole development of Western thought, from the late Middle Ages onwards, can be thought of as a process of gaining power over abstract concepts, and increasing facility in using them. The artificiality of modern society is the logical consequence of this, and must be accepted, by a paradox, as natural – the result of a long growth.

The extraordinarily rapid technological development of the past hundred and fifty years is the consequence of this shift from the particular to the general, and has accelerated and emphasized it. The rise of abstract art during the early twentieth century in turn appears to have been both logical and inevitable.

The conclusion to which this leads me is that the characteristic art of the fifties and sixties is, in many important respects easier to understand (and easier to fit in to our total picture of society) if we think of it as providing services rather than goods. Let me put it another way. Artists have shown a natural fascination with new materials and new techniques – all of them part of the general technological development which I have just mentioned. Thus it is that we find young sculptors experimenting with direct welding or with fibreglass. It would be illogical if they didn't borrow, as well as the techniques of industry, a good many of its modes of thought. The fascination which Pop artists have with the impermanent; the doubly abstract nature of Op – these are things we can relate to the whole nature of the society we live in.

It may, I admit, seem cold-blooded to look at art in this way. But let us consider precisely what our expectations are. It often seems to me that, where modern art is concerned, the modern spectator has two quite different sets of attitudes, one of which is perhaps more honest than the other. We, for better or worse, are prepared to enjoy modern art simply as 'sensation', but we are reluctant to admit this enjoyment.

One sphere where the conflict becomes particularly acute is in the matter of public commissions for the modern artist. Here, muddled thinking is seen at its worst. There is a general feeling

41

that distinguished modern artists ought to be asked to design our public monuments and to adorn our places of public assembly. The trouble is that when, in spite of repeated disillusionments, the commission is given, the result is usually another disaster. Why should this be so?

But there is a query which comes before this: does art always and invariably fulfil the same function in whatever society it finds itself? The answer seems to me to be 'no'. Perhaps the function it fulfils in ours has become inimical to the usual function of the public monument. The usual function of such a monument is to provide the concrete expression of general ideas. When people thought in particularities, the monument was satisfyingly particular, but took the place of some general idea. This, it seems to me, is what the sculptures of the Parthenon do – they embody the State of Athens. Have we any need for such embodiments now? Do we need them, and are we grateful for them? Our public monuments seem to me to be of two kinds. There are those where the artist has simply produced a work characteristic of himself, but on a large 'monumental' scale. Henry Moore's statue for the United Nations building seems to me to be of this sort. The second kind is more disastrous. There are works of art, like Graham Sutherland's mock-Romanesque Christ in the Coventry Cathedral tapestry, where the artist resorts in desperation to some earlier idiom. If we are looking for some general reason to account for this history of failure, then I think my distinction between goods and services may perhaps supply it. Public monuments are at once too materially present and too insistent.

And yet it may be objected that modern art, even (or perhaps especially) in its more outrageous manifestations, does undoubtedly enjoy a public platform and a public existence. It appears, not on a pedestal in Trafalgar square, but in all the colour-supplements. Exhibitions, art books, journalistic controversy: all of these have helped it to make its impact. It is quite arguable, and indeed I myself *would* argue, that this is its proper mode of public existence, the one that conforms to its true nature. The exciting, impermanent and various Gulbenkian Exhibition,

held at the Tate Gallery in 1964, seems to me as relevant to modern conditions as the Sutherland tapestry is irrelevant – and this opinion is not the product of a doctrinaire secularism. Indeed, I would add this – that the best proof that the visual arts have changed their role is to be found in museums of modern art all over the world.

A museum, it may be remembered, was originally a repository; its job was to conserve art as much as to display it. Today a museum of modern art is something more closely resembling a theatre, where the drama of modern art is played out before an audience. It is something dynamic rather than static. It owns more than it can ever show, and buys far more than posterity will want to keep. And this seems to me both right and proper, given the nature of modern art itself.

But it is time to try to draw my various arguments together. From the social point of view, art can be looked at in two ways. We can look at the relationship between the artist and what surrounds him, and we can look at the work of art and examine society as the living context of the art-object. I hinted, at the very beginning of my essay, that the modern artist does not always seem very happily adjusted to the society in which he lives, to the point where his actions begin to fit certain standard patterns of psychological maladjustment. It does not, for instance, take a very deep reading of the textbooks to lead one to suspect an element of anal aggression in the deliberate messiness and unwieldiness of certain recent assemblages and collages. On the other hand, and this is the more important point, recent developments in modern art do seem to conform to patterns that can be seen in society.

To interpret these patterns, we have, unfortunately, to resort to a process of categorization which may lead us to distort their significance. We have to consider Western society both as an economic entity and as a psychological one, and, where art is concerned, the two halves are sometimes difficult to fit together. From the economic point of view, art has, as I have tried to prove, followed a general trend by becoming a service rather than a commodity. The fact that we regard *avant-garde* paintings and

43

sculptures more as performances than as possessions has inevitably tended to alter our scale of critical values. The account tends to show both a loss and a gain. We have difficulty in devising a new scale of values, which will deal with works of art in their 'sensational' aspect (it will be obvious that I am using the adjective in a specialized sense). On the other hand, we have shed many cumbersome preconceptions about what a work of art is. We have learned to separate ideas from embodiments, and our experience of manufactured objects, turned out in series, has led us to look beyond the physical presence of the work of art to the general concept that subsumes it.

The assimilation of the fine arts to a pattern simultaneously abstract and industrial has not, however, as the Constructivists assumed it would, led to any retreat from subjectivity. The reason why art changes its role as society alters seems to be because it is basically something that compensates, that supplies whatever elements are missing, so far as it is able. What is missing from our society is certainly not the sense of social coherence. If anything, we are chafingly aware of it. On the other hand, we do seem to need the chances which modern art gives us to explore areas of private feeling. The publicly displayed work of art can still trigger off a private reaction, just as the assertion of individual identity can survive the use of industrial techniques – these seem to be at least two of the conclusions to be drawn from the most recent developments in the visual arts.

REFERENCES

AMAYA, MARIO. 1965. *Pop as Art*. London: Studio Vista.
BERNE, ERIC. 1966. *Games People Play*. London: Deutsch.
GRAY, CAMILLA. 1962. *The Great Experiment: Russian Art 1863–1922*. London: Thames & Hudson.
RICHTER, HANS. 1966. *Dada*. London: Thames & Hudson.

DENNIS GABOR

Art and leisure in the age of technology

Ours is not yet a sick civilization, but a dangerously infected one. It is vigorous, expansive, even childish in many respects, but it is like a young man already marked by the ailments that will strike him in his maturity. The ailments are just those that could super-ficially be mistaken for symptoms of health; the rapid increase in population, and the ever-accelerating progress of technology. Sooner or later, but probably sooner than most people think, these will create conditions unfit for the human mind, however lavishly and easily they will provide for the needs of the human body. In fact it is the very ease with which modern mass-manufacture can satisfy all needs for purely material comfort that constitutes the greatest danger. Man is a wonderfully adaptable animal when it comes to hardships, but very poorly adapted to ease and leisure. Only the blind can deny this, but very few people dare to open their eyes to the unpalatable truth. David Riesman (1964) had the courage to express it in merciless words: 'What we dare not face is not total extinction, but total meaningless-ness'.

In the Age of Leisure, if it strikes us unprepared, the name of the sickness is *existential nausea*. The rich have always suffered from it; modern technology is now putting it within the reach of everybody. The danger is not just in the numbers of those who

45

might be affected, because the privileged classes of the past always had the uplifting feeling that they were an *élite*; the dull average could 'live by inviting or not inviting one another' (Ortega y Gasset, 1930). Even so many of the feeble ones perished from boredom, alcohol, or drugs. The 'craving for kicks', the criminality which is rising around us in the highly industrialized countries of the West at the rate of 10–12 per cent per annum ought to be sufficient warning for anybody who still believes in the fundamental soundness of our civilization.

Like almost all of our contemporaries, I would be shy of writing hopefully of 'the great arts of the future', comparable to the great art which was the glory of Greece, of the Renaissance, or of Elizabethan England, and which many people feel to be the chief justification of man's evolution. I will put my hopes rather in *art as a popular medicine*, with the humbler but vitally important task of saving millions from the feeling of aimlessness in their lives. Artists by themselves cannot achieve the necessary change in the climate of opinion; they will have to be aided by writers, educators, governments, and by every imaginative and thoughtful person.

The main responsibility will be with the architects. It may be true that a rural habitat is natural for the human species, but the suburb with back-yard gardens is not the habitat of the artist. It will, of course, be indispensable for any responsible planner to save as much as possible of the beauties of nature – and the French planners have made a good start by reserving forever 6 per cent of the area of France – but the place in which the arts can best prosper is the beautiful city. I feel a little embarrassed when writing down the word 'beauty', which has become almost a dirty word among writers on art, but I was myself born in a beautiful city, Budapest, and I can attest that we consciously enjoyed its beauty, every day when we stood on the shores of the Danube or crossed one of its bridges. Life had a heightened tone there, as it had, and still has, in Paris.

For almost forty years now Lewis Mumford has never tired of warning us of the destructive effect of motorcars on cities and their

culture.[1] Most people who can afford it flee the cities and settle in the suburbs; the city centres change into traffic-jammed shopping districts, sometimes (as in the United States) into slums. In the meantime another enemy has arisen: overpopulation. In Britain the increase is comparatively slow, (0.6 per cent p.a. as compared with 1.2 per cent in the U.S. and 2.1 per cent overall on the globe), but even this amounts to 300,000 more people every year; enough for six medium-sized new towns. But not even the greatest architect can make these new towns into anything comparable with the historic, organically grown centres of culture if he is told to make them as small as possible, as cheap as possible, to provide parking space for at least 10,000 cars, and arteries for through-traffic for many more. At the best such a new town will be an efficient contrivance for working, shopping, eating, sleeping, and breeding; and the streets will be just channels for the traffic, to get from one place to another.

Probably not much can be done until the population increase is stopped; but it *must* be stopped. Even without it there would be overcrowding, because modern man needs more elbow room. But as it looks now, if the present trend continues, there may come into being in less than a hundred years that gigantic steel-concrete-glass rabbit-warren, stretching almost continuously from London to Peking, which the Greek architect C. A. Doxiades has called *Ecumenopolis*. Technological civilization will then have led itself *ad absurdum*; and this long before the Malthusian limit is reached, because with modern methods, fifty thousand million people could be fed – after a fashion. We must stop long before that. In Britain, as in other industrial countries the population does not increase any longer through ignorance; it increases because people like to have large families. (At the present level of hygiene three children per couple is a large family, and this leads to hopeless overpopulation.) This healthy, and by past standards, virtuous desire will be more difficult to fight than ignorance or poverty.

[1] See his latest books, *The City in History* (1961) and *The Highway and the City* (1964).

Many resources will have to be mobilized to counter over-population; among them a strong feeling of responsibility for the civilization of the future, which I would almost equate with *artistic conscience.* We must be determined not to leave such a horrible heritage to the twenty-first century as the nineteenth century has left to us in the bleak industrial towns of the North. Of course our new towns will not be so black and sooty, but they will have a glass-and-concrete uniformity that only stunted human beings can endure.

Even before the trend to overpopulation is stopped, we can do something if only we are determined not to build anything for which the twenty-first century will curse us. The very least we can do is to exclude motor cars from the administrative, theatre, and shopping centres of the cities. Let these be plazas, where only pedestrians are admitted, with galleries, arcades and awnings against bad weather, so that people may rediscover the joys of walking, as one still may in San Marco. Let there also be open-air cafés and restaurants, where people can sit, talk, and enjoy their leisure. It is not true that the English climate is not suitable for them; they flourished in London in the eighteenth century. It was not the rain that drove them out, but the Gospel of Work.

When people have learned again to walk and to gaze, they will also like to look at something better than 'that vast repetitive inanity, the high-rise slab.'[1] There is indeed no technological justification for the multi-storey office building. It chokes itself by the difficulties of access, and with modern communications the clerks could just as well be 20–30 miles away from the city centres. Much of their work is already done by mail and telephone, and even more could be done by facsimile transmission. The sky-scraper is an anachronism, and if the world became so over-crowded that it would become a necessity, life would have become hardly worth living anyhow. Perhaps this simple truth will penetrate the mind in the next twenty years. Until then who can blame the architect if he agrees to erect a new skyscraper in some

[1] Lewis Mumford, 'The Case against "Modern Architecture"', in *The Highway and the City.*

already overcowded spot in London? It would be too much to ask him to become a conscientious objector until he receives strong backing from public opinion and from the authorities.

We are still far from such a happy state of affairs. Housing shortage has been a regular feature of life in Britain since the end of the war, and there is still little sign of improvement. It is true that the present Minister of Housing has not instructed the builders, like the first holder of that office 'to cut out the frills'. But neither is he in a position to tell the architects: 'if you cannot build something of which you can be proud, build nothing at all!' But improvement must come because, while automation will enable, and even force, most manufacturing industries to reduce their labour force, the building industry still has a vast capacity for semi-skilled workers, and the tasks before it are almost unlimited.

Pari passu, as the new architecture will create an ambience for the common man in which he can become conscious of culture as 'sweetness and light' the new education will have an easier task. No wonder that in our transitional epoch, modern art has turned its back upon *ordre et beauté* and its dominant tone is bitterness and disgust. At the risk of being called a sentimental reactionary, I must again quote Lewis Mumford (1965):

The only group that has understood the dehumanizing threats of the Invisible Machine are the *avant-garde* artists, who have caricatured it by going to the opposite extreme of disorganization. Their calculated destructions and 'happenings' symbolize total decontrol: the rejection of order, continuity, design, significance, and a total inversion of human values which turns criminals into saints and scrambled minds into sages. In such anti-art the dissolution of our entire civilization into randomness and entropy is prophetically symbolized. In their humourless deaf-and-dumb language the *avant-garde* artists reach the same goal as scientists and technicians, but by a different route – both seek, or at least welcome, the displacement and the eventual elimination of man.

49

As a scientist I must admit that Lewis Mumford's bitter reproach to scientists and technicians has a great deal of truth in it in the age of hydrogen bombs, ICBM missiles, and decision-making computers. The humanizing of scientists and technicians to make them abandon their creed that 'whatever can be made must be made', is also a *sine qua non* for any happy outcome of the human adventure. But this is another story. I do not think that any similar frank admission will be forthcoming from *avant-garde* artists. But whatever the *avant-garde* may do in the future, popular art will have to take the backward step to Matthew Arnold's 'sweetness and light'. Often wonderful creations are wrought by patients in mental hospitals; but we do not want the common man of the future to be psychotic or even neurotic in order to produce great art.

Modern technology has taken away from the common man the joy in the work of his skilful hands; we must give it back to him. Machines can make anything, even *objets d'art* with the small individual imperfections which suggest a slip of the hand, but they must not be allowed to make everything. Let them make the articles of primary necessity, and let the rest be made by hand. We must revive the artistic crafts, to produce things such as hand-cut glass, hand-painted china, Brussels lace, inlaid furniture, individual bookbinding. The social body has already shown a sound reaction to the neurosis that threatens it, in the vigorous spread of the 'do it yourself' movement. But working alone in a shed or workshop will appeal to the more introverted with a better than average urge to express themselves with their hands. For the far more numerous extroverts (and for the even more numerous average lazy people who would rather stretch out before the TV set), we must create more art schools, and everywhere *manufactories* as they existed in the seventeenth and eighteenth century, before the invention of the division of labour. Once these gave work and bread to thousands of men and women; in the age of leisure they will have the no less important task of keeping them from becoming neurotic. We must get used to the idea that *occupational therapy* will become as vital in the

age of leisure as work for production was in the ages of economic scarcity.

Will the new popular art produce results beyond the purely therapeutic? Will it produce masterpieces of art? We can, I think, dismiss this; the great artist will always be a man obsessed, never an amateur. Will it at least produce masterpieces of craftsmanship? Aldous Huxley asked this question in one of his last essays (1964), and he answered it in the negative.

> . . . the older craftsmen took for granted the style in which they had been brought up and reproduced the old models with only the slightest modification. When they departed from the traditional style, their work was apt to be eccentric or even downright bad. Today we know too much to follow any single style. Scholarship and photography have placed the whole of human culture within our reach. The modern amateur craftsman or amateur artist finds himself solicited by a thousand different and incompatible models. Shall he imitate Phidias or the Melanesians? Mirò or Van Eyck? Being under no cultural compulsion he selects, combines and blends. The result, in terms of art-as-significant-communication, is either negligible or monstrous, either an insipid hash or the most horrifying kind of raspberry, sardine and chocolate sundae.

This is indeed more than likely if the amateur artist is left to himself to face the impact of all art, past and present. But could a new style not develop in some of the voluntary *manufactories*, such as I have suggested, directed by gifted artists? Steuben Glass has a *cachet* as characteristic as Dresden China or Limoges, and this has established itself under our eyes, within a decade or so. Why should not a corporate spirit arise in the voluntary *manufactories*, which will cultivate a tradition? Traditions do not require as much time as one usually assumes: C. P. Snow reminds us that most English traditions originated in the last quarter of the nineteenth century. Styles require even less: *Directoire* and *Empire* were fashions created in a few years. Only the modern commercial compulsion to create fashions every year, whether a

truly new idea has emerged or not, is the deadly enemy of style.[1]

The artistic consciousness of the public will unavoidably conflict with commercialism – but all the better. Artistic consciousness is almost synonymous with that sort of social consciousness without which there can be no bright future for the human race. At present many good citizens of the United States firmly believe that their prosperity is based on an output of at least 9 million motorcars a year, and that it is therefore their duty to exchange their old cars long before they have stopped being serviceable. If things are going on as they did in the past, perhaps they will soon be persuaded to turn them in twice a year. This 'whirling dervish' economy of the consumer society will have to stop some time; a moment comes when the dervish flops exhausted on the floor. Somehow we must get away from the fetish of the annually growing Gross National Product to which at present all governments, capitalist and communist, are equally committed, and which, in the industrial countries at any rate, can now be maintained only at the expense of waste – not only of material products but also of human lives. Economists have not yet found out how to slow down the machine without catastrophe. Perhaps they will never find out unless the climate of opinion turns from the consumption of machine-made articles to the possession and creation of durable artistic goods. Is this a daydream? I do not believe so, if I think of the hundred thousands of people who work all day more or less listlessly in efficient factories, where the goods must be turned out in the minimum possible time, and then go home to work patiently, for example, on a complicated piece of woodcarving, with nothing but a single chisel and hammer, and are proud if it has cost them many hundreds of hours of work. This fundamental re-valuation of time already exists in our midst in a sizeable minority; why should it not become the dominant majority?

It may hardly be necessary to emphasize that this change of spirit will never come about unless it affects men and women

[1] Some sociologists who want to believe that nothing is wrong with commercialism try to persuade themselves and others of the contrary. A characteristic example is Ernest Zahn (1960).

equally. Women are now the main target of consumer propaganda, for the simple reason that most of the money flows through their hands. It is rather generally believed that it is in their nature to spend. But are our women more natural than their mothers or grandmothers who were unable to throw away a garment? Is it more natural for them to use plastic or even paper dishes than china and silver? I do not think that the process is irreversible; if it were, there would not be much of a chance for the revival of an artistically oriented civilization.

So far, when talking of art, I have had in mind the visual arts; material creations of human hands, whose valuation will affect the future of our society in a very direct way; but the effect of the verbal arts and of music, if perhaps more indirect, may be equally decisive. At first sight, the outlook for amateur art does not look very promising, because in the verbal arts and in music there is no 'do-it-yourself movement'. On the contrary, there are now probably fewer amateur musicians than fifty years ago, when the lady or the daughter of the house had to sit down at the piano to entertain her guests. There is probably also less amateur acting now than there was in J. B. Priestley's youth. No wonder, because high fidelity sound recording, radio, and television have brought the masterpieces of music and of the stage into every home. These highly democratic inventions have brought a triumph to the aristocratic principle that nothing is worth doing unless it is done supremely well. As I wrote some years ago, 'today there is no *need* for anybody to play the piano who plays it less well than Myra Hess'.

Nevertheless, there is no reason to complain, because the passive enjoyment of music has enormously increased by the hi-fi gramophone and by the radio, and music is a wonderful occupier of leisure, and a powerful soother of nerves, whether enjoyed actively or passively. I am not sure whether the eulogy of beer which 'can do more than Milton can to justify God's ways to man' does not apply to equally to music. Unfortunately, I do not believe in the ethical effects of music, even the greatest; I have read too much about the good music played or listened to by the warders

53

in German concentration camps.[1] It takes more even than Mozart or Beethoven can give to make bad people good. But bad music can be stultifying. I am thinking of that infernal invention, the jukebox, which keeps teenagers in their cafés in a stupor all night long.[2] I hate the jukebox also because since it has spread in Italy, people there do not sing any more, as they used to sing to themselves in the streets, and in railway carriages at the time when I first visited that lovely country in my youth. Here is an enemy that must be destroyed!

It is hard to say whether amateur writing is on the increase or decrease. Diary writing, which must have been good self-therapy for many lonely souls, has almost certainly decreased. On the other hand, there are now many more professional and semi-professional playwrights, who write television plays, or films, and amateur film societies are enjoying a modest boom. Amateur television play production will soon receive a boost by the advent of the cheap video-tape recorder.

Technology is likely to influence the amateur arts in the future by many new inventions which are now within our reach, such as the drawing or painting of three dimensional pictures, or viewing aids which will change a picture into a scene which surrounds the viewer from all sides. Computers as an aid to (modest) artistic creation cannot be entirely dismissed as a possibility, but I consider them as a threat rather than as a source of hope.

As I see it, the small élite of humanity, the uncommon men, have now created conditions by the progress of science and technology in which the common men and women are threatened

[1] For instance, in Alejo Carpentier's great novel, *The Lost Steps*, 1958, and in a good many sad documentaries.

[2] George Paloczi-Horvath in his fascinating book *Jugend* (1965; *Youth*, at the time of writing obtainable only in the German translation, though the original was written in English), describes such a dismal scene in a London basement café (p. 46). He also describes a Youth Club in a London slum district, where a dedicated teacher has succeeded in attracting the young savages by playing them pop records. One evening he tries a daring experiment, by smuggling in a Mozart divertimento. But he does not get half-way through before they become angry and force him to play pop music.

in their emotional equilibrium by being no longer needed in the production process. I am not concerned here with the economic problems this will raise, by technological unemployment, which will be a constant headache for governments in the years to come, but with the psychological impact of 'social uselessness'. A great reassessment of our conventional values is needed, including a revolution in art. A biological change in the capabilities of the average person is out of the question; natural evolution is so slow that even its very existence can be doubted; and no responsible man would dare to believe that eugenics, even applied with a ruthlessness incompatible with democracy, could bring about a perceptible change in one generation. Too much of the true creativity of our times has gone into science and technology. Perhaps it is not yet too late to remind these creative spirits of their duty to human dignity.

REFERENCES

CARPENTIER, ALEJO. 1958. *The Lost Steps*. London: Gollancz, 1960.

HUXLEY, ALDOUS. 1964. Liberty, quality, machinery. In *Tomorrow and Tomorrow and Tomorrow*. New York: Signet Books, p. 81.

MUMFORD, LEWIS. 1961. *The City in History*, London: Secker & Warburg.

— 1964. *The Highway and the City*. New York: Mentor Books.

— 1965. Utopia, the city, and the machine. *Daedalus*, Spring 1965, p. 290.

ORTEGA Y GASSET, J. Y. 1930. *The Revolt of the Masses*. New York: New American Library, 1950.

PALOCZI-HORVATH, G. 1965. *Jugend*. Schweitzer Verlagshaus.

RIESMAN, DAVID. 1964. *Abundance for What? and Other Essays*. London: Chatto & Windus.

ZAHN, ERNEST. 1960. *Soziologie der Prosperität*. Cologne: Kiepenheuer. DTV, 1964, Chapter V, 7.

GYORGY KEPES

Private and
civic art

One of the most evident signs of the contemporary self-con-
sciousness is the obsessive questioning of what roles we are to
play; and nowhere is this more true than in the urgent concern
over questions of the justification, the scope, and the significance
of artistic forms. In no other area of contemporary civilization are
claims and counterclaims made with such vehemence, such
offensive and defensive rigidity. Quacks and peddlers of fake
solutions, with their artistic nostrums, are hard to distinguish
from persons with honest beliefs and deep commitments. The
part controls the whole. So many of our artists single out frag-
mentary aspects of a complete image of human experience. At one
moment they are busily improvising an image of speed, casting
away repose and introspection. At other times they are manu-
facturing new fertility symbols or paying homage to the increasing
production rate of our industrial society, rejecting the broad
panorama of nature. Lately, infatuated with the isolated kin-
aesthetic act, they accept the autobiographical note of an accidental
moment at the expense of the rest of life.

Some fifty years ago the Italian Futurist Filippo Marinetti
orated about 'the racing space, the acrobatic somersault, the slap
in the face and the blow of the fist – "war", the bloody and neces-
sary test of the people's force.' Naum Gabo and Antoine Pevsner
(1920) answered him thus:

The pompous slogan of 'speed' was played from the hands of

57

the Futurists as a great trump. But ask any Futurist how does he imagine 'speed', and there will emerge a whole arsenal of frenzied automobiles, rattling railway depots, snarled wires, the clank and the noise and the clang of carouselling streets . . . does one really need to convince them that all that is not necessary for speed and for its rhythms?

Look at a ray of sun . . . the stillest of the still forces; it speeds more than 300,000 kilometres in a second . . . behold our starry firmament . . . who hears it . . . and yet what are our depots to those depots of the Universe: What are our earthly trains to those hurrying trains of the galaxies?

Mere revelry in the novelty of immediate visual dynamics without an understanding of their roots and of their direction of growth only prevents us from finding the way out of our blind alleys. Some attempts to come to terms with our explosive world have bogged down in just such easy-to-come-by excitement; the central interest of many artists has been riveted to the mimetic surface aspect of our surroundings.

This is not to deny that other artists have searched with admirable discipline for visual idioms capable of rendering the fundamental dynamic character of twentieth-century experience. The first, in significance as well as chronology, were artists working in the early part of this century. Artists of the Cubist era realized that the visual qualities of our surroundings cannot be projected in an artistic image seen from a single fixed view. The Cubist's painted image of physical space was not the painted replica of his optical image. It was an evocation and ordering of the changing views collected by his moving, exploring eyes.

Although these painters limited themselves to a single and one-sided goal, to an exploration of the structure of images, their efforts led to the rediscovery of three fundamental aspects of artistic vision: *complementary unity* – the unity of interaction of observer and observed, of order and vitality, of constancy and change; *rhythm* – basic to all living process, and so, too, to the creation or reliving of an artistic configuration; *sequence* in the life

58

span of created experience. Images are created and perceived as structured sequences of patterns; melodic line and contrapuntal organization are inherent not only in musical patterning but in all created forms. It is to these three conceptions that I shall relate the thoughts that follow.

Artists after the Cubists, however, went other ways. The Italian Futurists were typical. They closed their eyes to their inner world and focused on the dynamic outside environment. Living in a country that was lagging behind industrially and was dreaming of past glories – a country of museums with little relevance for twentieth-century man seeking his identity – they held that the two worlds of the old and the new could not coexist and, rejecting their heritage, they blasted away at all the inhibiting memories of the past. Thus they used techniques of recording the motion of objects that closely resembled the photographic motion studies of the great nineteenth-century physiologist E. J. Marey, and then held them to be art-saving, revolutionary innovations. They claimed complete authority for this one-sided vision and denied the existence of other forms of visual expression.

In the same way that the Futurists were blind to the past, more recent artists have been blind to the future. They have renounced the public forum and recoiled to the innermost privacy of unsharable singular moments of existence. They shrink the world to a rebellious gesture, to violent graphs of the cornered man. 'The big moment came', as an articulate spokesman of this group has put it, 'when it was decided to paint . . . just to paint. The gesture on the canvas was a gesture of liberation from value – political, aesthetic, moral'. (Rosenberg, 1961, p. 30). But in fact, these artists recoil from the necessary vital interaction with the outside environment and thus have broken again the essential unity of the seer and the seen.

Later, the interest of a new group of motion-addicted artists swung back again to the outside world. Instead of looking for new qualities of twentieth-century life, they produce substitute moving objects, either cerebral, impeccable, watchwork-like toy machines or self-destructive Frankenstein monsters made from

59

corroded fragments of industrial waste. Some painters also experiment with motion, and their sophisticated knowledge of visual illusions produces amusing, well-groomed eye-teasers by mobilizing every optical trick to animate surfaces into virtual motion.

A most recent group of artists has returned from abstract images to concrete objects in their environment. They have become fascinated by vulgar features of everyday life, and they have chosen them as emblems. Seductive selling devices of the competitive society-advertising pictures, containers, packages, and the mass-produced heroes of the comic strips – are their preferred images. These artists have a just resentment against the gigantic, semantic conspiracy of newspapers, billboards, and television to catch public attention through deliberate doubletalk. They recognize how language – verbal and visual – is exploited to force the responses of a passive public. But, parallel with this awareness, they have developed an attachment to objects that never left their visual field. Their unresolved mixture of private attachment and public critical social commentary takes no account of the revolutionary artistic achievements of the earlier part of the century.

Most of the mushrooming art movements seem to have forgotten the essential role of artistic creation. By and large, the art world has become the scene of a popularity contest manipulated by appraisers and impresarios who are blind to the fundamental role of the artistic image. To find our way in this bewildering scene, we must return to fundamentals and ask basic questions. We all wish that we could live without these clumsy confrontations, but we cannot evade the specific problems that we encounter in art nor the fundamental questions of our condition. The eager prophets of the *dernier cri* are blind to the basic principle that what makes today is not only today. 'From the oldest comes the newest', commented Bela Bartok, an authentic spirit of our time.

Vision is a fundamental factor in human insight. It is our most important resource for shaping our physical, spatial environment

and grasping the new aspect of nature revealed by modern science. It is at its height in the experience of artists who elevate our perception. Artists are living seismographs, as it were, with a special sensitivity to the human condition. Their immediate and direct response to the sensuous qualities of the world helps us to establish an entente with the living present.

Yet artists today lack orientation in the contemporary world. They come together in small groups in great cities, where, in the safety of little circles that shut out the rest of the world, the initiates share one another's images. They generate illusory spontaneity, but miss the possible vital connections with contemporary intellectual and technological reality. It is unfashionable today, if not taboo, for artists to think and act on the broad terms of cultural and social ideals. No doubt moralizing in art can lead to creative suicide, just as market-policed and state-policed art can lead to the murder of artistic honesty. But the other extreme – lack of intellectual curiosity and rejection of commitments – leads to emaciation of artistic values.

It seems to me that the overwhelming task of creating modern science on its present large scale has used up some of our most important intellectual and emotional equipment. When a vital part in a complex machine is worn out or out of adjustment, it is wiser to stop the mechanism than to grind on to destruction. Engineers, therefore, devise arrangements that ensure orderly shutdown when a part gives way. It may be that our cultural life has had such a 'safety failure', as the engineers call it. Our artists may have served us by preventing a disaster. Nevertheless, an emotional return to the archaic, ancestral cave would obviously be a failure to function in contemporary terms. Let us not mistake this temporary standstill for a genuine answer to our long-range needs. We cannot renounce the dimensions of the twentieth century – of which the new perspectives opened by scientific triumphs are a part – just because in certain respects adjustment to them is not achieved without distress; we may suffer from exposure to the new scale, but it is necessary for us to meet it. Only complete acceptance of the world that is developing can

make our lives genuinely acceptable. Such acceptance involves two tasks: to advance in every field to the furthest frontiers of knowledge possible today; and to combine and communicate all such knowledge so that we gain the sense of structure, the power to see our world as a interconnected whole. Today there is a growing general awareness of art as an important human faculty to provide this sense of structure. Museums, art centres, art magazines, and proliferating galleries are doing an important job in helping the artist to communicate with the public. But with all this, there are significant areas still in the shadows, areas that will remain in the shadows unless we can find means of stimulating discourse of two kinds. One is discourse between artists who work in various media and have common interest in exploring the many potentials for them that lie in technical developments. The other is the interaction between artists and the major scientific and technical contributors of our time. Particularly in the second of these areas of interaction the need is evident enough, if one may judge by the frequent expressions of hope for some kind of fruitful plan. Fully aware of the considerable difficulties, I wish to put forward a modest proposal.

I propose the formation of a closely knit work community of eight to ten promising young artists and designers, each committed to some specific goals. The group, located in an academic institution with a strong scientific tradition.[1] would include painters, sculptors, film-makers, photographers, stage designers, illumination engineers, and graphic designers. They would be chosen for their demonstrated interest in, and alertness to, certain common tasks. It is assumed that close and continuous work contact with one another and with the academic community of architects, city planners, scientists, and engineers would lead to a climate more conducive to the development of new ideas than could be achieved by individuals working alone, exposed only to random stimulations and subjected to the pressures of professional competition and the caprices of the art market.

[1] A proposal based upon these ideas has been submitted to the administration of the Massachusetts Institute of Technology.

Beyond any doubt, unique, authentic, and essential contributions come from the hidden layers of the personality. These deeper sources of creative imagination cannot be manipulated externally, nor can they be released simply by financial aid or even optimum physical working conditions. On the other hand, the past has given us ample evidence that major creative achievement comes from the confluence of many types of creative personalities. George Gaylord Simpson, the palaeontologist, has commented that as organic evolution was brought about by interbreeding, so must our further cultural evolution today come about through broad-scale 'interthinking'. An experimental effort to encourage such interthinking between different disciplines in the visual arts and scientific and technical fields is more than overdue. As the twentieth century has grown older, such intercommunication has become seemingly more improbable. Lacking orientation in the total contemporary world, which holds as much promise as it does menace, many artists have inevitably withdrawn into themselves. Their only honest response to this world has been the expression of complete isolation. In their frantic retreat, many of them have adopted a scorched-earth policy and have burned their most valuable cultural belongings. Cornered and confused, some of them disguise brutality as vitality and intellectual cowardice as existential self-justification. In a less fragmented life, before the common life of society was frozen into separate compartments, each with its specialized interests and jargon, priests and laymen, scholars and artisans, poets and artists could communicate to a larger degree in the same language and could pool their feelings and knowledge in a common cultural stream. A hope for such unity can hardly be entertained when we are faced with the complexity and scale of the present cultural situation. We cannot improvise a new central theme for our lives, nor can we create a unity with a well-defined scale of values for all aspects of our civilization. But we can mobilize latent aspects of our cultural life that offer a strong centripetal pull.

The proposed small work community, by recognizing common problems of adjoining or related fields, could accomplish the

63

dovetailing of knowledge and feeling, or of knowledge and knowledge. Engineering knowledge could serve to reinforce the insights of artistic sensibilities. The approach and craftsmanship of one artist or designer could serve to complement that of another and lead into new directions.

Among the wide range of artistic goals today, there are many that could and should be of equal concern to painters, designers, film-makers, sculptors, and others. Themes that suggest themselves for the initiation of such a programme include (1) the creative use of light; (2) the new aspects of environmental art – the gearing of sculptural and pictorial tasks to the dynamic scale of the urban environment and to the new wealth of technical tools and implements; and (3) the role of visual signs in artistic communication – an investigation that could branch out into a creative exploration of subjective icons as well as of the common visual symbols in the cityscape, and a scientific exploration of communication and the use of graphic signs for didactic purposes.

Of these and many other possible themes, I have selected some for concrete discussion. Each of these cases will indicate that the task defines itself differently for different groups within the work community. The supporting personnel for each can be drawn from the various segments of the academic host institution, such as electrical engineering, metallurgy, psychology, communications engineering, city planning, or architecture, as the given undertaking requires. In such a cooperative effort the value will come not only from an exchange of complementary ideas, but also from the friction of the conflicts that inevitably arise when such a group of individuals, each with his own angle of approach, works toward a common goal.

Following are more explicit statements of the scope and approach of some selected themes suggested for cooperative treatment.

ENVIRONMENTAL ART AND THE NEW TECHNOLOGY

There are now tremendous new opportunities to reshape our spatial environment. Our technical knowledge and competence

offer us many solutions for a more comfortable world; they also offer us the means of revitalizing the urban environment by means of new artistic organization and new ways of projecting, in visible symbols, the current meaning of corporate existence.

For various reasons, these new opportunities have not yet been explored. Our best artists have concentrated on personal comments, communicating their feelings and thought through the channels of galleries, museums, or private collections. Their elegiac and lyric – or acrid! – personal comments are significant, to be sure; but there is a need for a parallel visual summation in the large-scale physical environment. In the last few decades, projects on an immense scale have transformed our cities, but very few of them have had a convincing artistic focus. In fact, there is not one new environment that is comparable to the work of some of our easel painters in expressive intensity. The gap between our new opportunities and the artists' willingness to grasp them – to say nothing of the adequacy of their knowledge for the task – is a serious one. The transference of thinking to such a broad artistic scale cannot be suddenly brought about. There are many human, aesthetic, and technical issues that the artist must understand before he can function within this new and vast scope. Some first attempts have proved abortive because the artists involved had not enlarged their vision or learned the technique of collaboration. They were untutored in those technical potentials of our industrial civilization that can offer them a new palette for their work.

There are, then, three basic conditions that must be fulfilled if our artists are to live up to the new tasks. First, they must cultivate those neglected areas of their creative imaginations which can render them responsive to the new scale. Second, they will have to learn to adjust to and communicate with architects, engineers, city planners, and many others who are working at reshaping the environment. Third, they will have to learn to explore the new technical potentials needed to implement their findings.

The visualization of new opportunities cannot be taught, but it can be stimulated. Intense work in a cooperative spirit by a

group of artists invited to join in such an undertaking as has been proposed can bring about a type of imaginative thinking which the individual artist could hardly achieve alone. A prototype task would be, for example, the chromatic organization of factories and offices where all spaces, colours, textures, and light are structured in an ordered pattern with a contrapuntal sequence. This could then be worked out further at different scale, each with its own demands and opportunities. As another project, city areas and their component form elements could be evaluated in terms of their visual intensity in a sequence of experiences. The same thing could be done with large-scale sculptures and murals in such a way as to give value to their sequential meaning as well as their individual quality. Form in its broadest sense could be considered on pedestrian, vehicular, or aerial scales. Again, these rough outlines will achieve concrete direction and meaning only as they are worked out in the collaborative projects of the painters, sculptors, architects, city planners, illumination engineers, and others.

A continuous give-and-take among the group, together with help from the outside, will develop techniques of teamwork without curtailing the initial intensity of the creative ideas. Techniques of model-making, films, or slides could be used to simulate the full-scale reality. Furthermore, learning to use the new tools, implements, and media of industrial production will reinforce the ideas and techniques of collaboration. The sculptural possibilities of reinforced concrete, prestressed concrete forms, plastic, stainless steel, aluminum, new techniques of welding; and the potentials of prefabricated units, pictorial use of baked enamel on steel, luminescent walls, photosensitive glass, spraying techniques ranging from metal spraying to colour spraying, and new adhesives are only a few suggestions of the technology waiting to be explored.

In the Middle Ages, artists in Italy or Flanders did not limit themselves to one area of specialization. They were willing and able to participate in any visual task. Designing a tournament or a ceremony was no more outside their range than painting an altarpiece or carving a cathedral moulding. They sought to complement the starkness of contemporary life, with its continual perils

of disease and hunger, by an intoxicating luxuriance of visual fireworks. The Middle Ages not only needed to express, but did express, communal rejoicing in feasts of colours, in pageantry, in church windows. Our fears today, our perils, are different, but our industrial civilization nevertheless is fighting for its own heraldic embellishment. The change of seasons which throughout history has enriched our lives is now for a large fraction of urban dwellers only a rare experience. If we are to turn our cities into congenial human environments, colour and light, form and texture will have to be domesticated in a creative sense.

VISUAL COMMUNICATION IN THE CITYSCAPE

Our society exhibits, in addition to a small body of explicit symbols – the signs or tags, verbally or otherwise coded, orientationally or otherwise directed, with unequivocal messages delivered by visual means – a vast body of implicit symbols of all kinds. Just as the way in which we respond to our environment gives shape to our social structures and our arts, our social structures and our arts provide mute testimony of the quality of our responses to our environment. This is testimony that we can read – with all shades of clarity and depth of understanding, in proportion to our own aptness of response to the objects and events that we encounter.

At its simplest level, the *implicit symbol* that provides this mute testimony is almost indistinguishable from the explicit sign – for example, the initialled sweater that proclaims the officially accredited college athlete. Such sweaters and such initials, our society agrees, are the conventional indexes by which we are to recognize men who have distinguished themselves in physical sport. Similarly, the Phi Beta Kappa key proclaims socially recognized mental attainment.

There are other indexes that, if less official, are equally socially generated. Juvenile delinquents have their uniforms of horsehide jackets, belt buckle, blue jeans, and boots; beatniks are bearded; undergraduates wear crew cuts, soft-tailored tweed jackets, and

67

slim trousers. We absorb these conventions as part of our acculturation. In a different context of visual meaning, trained archaeologists, through the internal evidence of style in historically evolved forms, can determine within a decade or two the date of a piece of statuary or a carved bit of tracery. No matter how modern the guise, a church is recognized by everyone as a church, because of the persistence of familiar trends that go as far back as the era of Constantine. And we recognize a bank as a bank even more easily now that we did when banks wore the outer trappings of Greek temples; the inner array of counters, tables, giant vault door, and desk is still the same, although purified into more elemental shapes and colours, and the vast expanse of glass now permits us to see this inner structure directly from the sidewalk or the road.

Our immediate experiences trigger our memories, releasing the cognate images from our stored experience into the temporary focus of awareness and establishing a relation between our present and our past. This is obviously true of our personal, individual, uncommunicated experience, but it is also true of the stored-up experience that we share with other persons of our condition – our profession, our town, our income bracket, our political party, our religion, our nation, our century. Some images are common images; some symbols, common symbols. Without common symbols, men could not have evolved very far above the animal level; but with them men have gone in a mere five or six thousand years from simple to ever more complex social levels. The socialization, or standardization, of such spatial divisions as the length of the human foot or the thickness of the human thumb or the weight of a stone became unit monetary measurement according to the selected index, or symbolic connective characteristic, thus establishing the social basis of technology and science.

Foci of common life – the family home, the community church or school – command the individual and collective respect of the group involved. They symbolize common life as well as house it. In giving concrete shape to our awareness, such symbols give rise to expressive, manifestly significant forms, moulding and

creating our arts and rituals. Monumental – self-consciously impressive – architecture arose many thousands of years ago out of the need felt to call attention to the place where men met to deal with their important common problems. From Stonehenge to the Athenian Agora, from the Forum Romanum to the United Nations building, the place of assembly has formed and been formed by the power of impressive design. The forms have varied according to need and according to the different type of cooperative activity considered necessary to group survival. Over the centuries, of course, the radius of group involvement has increased. The different scales of a New England common and Rockefeller Plaza indicate changing concepts of human cooperation; but, whatever the range of interest these urban forms may express, there can be no doubt that they perform a symbolic function. They are symbols of a common perceptual reality, and, as such, belong to a common symbolic world. Without the images of this world, the growth of the urban environment could not be guided or controlled.

JUXTAPOSITION OF SYMBOLS

In the visual field, particularly in the successive images that we perceive in our environment, the juxtaposition of images offers the most potent symbolic qualities. The contrast of the towering cathedral with the cluster of small dwellings in a medieval city had a symbolic quality. In some of the great cities of the Near East, the bleak, undifferentiated long span of the desert, offset by the flamboyant richness of the clustered buildings, created a perceptual tension with great symbol-evoking power. In our cities, the juxtaposition of very large with very small buildings, of busy with tranquil areas, are more than simple expressions of variety. Contemporary urban dwellers living in a restrained, almost inhuman setting usually welcome every sign of the natural world that can be introduced. Central Park is more than a pleasant means for escaping the busyness of the city; in its juxtaposition with a surrounding frame of high buildings it is a symbol of the richness and strength of metropolitan existence. It is self-evident that the

69

architect or planner cannot consciously create this grand scale of poetry with such symbolic juxtapositions; but, on the other hand, awareness of the power and meaning of contrasting forms is necessary if we are to guide the shaping of a rich poetic city. In the intricate and numerous visual-sequence relationships that the city offers its population, meanings are conveyed in accordance with the structure of the sequence path we follow.

We read the personality of a man through observing the sequence of his expressions and actions. We read the character of the cityscape in the same way. A single-cell organism is immediately dependent on its environment, and has no means of controlling it. Only when cells grow into complex masses do they develop a fixed internal organization capable of protecting them from change or disturbance in the external environment. In this complex stage there is a division of labour, with the functioning of specific organs coordinated. In a complex social state, a similar structuring develops. Under primitive conditions, individuals are free to move. In the complex production processes of our civilization, the division of labour and the physical stability of the work place bring about a relative fixation of the individual in the group. His mobility is a highly limited one. From home to work, from work to home, from home to shopping, the individual follows a defined path at a specified time. Each path of travel offers its characteristic challenge. The basic unit of our urban vision, accordingly, is not the fixed spatial location but the transportation-defined pattern of a sequence of vistas.

Let us compare the succession of impressions from opposite directions in a sequence experience. A commuter usually takes the same route in entering and leaving the city, but the elements of the sequence experience are in reverse order. Entering, he sees calm, well-groomed suburbia; then the industrial outskirts; then the belt of slums; then the heavy traffic and kaleidoscopic variety of the business area. In the sequence each shift of vista conveys meaning. The jump from the tidy, pastoral quality of the suburban area to the garbage dumps and smoke rings of the industrial outskirts inevitably gives rise to some feeling in the perceptive

traveller. Going home, he finds similarly that the sequence of scenes from the power-suggestive industrial plants to the inhuman substandard dwellings of the industrial slums is charged with larger meanings. The same form elements, in reverse order, evoke different responses. The succession of distances and the strength of the impacts are compositional elements of symbolic significance.

It is evident that without a major restructuring of the environment this chain of images cannot be modulated. But an analysis of their impacts can bring significant understanding and, possibly, tools for shaping and controlling parts of the environment. An awareness of the qualities of meaning evoked in the spectator by certain sequence relations of morphological elements would help him to develop the sensitivity necessary for forming sound judgements. There is a potential new keyboard of creative formation that can be understood with the aid of technical tools, such as motion pictures, and it may be used with increasing scope. A careful survey of the relationships of form elements in succession is the necessary beginning. Sequential relations of open and closed space, high and low buildings, rich or simple surfaces, natural features and man-created forms, and the many other variables, can be studied, recorded, and manipulated in order to gain some feeling for the expressive qualities inherent in the juxtaposed features in the sequence chain. Regular and irregular changes, rhythmical or contrapuntal sequences of different space distances, have to be recorded and interpreted. The range is too vast to be brought down to experimental testing, but there are means for helping us to understand these processes.

Because of the enlarged scale and increased complexity of the metropolitan environment, one central core as an expression of civic connectedness is insufficient for all purposes. There is an increasing need to express in symbolic form not one cooperative act, but the interrelatedness of the whole urban field. Architectual history suggests a procedure common to all cultures: the emphasizing of structurally important elements. To reveal the cooperative functions of the separate structural members, master builders and architects have accented the primary weight-carrying members,

especially at the critical points of their function. There is a similar possibility in the broader scale of city structure. Dominant functional areas that reveal significant cooperative effort can also be articulated by decorative means appropriate to the scale and dimensions of the city. In our present cityscape the various areas are undefined. The basic characteristic of our present life is interdependence, but the moulding expressive symbols of this interdependence are still missing.

The exploded space of the metropolis in which effective distance depends upon the mode of travel, and in which vast areas and populations become linked in a single urban fabric, makes the unit building or unit area a less important symbol than in the past. We must find contemporary substitutes and expressive symbols of these new dynamic dimensions. This is especially difficult when the parts of the city are unclear; often today, when one drives in from a suburban residential area to the working centre of the city, the sequence of scenes is chaotic, its connecting links are lost, and its symbolic significance is stillborn. What is actually expressed is planless, haphazard growth. But the city's parts can be made clear, and a restudy of the sequence of vistas in expressive continuities can offer new symbols. Sharp accents signifying character changes between two areas give legibility and underline the structural logic of the total urban scene. The heights of buildings, open or closed spaces, changing colour schemes, or the alternation of intense, vibrating shopping areas and disciplined public squares can express meaning in and through their connections.

A new art form of our century is the collage, a device by which materials from the most heterogeneous fields are brought into a contrasting but complementing ensemble. The cityscape is to some degree a counterpart of the collage, in which the contrast and variety of the elements produces a vitality through tension and the potential of structure. Through the cooperation of architects, designers, painters, and sculptors skilled in the expressive nature of forms, a wealth of new architectural devices, colour, and textural values can be brought into play. We must learn to

72

make every building expressive, not just by its material and structural principles, but by the nature of the life it serves. Secure on this level of small units, the next step would be to group the buildings where the spatial relations with each other and with the ground could form a broader scale of differentiation by means of a common spirit. The individuality of a building should co-operate with the expressive form of a group of buildings. This expressive articulation of the cityscape can be expanded to include districts, areas, and sections. By defining characteristic features, the variety that exists latently can be made manifest. Redirecting interest toward differentiation would inevitably bring qualities of visual distinction to the fore.

If the spatial network of a city is logical and its physical patterning clear and legible, then the people will be able to perform their complex activities efficiently. There is a threshold beyond which social intercourse becomes impossible. Our simple perceptual processes select and edit the complex visual field until a meaningful hierarchy of significant shapes arises. Similarly, in the intricate pattern of group communication in an extended environment there is a need to break up the complex field into distinct groups and units and then relate them in a functional and logical pattern. The bigger the city area, the greater the need to make the component parts (buildings, streets, districts) distinct in character and with clearly defined boundaries. They must be sensed not only in their individual characteristics but as a part of the overall background pattern. The individuality of a group or unit must also be realized in its functional connectedness with the social, economic, and cultural whole of the city. Thus, the physical make-up of the urban environment must not only take the individual units into consideration, but these distinctly perceived separate features must also be grasped in their relation to the spatial and functional fibres of the whole.

The increasing differentiation of the city offers a wide variety of scenes. Each city possesses a total personality, yet it contains a broad spectrum of individually characteristic units. The increasing scope of the living space of a city brings a greater variety of

73

stimulation, opportunities, and vistas to explore, and increase in complexity becomes an asset. No richness is added, however, through the mere multiplication of identical units or areas. Only a disciplined differentiation of the city offers perceptual challenges such as contribute to a city environment that is emotionally and intellectually stimulating. The difference between the impact of continuous challenge on the mechanical and on the organic level is clearly put in a phrase from D'Arcy Thompson: 'The soles of our shoes wear thin through use, but the soles of our feet become strong through it'. The challenge created by the wide range of stimulations coming from a well-differentiated and at the same time well-articulated environment is an important factor in the growth of knowledge, in richness of experience, and in civic connectedness.

Differentiation must be purposeful. The variation in character among city areas has to be consistent with realities; otherwise articulation becomes tiresome repetition. Extreme contrasts – for example, the contrast between a wealthy residential and an impoverished slum area – defy articulation because of a gap too wide for bridging and they attenuate the potential unity of a city. But open squares, narrow streets, a tranquil park, a business area, or a well-sheltered residential section – all are perceived more clearly, more intensely, and more characteristically if they are in proper proportion to one another in size and distance, and in proper order in the sequential circulation pattern of the city. In any artistic creation, varied elements have to be brought to a common goal. A city must find a structure in which a wide range of elements is brought into a common functioning whole through gradations, contrasting boundaries, rhythmically repeated similarities. A well-harmonized basic spatial pattern can be greatly helpful in manipulating group life, mixing people, or keeping them separated, as necessary. At the same time, however, it is imperative that this pattern be flexible enough to permit new orientation via improved technology, changes in custom, and new groupings.

A city form that has such unity does more than facilitate the life within it. The richness, inner logic, and harmony of units in

74

an urban environment function symbolically. In a certain sense, there arises an artistic creation that stimulates sensibilities, increases sensitivity to surroundings, and transforms attitudes.

ARTICULATING THE CITY: THE PROCESS

Every process of high-level schematization follows this sequence. (1) The introduction of stress into the unstructured field yields a figural pattern. (2) Component units of the figural pattern are read through the establishment of their boundaries; we become aware of the parts of the structure. (3) The connexity of the parts is read through the determination of the links among them. (4) The structure itself is read through integrating the parts in their connexity. Thus, the low-level structure of the field becomes a high-level structure.

We bring the symbolic structure of the urban environment into legibility according to the following sequence. (1) From the perceptual field of the urban environment we resolve such units as houses, streets, squares, neighbourhoods, sections, according to our grasp of the individuality of their features. (2) We read the boundaries – rivers, walls, gaps, changes of form or expression – that define these units. Thus we become aware of the parts of the city structure. (3) We read the connexity of the parts in terms of their bonds and links – on the one hand, the traffic arteries and rail and transit lines that collect and distribute the life blood of the city; on the other, doors, windows, bridges, tunnels, and long inclusive vistas. (4) The parts in their connexity are read together as a common structure – the symbolic form, the intrinsic symbol of the urban whole. The 'New-Yorkness' of New York is due largely to the exciting variety of its constituent areas. Fifth Avenue, Central Park, the United Nations building, Harlem, Greenwich Village, the East River, Wall Street, etc., together make up what we perceive as New York the city. In our imagination we may toy with the idea of leaving out one or another of these areas, thus changing the composite character of New York. To test our sense of the wholeness of the city, we may carry the

75

game further and in our imagination gradually delete a series of successive parts. It soon becomes evident that eliminating certain parts of New York implies not only a change of size but a change of character. If we played the same game with a city like Los Angeles, whose parts are less differentiated, the deletion of some of them would mean more of a change in size than in character. We may carry on this imaginary game in another direction: instead of leaving out parts, we can try relocating them. We will inevitably discover a certain logic of growth expressed by the present structual configuration. Evidently, the variety of characteristic areas is an integral part of New York. The boundaries between one and another region are consequent and belong to its structural expressiveness.

The communication path has less symbolic significance, for recent years have witnessed major transformation without altering the essential characteristics of the metropolitan whole. Many smaller cities, however, have resisted the passage of new throughways bypassing the centre of the city, for this would entail not only an economic displacement but also a major shift in expressive character.

In the town small enough to be grasped in a clear structural pattern, the communication and transportation network tells us the most. The larger the city, the more significant the differentiation of its parts, their boundaries, and connecting links. On a visual level, the transportation network as a whole becomes increasingly conceptual, a question of cartography abstracted from immediate visual legibility. Nevertheless, key parts of the transportation network can become symbolic through their autographic style: bridges, stations, or other details. A bus stop in Boston is marked by a band on a pole, in New York by a sidewalk standard. A Metro entrance with its *art-nouveau* character means Paris. Trolleys run in subway tubes only in Boston. The Moscow subway station is *sui generis*.

Differences in age further enrich the characterizing parts. In, let us say, a small New England town composed largely of historically meaningful buildings, a few new buildings may provide

too sudden a contrast, and, instead of adding to the total, may have a jarring effect. In a large metropolis, where historic growth has characteristic areas comparable to the age rings of a tree, each new one is absorbed in a visually and meaningfully connected continuum and adds to the richness of the whole. The new buildings or sections have no formal structural connections with the total but complement one another in an enriching sense. The Lever Brothers buildings or the United Nations building in New York may bring a shift of emphasis but always within the total field. On the other hand, the John Hancock building in Boston is too abrupt a contrast to the smaller scale of its surroundings and is thus a disturbing and unbalanced factor. Philadelphia, like Boston, abounding in visible links connecting the modern supercity with its eighteenth- and early nineteenth-century past, has developed a master plan for ensuring the survival of these historic links in the symbolic patterning of the burgeoning metropolis.

ARTICULATING THE CITY: THE CONNECTIONS

The door, the window, or any opening between enclosed spatial units is an index to the freedom of movement possible on the actual physical level, to the freedom of the eye to wander on the visual level. There are numerous devices men have discovered or invented that bridge separate, bounded spatial regions.

The window or the door has another important feature as well: it can be regulated, that is, it can be a part of the fence or barrier when it is closed, or it can function on its own terms when it acts as an opening. The height, the width, the strength, the degree of opening are also indexes of the opportunities for freedom of traffic. The link or path between spatially defined areas helps to articulate a spatial continuum. This may be an extended door or window actually providing a direct transition from one place to another; it may be an extended transition actually incorporating spatial areas. Roads, bridges, tunnels, air routes, river paths, subways, overpasses, underpasses, rotaries, or cloverleafs are such

77

patterns; they connect regions by concentrating and distributing traffic. Utilities and communications have corresponding distribution paths: power lines, water pipes, telegraph and telephone lines, radio and television channels. Here again, the visible features are the indexes of certain actual or potential events in transportation or communication. They may have a wide range of spatial configuration in different geometries.

Boundaries, openings, and links are important aspects of the intrinsic symbolism of the urban environment. Their specific characters, their aesthetic features, their references to the life pattern – all constitute important elements of the symbolic structure. The degrees of relationship between boundaries and openings are determined by the type of life associated with them and are expressive of the values and aspirations of the group. The differences between a well-fenced suburban area and an unfenced fluid space show clear differences in human attitudes. A confining, restrained subdivision of space expresses a lack of a sense of community in a typical class, a caste, or a prestige group. Condensed space, with rigid isolation devices, facilitates and expresses aspects of community life.

As we have said above, single factors become intrinsic symbols only through their structural connectedness. Naturally, these spatial devices gain meaning only through reference to what they divide or connect. The boundaries are boundaries of characteristic spatial areas. The interior of a house and the garden outside are particular types of surroundings; their dividing boundaries are meaningful only in terms of what they separate. Today, there is a growing tendency to design houses in which the boundaries between the inside and the outside are minimized. Structural devices of the house accent the structure of the outside, for example, walls that extend into the garden. On the other hand, landscape elements assume an important role inside the building.

This semi-fusion of two distinct spatial atmospheres is justified for many reasons. As technical knowledge enabled the production of buildings with thermal and illumination control, the old heavy-masonry protective walls became unnecessary in

order to give a feeling of shelter. On the other hand, as the increasingly mechanized world isolated us from the rich fluctuation of the organic world, the psychological need arose to borrow as much as possible from nature to make urban life acceptable. Here again, the structural combinations of the space areas, with their defining or connecting devices, are characteristic of the needs, attitudes, and values of contemporary man. In the broader urban pattern, similar needs may be recognized. The city is no longer an enclosed territory with walls to protect it from an outside enemy. It is a spatial pattern that needs to fight against the internal enemy of complete isolation from fresh air, sunshine, and open space. Boundaries, connecting links, and openings are being structured in a new pattern. This structure is again a symbolic form expressing certain emerging values.

TRAFFIC AND SYMBOLIC FORM

Traffic is a major battleground of the city's struggle to preserve itself as a place where the human life within it may continue to exist, to grow, and to encompass its organic and symbolic ends. Traffic and the parking of vehicles are a factor of confusion in our attempts to articulate the city form.

There is a basic form relation among those stable elements in the environment that have long historic memories and relatively well-established aesthetic roles. Though our spatial concepts and our dominant aesthetic attitudes have undergone changes, we have accumulated knowledge of what the satisfactory space patterns of related spatial forms are. We have, however, little historic guidance for relating static space forms, such as buildings, with today's fast-moving vehicles of transporation.

Problems arise at many levels. First of all, the aggressive dynamics must be balanced by the larger stable world. It would also seem that there is an incompatible contrast between the forms of buildings and of cars. This is most apparent whenever the cars are stationary and their endless lines blur the perceptual ordering of architectural relationships. The clash of colours of the

79

two- and three-tone cars, with their chaotic geometry and chromium haloes, serves only to create disturbance. Herein lies one of the most serious aesthetic bottlenecks of the urban scene. In motion cars tend to blend into a kaleidoscopic stream that, in an aesthetic sense, can accent the nature of the surrounding buildings. Standing, they at best compete with and in most cases suffocate their surroundings.

Aside from functional needs, the aesthetic handicap alone is serious enough to demand our attention. Few of the innumerable parking solutions take this factor into consideration. Although fringe parking alleviates the downtown traffic press, it takes unpleasant visual forms in the important connecting areas between downtown and the city periphery. The problem of desk-side parking facilities for new office buildings, theatres, hospitals, and stores will be fully solved only when the aesthetic aspect is controlled. This will necessitate some carefully considered, visually satisfactory screens to hide the groupings of motor cars. Natural or artificial screening, such as trees or aesthetically pleasing fences, will help to accommodate the appearance of parking lots and meter areas to the surrounding city scene. Municipal or private garages, in alleviating parking, must, like open-air lots, be considered as to their location, their approaches, and their visual relations to the total space pattern. Open-deck, exposed-steel garages can bring a new technical accent to the environment in keeping with the car forms.

The filling station is a similar problem. Its gaudy, attention catching 'acrobatic' devices in a sense are justified by the necessity of attracting the fast-moving eye, but the station, too, must find a proper relation with its background.

Both the problem of advertising and display and that of parking demand a thorough analysis and fundamental proposals. These fields are allied through their visual needs. Each has arrived at a point of supersaturation at which original purposes have been lost through exaggerated crowding. Both problems demand a new structural solution, common denominators that can reduce their complexity into controllable terms. A possible starting-point is to

eliminate all unnecessary redundancy in an attempt to simplify a codification of the elements. This need is already self-evident in advertising. Parking simplification can be achieved by concealing those aspects of the environment that choke off visual and physical traffic orientation. This system of codification has two interdependent objectives: to be functionally efficient and aesthetically satisfactory. Both goals are important in a broader context, for they must be related to, and fit in with, their surroundings. There is no rigidly fixed code one can use, for the underlying objective in designing an efficient communication system is to make it an aesthetically pleasing, vital form giving flexibility and susceptibility to change.

ACKNOWLEDGEMENTS

Excerpts from article published in Winter 1965 issue of *Daedalus*, Journal of the American Academy of Arts and Science. Vol. 94, No. 1.

Excerpts from essay 10, 'Notes on Expression and Communication in the Cityscape', published in *The Future Metropolis*, edited by Lloyd Rodwin, published by George Braziller, Inc. New York, 1961. All essays originally published in *Daedalus*, Winter 1961.

REFERENCES

GABO, NAUM, & PEVSNER, ANTOINE. 1920. *The Realistic Manifesto*. Moscow. Reprinted in part in *Gabo: Construction, Sculpture, Paintings, Drawings, Engravings*. Cambridge, Mass.: Harvard University Press, 1957, p. 151.

ROSENBERG, HAROLD. 1961. *The Tradition of the New*. New York: Grove Press, p. 30.

RALPH BERRY

Patronage

INTRODUCTION

I. Patronage of the arts implies support, sponsorship, encouragement. It makes little sense, however, to regard it as a separate and autonomous process. Rather, the term indicates additional aid to a process that already exists, a kind of top-dressing. The White Paper of 1965 correctly distinguished between the support given to the arts through education, through preservation, and through patronage. One could go further. In the fullest sense, patronage must be related to the means whereby contemporary society (in Britain, for our purposes) subsidizes the artist/designer. In fact, much of what can strictly be regarded as patronage applies to a small number of individual artists, or to a part of those individuals' earnings. Therefore, before we concentrate on that limited range of activities that is called patronage, we must at least glance at the structure of bread-and-butter work that supports it. Who, in general, are the artists? And how do they earn a normal living?

II. We cannot define art. But we can try to define artist. This is an occupation group of a sort, which falls to the lot of the Ministry of Labour to categorize, together with the Census Branch of the Register Office. The simplest approach is purely empirical: we may say that artists (almost entirely, nowadays) are those people other than architects who have been students at a College of Art. Colleges of Art categorize their students according to four areas, of which three are concerned with design (Graphic, Three-dimensional, Fashion/Textile) and one with Fine Art. Thus, the distinction between art and design is established before students

83

leave College. It follows them into the outside world. They have, however, sufficient in common to warrant their being treated as an overall group that is not totally fragmented. The difficulties will shortly emerge.

First, Fine Art. The 1961 Census of England and Wales comes to terms with the problem – not altogether successfully – in Table 26 of its Occupation Tables. Category XXV (Professional, Technical Workers, Artists) contains a section devoted to 'Painters, sculptors, and related creative artists'. In this occupation group are 22,600 men and 12,560 women. The Census does not impose a definition of 'artist'; the persons approached merely describe themselves in those terms. The figures should on other grounds be treated with caution. They represent a 10 per cent sample of the population, that is subject to statistical bias. They exclude teachers, a group (of which more later) that includes many who could perfectly properly describe themselves as 'artists'. Finally, no comparison with the 1961 Census is possible, since the classification system had been completely revised.

If 'artist' poses problems, 'designer' baffles pursuit. It is a general term that needs to be re-defined in the context of each industry. A graphic designer might be found in advertising; an industrial designer in one of many different manufacturing industries, such as furniture, electrical goods, or textiles. Indeed, an engineering designer might be regarded as primarily a technologist. (This demarcation line dispute is certain to pose increasing problems to Colleges and Industry in the next decade.) If we turn to the Ministry of Labour, which takes an annual survey of occupations of employees in manufacturing industries, we find that 'designer' has no category of its own. Designers are found in a group termed 'Other technicians', for which the definition is 'Persons carrying out functions of a grade intermediate between scientists and technologists on the one hand and skilled craftsmen and operatives on the other' (Ministry of Labour, 1966). The Ministry's most recent survey of manufacturing industries lists twenty-six tables, of which only one refers specifically to designers ('Designers and Typographers' are listed for the Printing

and Publishing industry). Designers, then, are submerged in a heterogeneous group.

Turning from the official sources to the professional institutions, we find a similar lack of centralized definition. The most important (though not the only) such institution is the Society of Industrial Artists and Designers. For this Society, designers are 'creators of FORM': the Society claims to be unique in uniting in a single organization illustrators and graphic designers with three-dimensional designers. The membership of this Society is nearly 2,000, but there is no means of calculating the proportion of the profession that this represents. Membership tends to wax and wane according to the periodic recruitment campaigns, not to larger social and industrial rhythms. However, an extremely well-placed authority (whom I may not quote) has estimated to me that membership of the SIA represents at least a third of the total number of designers in this country. If, therefore, we accept the SIA's general definition of designer, we can set down approximately 6,000 of them working in Britain today.

Finally, teaching. Schools and Colleges together account for a large number of teachers of art and design. There is an overlap to consider here: it is quite normal for the artist/designer to teach for a few days in the week, and devote the remainder of his time to his studio. Oddly, the Department of Education and Science maintains no figures for those who teach art. It has, however, an important statistic available: the number of teachers *with art qualifications*. (This we may safely assume to be virtually the same as the number of art teachers, though painstaking research might well shed lurid light on even this primitive assumption.) For England only, the number of teachers so qualified is 5,058 (3,204 men and 1,854 women). One can reasonably double this figure to take into account Wales, Scotland, Northern Ireland, and schools outside the State system.

III. I have treated at some length a point which is not self-evident, and is a necessary preliminary to any survey of patronage. It is this: when we speak of artists and designers, we refer to an elusive

85

and mobile group that has so far managed quite surprisingly well to escape various official attempts to define them, to pin them down, to number them, to organize them. (I have noted, in the course of my inquiries, what has appeared to me a note of distinct, if discreet, official chagrin at this phenomenon.) This group, some 50–60,000 strong by my computation, earns a perfectly good living largely by means which fall outside patronage. Their incomes stem mainly from the Local Education Authorities, from industry, from a variety of small commissions, from sources which one would not in general terms associate with art at all. Society itself is their main patron. And in this, matters nowadays differ very greatly from a period such as the Italian Renaissance, when one could say that patronage *was* art. No patron (Church, nobility, or merchants): no art. In the broadest sense, this is still true today. But we must not make the mistake of regarding the Arts Council estimates, together with a few other major sources, as a final or even outstandingly significant statement of the nation's provision for the arts.

IV. Granted this caution, we can now return to 'patronage' in its generally accepted sense and seek to document the ways in which society directly and deliberately fosters the arts. Though I shall concentrate on the visual arts, the main channels of patronage naturally make no such exclusive statement, and I must accordingly cite figures that relate to the other arts. These overall figures cover both art, and artists. A great deal of money so devoted must relate to housing, administration, and so on: the artist benefits, but is by no means the sole beneficiary of the money. This distinction is worth stating, but cannot be pursued.

Patronage which we can discuss in detail may conveniently be described under two heads, public and private. I turn first to the public sphere.

THE PUBLIC SPHERE

The public sphere comprises central and local government. Of these, the central government is now the more important patron

86

of the two. This fact, only arguably true until very recently, is now undoubted. It is the major change that has affected the patronage scene of recent years.

The Arts Council

The instrument through which the Government exercises patronage is the Arts Council. Its function, as set out in the Royal Charter of 1946, is to develop

> a greater knowledge, understanding, and practice of the fine arts exclusively and in particular to increase the accessibility of the fine arts to the public throughout Our Realm, to improve the standard of execution of the fine arts and to advise and cooperate with Our Government Departments, local authorities and other bodies on any matters concerned directly or indirectly with those objects.

The importance of the Arts Council is directly related to its income; and this, over the years, has not been large. In 1945–6 its first grant from the Exchequer was £235,000: ten years later the sum was £820,000, and not until 1958–9 did it exceed £1 million. Thereafter progress has been more rapid, with the £3 million mark passed in 1964–5 and in 1966 – an *annus mirabilis* for the Council – a total of nearly £6 million promised for the following year. Later, however, we can review the details of that historic announcement. For the moment I emphasize the past role of the Arts Council in 'doling out National Assistance to the Arts' (to use the bitter phrase of a past Secretary-General).

The Arts Council is the Government's agent. It derives its income from the Treasury, but thereafter is the sole judge of how the money shall be spent. The Treasury decides the amount, the Arts Council the details, of the Government's patronage. I give the main heads of the Arts Council's distribution of its moneys for the year ended 31 March 1965 (Arts Council, 1965, p. 98). The Arts in England received, in all, £2,689,700.[1] Of this sum, music

[1] Separate Committees are set up for Scotland and Wales. In 1964–5 expenditure in the arts in Scotland totalled £176,457: in Wales, £133,895.

received nearly £2 million, of which the Royal Opera House received a block grant of £1 million, and Sadler's Wells £425,000. Drama received £545,092, which included £142,000 to the National Theatre and £88,000 to the Royal Shakespeare Theatre. Thus music and drama account for 93 per cent of the Council's expenditure, with relatively little left for Art (£89,000), Poetry (£5,148), and Arts Associations (£38,170). These are naturally not statements of values, but reflections of the varying needs of different arts. It has, however, in the past been a matter of adverse comment that painting and the film have received relatively little support from the Council. The Cinema has not been recognized as a 'fine art'. Painting is presumably not regarded as an occupation that stands in need of official support: and of the £89,000 devoted to Art, £76,263 went towards the cost of holding Exhibitions. However, for 1965–6, the Council allocated £11,000 for awards to living artists. This covered grants for sabbatical leave; for purchasing the work of artists in need of encouragement and financial help; and for contributing to the commissioning of works by public institutions.

The 1964–5 balance sheet reveals, besides the major items that I have cited, a vast number of small sums that give perhaps a clearer picture of the Council's help. In the main, it is the Council's policy to direct its subsidy towards the professional artist, not the amateur. Thus (of many such examples) £6,775 to the Cheltenham Everyman Theatre. But there are many instances where the Council lays out with advantage a little money on the amateur, especially in fields where there can be fruitful collaboration with the professional. Thus, £125 to the Launceston Society of Arts; £275 to the Society of Barrow Poets; £2,500 to the Aldeburgh Festival. Enthusiasm and local self-help have normally been major factors before an Arts Council grant can be received. The Arts Council has never had the resources to lavish money on projects without good evidence of local commitment.

A matter of standing controversy is the ratio of the Council's help to London and to the provinces. This cannot be established exactly, as (for example) a London orchestra will periodically

tour the provinces. It has, however, been estimated in the PEP pamphlet, *Public Patronage of the Arts* (PEP, 1965), that London consumes approximately 30 per cent of the Arts Council grant. The writer argues interestingly that a quasi-Beeching policy should be enforced, with support going primarily to London and the major regional centres where the arts, with local cooperation, flourish.

> This means a fairly ruthless policy of weeding out and the cancellation of grants to a number of organizations which have been in poor health for a number of years: for example, thirty-six theatres outside London are now receiving aid, and this number could be substantially cut . . . The Arts Council should concentrate its expenditure far more than it has done, even if this means a certain amount of hardship for those areas of the country where the level of artistic life is dismally low (PEP, 1965, p. 329).

Tempting though the argument is, I find it somewhat unrealistic. The end of Arts Council administration is not *efficiency*, in an industrial sense; it is the fostering of the arts wherever they are found. Death is hardly a viable alternative to 'poor financial health'. The Arts Council is not concerned solely with high standards of artistic achievement (which would indicate a total and rigorous concentration on London and the major centres) but with artistic activity. Art, in fact, is a social service – a term actually used in the White Paper, *A Policy for the Arts* (para. 98). Finally, the very large recent increases in the Arts Council grant make it perfectly possible to do two sorts of things: to spread money thinly over a large number of enterprises, and to back the major projects well.

A Policy for the Arts

The position of the Arts Council, and the whole standing of Government patronage of the arts, was significantly altered by the publication in February, 1965, of the White Paper, *A Policy for*

the Arts: The First Steps. This document recognized that 'more generous and discriminating help is urgently needed' for the arts, and announced certain far-reaching decisions. First, the Arts Council's relationship to the Government was changed. It became responsible not directly to the Treasury (as before) but to the Department of Education and Science, whose Under-Secretary, Miss Jennie Lee, had been given special responsibility for the arts. Second, the Government recognized the need for the Arts Council to have a capital fund from which the building and renovation of theatres and concert halls might be financed. This was in response to a long-standing plea – previously, the Council had never been able to spare more than token grants towards the building of new theatres and concert halls. Now, the Arts Council was authorized to enter into commitments up to £250,000 in 1965–6 to encourage local and regional authorities to develop their plans. This did not mean a blanket subsidy; in no case would the Arts Council contribution exceed 50 per cent of the cost of any project, and normally it would be much less. In short, the arts were to be properly housed; the Government recognized its responsibility to shoulder its share of the burden; and a clear indication of greater commitments in the future was given. The major test of the White Paper was, however, its overall financial commitment. And here the signs were auspicious: in a bad year economically, the Government was able to find an extra half million pounds for the Arts Council, in addition to the normal 10 per cent annual increase.

Plans for 1966–1967

All this was notable enough. But the plans for the following year, announced by Miss Jennie Lee on 24 February 1966, marked an astonishing advance. Briefly, an extra £2½ million was to be found for grants to the arts in 1966–7, with the Arts Council grant approaching £6 million. I need only touch on a few outstanding items. The building fund was doubled, to £500,000; the newly-formed Literature Panel at the Arts Council would receive £50–70,000; the four London Symphony Orchestras would each

receive a block grant of £30,000; the National Theatre was to be rescued from debt.

I need not pursue these grants in detail; they clearly constitute a central, and inescapable fact. The Government is now the most important patron of the arts. It is, moreover, hardly to be considered that this fact is reversible. The whole history of British legislation follows a consistent course, that of reluctant, but increasing involvement in matters felt to be the concern of the State. I emphasize that the White Paper indicates not merely a short-term bonanza, but a steady commitment to the future. In an especially bad financial year, the growth in grants to the Arts might conceivably be restrained, or even halted. One cannot imagine a future Government reversal of these policies. Finally, in view of the State's dominance as patron, it is well to re-state the guiding principle of State patronage in Britain: it is permissive. It aims simply at providing the social context in which the arts can flourish; it does not seek 'to dictate taste, or in any way to restrict the liberty of even the most unorthodox and experimental of artists' (*A Policy for the Arts*, 1965).

Local Authorities

Stern words have often been passed on the performance of the local authorities in their patronage of the arts. It is an oft-rehearsed tale: how, in 1948, a benevolent Government empowered all local councils to spend the equivalent of a sixpenny rate on the arts and entertainment; and how, a decade later, the local authorities had grasped at this challenge to the extent of spending well under a single penny. The overall performance of the local authorities has been a decided disappointment – at least, to those who awaited the issue in the Wordsworthian dawn of 1948. Certain local figures have now become eternally fixed in the demonology of art administrators – as, for example, the Borough of Stratford-upon-Avon, where according to Lady Gaitskell in 1964, 'there is not one farthing on the rates for the Arts' (Stratford would seem to have a trade surplus without parallel in the Western

world). And there is the Clerk to a local authority (straight out of a nineteenth-century novel) who wrote to the Director of the local theatre, stating that some seven months earlier his Council had decided to make a contribution to the work of the playhouse, and was accordingly enclosing a cheque for one guinea.

There is, of course, a case of sorts. The Act is permissive, not mandatory. The local authorities represent their local electors, who for the most part incline to the view that those who want art, a harmless eccentricity in a democracy, should pay for it. The strains to which the rating system has increasingly been exposed of recent years may disincline even the well-disposed to support a costly project – which can get out of hand, as witness the Nottingham Playhouse controversy. The local authorities have simply borne out the classic statement of Lord Goodman, Chairman of the Arts Council: 'One of the most precious freedoms of the British people is freedom from culture'.

The picture has another side. Bristol, which used to provide the Bristol Old Vic with £250 a year, now spends £10,000 a year on the Little Theatre, and the Theatre Royal. Birmingham has decided to build a new Repertory Theatre at a cost of half a million pounds: Bromley's new theatre will approach that figure. Fifteen local authorities have resolved to build new theatres. The New Towns have shown enterprise, in line with the concept that art is a social service. The City of London plans to build an Arts Centre in the new Barbican development. All the evidence suggests that of late years there has been great progress, with some authorities greatly increasing their subsidies, and others – in the words of the Arts Council Report – getting their feet wet.

Local patronage of the arts has, then, a miserly past, but a soberly promising future. There is substance to Dorian's judicial and comparative statement that 'the tempo [of municipal art-support] is slow by comparison with that on the Continent' (Dorian, 1964, p. 377). In fairness to the local authorities, however, one can at least suggest that the past record may owe as much to the indigenous structure of local administration and finance as to philistinism. The present situation offers two con-

siderable grounds for optimism. First, the trend is now set; ideas prevail; and the stragglers, grumbling and blaspheming, must keep up with the caravan. Second, the notable lead cut out by the central government will enable the Arts Council to match pound by pound an ever-increasing local contribution, and prevail on local resistance with more generous help. Still, the future of local government's patronage must be linked with two contingent policies, neither of which can be predicted, and which lie outside the scope of this survey. A radical revision of the rating system, and a delegation of certain local burdens (most especially, education) to the Exchequer, would have far-reaching effects upon local patronage of the arts.

Education

The public sphere of patronage is by no means clearly defined in all its ramifications, and the field of education contains various examples of concealed, indirect, and unpublicized patronage. It is obviously true that the arts need to be studied, and that the teaching of a vast range of courses provides work for thousands of artists. But apart from this obvious sense, other opportunities for patronage occur, of which perhaps the most interesting relate to the Local Education Authorities and to the Universities.

A Local Education Authority can do a surprising amount to encourage the arts. In practice, it does so in three specific ways. First, it may buy live works of art to form a travelling collection to schools and other institutions. Second, it may commission a mural or piece of sculpture as part of the process of putting up a new building. And third, it may encourage schools to buy original works of art, either from their normal capitation allowance, or through private funds.

No definitive survey has ever been made of this field of patronage. Some LEAs do very little about the arts. Others exercise discreet patronage, but tend to be somewhat reserved about their good deeds – possibly because of a well-founded fear that local Ratepayers Associations would become over-active upon the

intelligence that creeping art was being sponsored at the Education Offices. A few general points can be made. It appears that the authorities that have formed serious collections of original works are counties, not cities (*Art Collecting for Schools*, 1963). This is largely because the cities can offer a major art gallery in any case. (Similarly, building costs for new schools tend to be higher in the cities, and it is more difficult to make money available for this purpose in school building contracts.) It is hard to judge the quality of the effort put in by individual counties, because of the still-disputed issue of reproductions versus original works. The economic advantages of investing largely in reproductions need no underlining: yet it is clearly desirable to support living artists, and the original work of art. My impression is that the idea of the original collection is gaining ground.

The value of such a collection must depend considerably on the quality of the advice given. It is usual for authorities to leave the choice to their own inspectors, art advisers, and teachers. However, two authorities, Nottinghamshire and Leicestershire, have led the way in consulting two critics with a national reputation, Mr Eric Newton and Mr Alec Clifton-Taylor. If this policy should spread, a gain in quality as well as amount of effort on the LEA's part is certain.

The scene is distinctly brightening here, but two cautions are needed. Miss Jennie Lee has recently stated that out of the 162 LEAs in England and Wales, only 45 have drama advisers, 46 have art advisers, and 70 have music advisers. The blunt statistic indicates the need for mass conversion of authorities who are provincial in every sense of the word. And the money provided for modest encouragement of the arts, in the ways I have mentioned, is not striking. We can fairly regard as progressive Surrey and Glamorgan, who set aside respectively £600 and £1,000 a year for the purchase of works of art (which in the former case now extends to collecting three-dimensional works). These are not large sums; but 162 authorities (to say nothing, and deservedly so, of Scotland, which does little in this field) have *en masse* a capacity to wield considerable patronage. The individual com-

missions invariably involve quite small sums, but affect a large number of competent artists, and provide for an increasing flow of original work of sound quality towards the schools.

The Universities straddle the public and private spheres, and can conveniently close this survey of the public domain. It is possible to regard the Universities' appointment of artists to their faculties as simply the apex to the total educational effort. But I think that of recent years the University patronage has been different in kind. To begin with, University departments of Fine Art and of Drama have an opportunity to appoint Fellows, in addition to their teaching faculty, whose function is simply to practise their art on the campus. Thus Bristol awards a Cilcennin Fellowship in Drama, which is given to a practising playwright. Nottingham awards a Fellowship in Fine Art. On a larger scale, Leeds has the Gregory Fellowships, founded with the intention of bringing artists (in any art) 'into closer touch with the youth of the country so that they may influence it; and, at the same time, keep artists in close touch with the needs of the community'. Here, as with the other Fellowships, holders are expected to make themselves accessible to students and staff, discussing their work informally. The arrangements are flexible – formal lectures may occasionally be given, but are not a requirement. Another and striking example is the recent success of York in persuading the Amadeus String Quartet to take up a three-year residence period at the University. They will give concerts, but will not teach (though it is hoped that they will occasionally coach). York in addition offers the Granada Fellowships in the creative arts, besides maintaining a Granada-endowed fund of £500 a year to purchase works of art by contemporary artists for display within the University.

The logical extension of these acts of patronage is the Arts Centre. Here the pioneer is the University of Sussex, now in process of setting up such a Centre. The concept of an Arts Centre offers an interesting gloss on the title of this symposium – for, as Dr Walter Eysselinck, Director of the Sussex Arts Centre, writes: 'The idea of a "Centre" . . . implies a rejection of the

95

cliché that art and the artist are separate, apart, alien to society.' As with the other Fellowships that I have mentioned, the main intention is to bring young and talented artists to live and work on the campus. But a Centre will have a definite base – a flexible theatre, an art gallery, a number of studios. And painters, sculptors, actors, musicians, writers will be attached to the Centre. The Sussex approach is to stress the interrelationship and essential unity of the arts. Again I quote Dr Eysselinck: 'It is not too much to hope for a play written by a playwright in residence, acted and produced by students and the nucleus of a professional resident company, with sets by an artist, and music by a composer living at the University.' Essentially, it will be the function of the Arts Centre not to hold courses, but to fertilize the creative process at the University.

Other parallel ventures are the decisions to build University Theatres, designed for joint use by students and professionals, at Manchester, Southampton, Exeter, Birmingham, and Hull. Each of these constitutes a considerable portion of what an eventual Arts Centre should be. It is, however, the University of Sussex which has gone farthest towards the bold conception of the unity of the arts. Such a Centre can claim to be much more than merely modish. It embodies a value that runs throughout this symposium – the recognition of the eventual integration (or, as romantics of various persuasions assert, re-integration) of the artist with society. The civilized and tolerant award of Fellowships to a few artists, such as a minority of Universities grant, is one thing. It is quite another to set up a permanent physical home for the arts, and to allow for the simultaneous presence of more than a few artists, of differing kinds, at a University.

All this requires a great deal of money. The Universities channel this form of patronage, but by no means provide for it all themselves. Since the great bulk of their income must always be devoted to teaching, research, and administration, the generosity of outside patrons is looked to very considerably. Not totally: Leeds, for example, backed up the original Gregory endowment with three Fellowships from its own funds. But Southampton's

Theatre came from the Nuffield Foundation, and the Calouste Gulbenkian Foundation gave nearly £50,000 to the Sussex Arts Centre. At this level of patronage, we are clearly moving from the public to the private sphere.

THE PRIVATE SPHERE

The private sphere of patronage covers three main types of support to the arts: that given by private persons, by Trusts and Foundations, and by Industry. About the first I propose to say nothing. Acts of patronage by private persons are not susceptible to documentation: and it is, moreover, impossible to draw a line between genuine support of the arts, and speculative investment in a painter whose works may one day net a fortune for the discerning patron. Trusts and Foundations range from the miniscule to the formidable. But only one, in practice, devotes most of a large income to the arts. The Nuffield Foundation, though it has occasionally helped the arts, is chiefly concerned with research and experiment in medicine and science, education, and the social sciences. The Pilgrim Trust aids art and learning, but is chiefly concerned with the preservation of buildings. The Carnegie Trust is especially concerned with social welfare schemes of a pioneer or experimental kind. Thus, a part of its income goes towards the arts. It does not, though, make grants to individuals. Each Trust has its special emphasis, and generalization is impossible. But one Trust, by virtue of its massive patronage of the arts, merits special attention.

The Gulbenkian Foundation

So far as the arts are concerned, the most important of the Trusts and Foundations is the Calouste Gulbenkian Foundation, Lisbon. The United Kingdom and British Commonwealth Branch of the Foundation, established in 1956, now exercises patronage over a wide area, and its grants have increased notably since 1960, the year when it began functioning in earnest. It has been the policy

97

of the Branch from the beginning, that the main emphasis of its activities should be in the arts, although it also makes grants towards charity, education, and science.

The reasons for this policy are not without interest. Before it was formulated, the Foundation asked for an enquiry into the arts in Britain, to be carried out by a small committee under the chairmanship of Lord Bridges. The report of this committee, *Help For The Arts* (June 1959), was accepted by the Foundation and forms the basis of the United Kingdom and British Commonwealth Branch's policy. The Foundation recognized that Britain, as a prosperous and highly developed country, contained a structure of public and private services and foundations that satisfied many current needs in most fields of the Foundation's statutory activities – particularly in the case of charity, education, and science. On the other hand, the arts were regarded by the Board as standing in need of patronage. Previously, patrons had been individuals of wealth and discrimination. But such individuals were becoming, apparently, rarer – after meeting their tax obligations. Thus, concluded the First Report of the Gulbenkian Foundation for the year 1959, 'the position is that, while the patron is becoming ever more rare, the part he formerly played in stimulating the arts and giving support to the artists is not being sufficiently assumed by the State and local authorities' (*Chairman's Report*, 1960, p. 146). The general rise in the standard of living had produced a large and growing public for the arts. Yet the needs of this public 'are outpacing the contribution that either the State or local authorities can make, so that it is in this sector that the help of the Foundation can be particularly useful'. This statement must, I think, be taken as a most authoritative comment on the situation prevailing in the arts in Britain, of recent years: at least up to the Government's policy statements of 1965 and 1966.

The support given by this Foundation to the arts has been very considerable. In the three years 1960–2, the arts in Great Britain received a total of £534,627 in grants. In 1963 the grants made or promised totalled £151,715: in 1964, £208,345: and in 1965, £258,000. It will again be helpful to observe the rough distinction

between aid to the arts, and aid to artists. The Gulbenkian Foundation's help to the *arts* has taken in the main two forms: it has made grants to institutions dedicated to the arts; and it has promoted projects which, without help, would probably never have come into existence at all. A few examples will illustrate this. £3,000 to the Walker Art Gallery, Liverpool, towards the acquisition of Rubens's 'Holy Family'; £4,500 towards the cost of the Scottish Opera Society's second season in Glasgow and Edinburgh; £10,000 to the Whitworth Art Gallery, Manchester University, towards modernizing and replanning the interior; £15,000 to the Royal Shakespeare Company, to provide a studio for the advanced training of actors; £48,500 to the University of Sussex, towards the new Arts Centre to be built there. Support to the individual artist is also a strong element in the Foundation's work. Its Second Report, covering the years 1960–2, expresses the 'conviction that the best way of assisting the artist, whether he be painter, sculptor, or musician, was to give him the opportunity of presenting his work to the public' (*Chairman's Report*, 1963, p. 159). This could be achieved (apart from the environmental facilities implied in the previous examples cited) through 'the commissioning of works, the offer of study, travel, and work grants, and the holding of competitions'. The Foundation has not, hitherto, itself commissioned works of art, but it has helped other institutions to do so. And it has set up a Committee to acquire works of certain selected artists, which are then loaned to provincial galleries and cultural institutions for exhibitions. In no case does the purchase price exceed £500 – clearly, a policy aimed at encouraging the younger and less well-known artist.

To sum up. The declared aim of the Gulbenkian Foundation is to find new audiences for the arts, and to help the individual painter, actor, and musician. In practice, it has been ready to back the experimental, the young, and the regional. But a 'cornucopia' image would be misleading; its grants are extremely well-judged and discriminating; the Second Report tells us that in the years 1960–2, the London Branch approved grants to about one-eighth of the two thousand applications it received. And apart

99

from some exceptional grants in the early years, no single grant has exceeded £50,000. The pattern that emerges is of careful and discriminating help to a large number of institutions and projects, often involving quite small sums.

Industrial Patronage

Of recent years, the notion of industrial patronage has gained ground. The concept received some publicity during the exhibition, 'Art in the Executive Suite', held at the Grosvenor Gallery in December-January, 1964–5. The catalogue to this exhibition contains some interesting assertions. 'Modern patronage, however, largely depends on enlightened individuals . . . The business world, with all its power and enterprise, its concern for staff welfare and ambiance, is potentially the most important source of all.' It quoted a recent *Times* editorial: 'It lies within the capacity of the business community to become the greatest patron of the arts in present-day Britain.' Clearly, a campaign of sorts was being launched.

At the same time, the Institute of Directors established an Arts Advisory Council, with Sir William Emrys Williams, a former Secretary-General of the Arts Council, as general adviser. Its first fruit was a brochure, *Investing in the Arts*, published by the Institute of Directors in April, 1964. Written by Sir William, it treats of the contribution that industry can make to the arts, beginning with an essay: 'Why should businessmen bother about the arts?' The reader will be struck by the title and the hard-headed approach which Sir William deemed necessary for his audience. 'Good art-work', he tells them, 'is good business . . . All along the line of industry he [the artist] is playing a practical and important part, and is as indispensable as any other technician.' Sir William pointed out that, to begin with, artists and designers were engaged in designing and packaging a firm's products.Then, a firm's image depended quite considerably on its advertising displays, its labels, and letter-heads. Sculpture and murals could embellish the exterior of a building, and the public rooms; the

presence of a few good pictures and pleasant décor in the board-room could 'create an agreeable and sophisticated impression'. Finally, a concern for the welfare of their own workers should motivate patronage of the performance arts. All this could be summed up as 'art on the premises': 'art used in the processes of production, art as an expression of a firm's image and, thirdly, art as a welfare amenity for the staff'. The other major outlet for a firm's patronage was art in the locality. Thus, industry was now in a position analogous to that of the squirearchy: it had inherited a duty to support good causes in the locality, and among these should be included the arts.

I cite these arguments at some length because it is, after all, not immediately apparent that industry has any pressing duty to spend shareholders' money on art. The arguments as laid out may be taken as the best available; that is, the arguments most cogent to the audience of industrialists. They provide a rationale for industrial patronage of the arts.

The performance of industry in these matters can now be partially assessed through a study of the *Arts Bulletin*, periodically issued by the Arts Advisory Council (there have been four to date). First, there can be no question that much interest has been aroused within the Institute of Directors by the establishment of the Council. The *Arts Bulletin* is made available primarily to members of the Institute who have registered their interest in the Council's activities, and wish to be informed of developments; the first number of the *Bulletin* quoted an enrolment figure of 1,884, with more still coming in. Of these, several hundreds had put forward comments and suggestions. A recurring theme was a request for advice – how to sponsor a symphony concert, how to go about organizing an exhibition of open-air sculpture, what painters to commission. Apart from individual advice given, the Arts Advisory Council has found it worth its while to set up certain general services. For example, it has published a pamphlet on *How to Commission a Portrait*, which gives guidance in select-ing painters 'whose style would be appreciated both by the sitter and by the Board of Directors who were paying for the portrait'.

This service has now been extended to sculpture and drawing. Again, it has mounted exhibitions for members of the Institute. One of them, especially worth mention, was 'Contemporary Paintings at Modest Prices', in which members were offered a well-chosen selection within the price-range £50–£200 – a confrontation, clearly, equally beneficial to relatively unknown artists and to inexperienced industrial patrons.

This, however, is board-room art. Much more relevant to the community as a whole is the individual patronage afforded by firms to local festivals up and down the country. I can do no more than mention a few examples here. Pride of place goes to Mr. L. G. Harris, of Brush-makers, Stoke Prior, Worcestershire, who for some years has promoted an autumn arts festival at his factory, not only for his own workers but for visitors. In a more general way the spread of arts festivals throughout the country – as at York, King's Lynn, Bath, Llandaff – has afforded an increasing number of opportunities for contributions to be made by local firms.[1] Another local activity is the sponsoring of symphony concerts, and here the way has been piloted by Sir Robert Mayer. Some industrial firms prefer to exercise patronage on a national basis. Guinness give awards to the best poetry of the year, and Watneys have sponsored prizes for musical composition.[2] And all firms can become members of the National Art-Collections Fund.

It is now time to assess this wide range of miscellaneous art patronage. Our primary distinction remains between art on the premises, and art in the locality or in the nation at large. In the first, art is essentially functional: a firm buys good design, good designers, and approved art, and hopes thereby to give a favour-

[1] Among those firms who have helped local art activities are Rolls-Royce, Whitbread, Fisons, Esso, Shell Mex, P. and O., Allied Records, Harvey's of Bristol, Wedgwood, English Electric, British Reinforced Concrete, Oxo, Hovis, Littlewoods, Schweppes, Heinz, I.C.I., Martini & Rossi, and Gillette. The ITV Companies have been outstandingly generous benefactors.

[2] Other firms who have exercised their patronage on a national level include Selfridge's, S. H. Benson, Lazard Bros., S. G. Warburg, Ind Coope, The John Lewis Partnership, Kleinwort Benson, N. M. Rothschild & Sons, and J. Lyons & Co.

able impression to the world – indeed, it has legitimate hopes of better business through art. In the second, firms cannot hope, nor do they seek, for direct benefit through local sponsorship. A little vague, general goodwill may accrue, and they may argue that if the arts flourish, so will good design. As inheritors of the squire-archical tradition, they pay up because it is expected of them, but exercise no control over the expenditure. Thus, in the first category, a firm consciously exercises choice not only as to amount, but as to direction of patronage – a firm can decide the *sort* of board-room painting it wants. In the second, it merely helps to provide the financial context in which art can operate. Industrial patronage, therefore, can hardly be said to be qualitatively influential. In the first category it must in the main follow approved modes; in the second, it is without influence.

The crucial question I have left till last. How much does industrial patronage amount to? The writer of the PEP pamphlet on patronage (published in November 1965) dismissed its claims summarily.

> Industry has regularly and naively been regarded by artistic administrators as a potential milch cow, but its yield has been consistently low. No figures of industry's annual contribution to the arts appear to be available and a calculation would be exceedingly difficult because such donations as there are tend to be both small and widely scattered: a major company which gave the equivalent of a junior sales executive's salary to the arts would be considered highly generous.

Since this was written, we have a little more to go upon. Sir William Emrys Williams, writing in *Arts Bulletin* in February 1966, hazards: 'your guess is as good as mine – and my guess is around a quarter of a million pounds a year. It could well be more, and is unlikely to be less'. This is a form of words: nobody's guess is likely to be so good as Sir William's. At least a quarter of a million, then, is our provisional estimate. Is this good or bad? It depends. Almost certainly, it is good compared with previous years. The pages of *Arts Bulletin* tell a story of patient, reasonably

successful shepherding of industrialists in the right direction. At times, indeed, the aura of missionary work is strong, and one receives the impression that the long-deferred betrothal of art and commerce will require the most delicate negotiations. Still, the work proceeds, and it would be unfair to decry it. On the other hand, it is fair to employ the standards of comparison that Sir William himself invokes. He speaks of industry and commerce becoming the 'Third Force of Patronage' – the others being Government and Local Authorities. Now Government, for 1966–7, plans to spend nearly £6 million on the arts. Local authorities in England and Wales spend about £3 million annually on the arts and entertainment, but about two-thirds of this goes on entertainment rather than art. Let us say £1 million from local authorities, then: and it is generally agreed that the performance of the local authorities has ranged from moderate to deplorable, with the latter predominating. At a quarter-of-a-million, industry does not look in good shape to sustain the comparison. The excited remarks of the 'Art in the Executive Suite' catalogue must, therefore, still be regarded as referring to potential rather than performance. Industrial patronage stands uneasily between the brusque dismissal of the PEP writer, and the 'Third Force' aspirations of Sir William Emrys Williams.

CONCLUSION

Frederick Dorian, surveying art patronage in Europe in 1963, found the British scene particularly well favoured. 'England', he wrote, 'presents one of the most convincing examples of diversified art support' (Dorian, 1964, p. 377). This judgement seems to me well justified. It is true that Dorian's main thesis was to juxtapose the American scene (where private patronage of the arts, though weighty in the past, is now proving inadequate) with the excellence of the European system of State and civic patronage. But his judgement was based on a thorough and judicious investigation of several European states, and it remains an authoritative tribute to the British system.

When, therefore, one considers Dorian's only substantial criticism of the British patronage system, one can well feel that the scene is now fairer than ever. 'The Government', wrote Dorian, 'does not make enough moneys available for distribution through the Arts Council . . .' (1964, p. 428). This view, hardly disputable in 1963, has now been largely overtaken by events. The Government patronage of the arts has recently been most generous, and promises to dominate the art scene in the future. Very few will not welcome this development. It does, however, call for certain reflections on the future trend in the art world.

The qualitative influence of other types of patron is likely to become less important. Local authorities, to put it mildly, have no ambitions to match proportionately the Government's allocation to the arts. Trusts and foundations have no means of suddenly increasing their grants to the arts in a manner comparable to the Government. Moreover, some trusts have terms that permit them to channel their resources in several directions – charities, the arts, education, science. It is conceivable that in future trusts may feel that there are socially effective ways in which they can deploy their resources, other than in the arts. Industry, as I have shown, is not an outstanding patron, and is now likely to become relatively less important. Both industry and trusts have this in common, that their sponsorship is of an uncoordinated and individual nature.

It is, therefore, the Government's kind of patronage that must prevail, and the Government's approach that must increasingly influence the art of the future. Now here there is no need at all to sound the obvious warning bell. The separation of Government support from Government control is an old and tested principle. Of long standing, it has recently been spelled out again in the opening words of the White Paper. This concept is in no sort of danger. It is, however, relevant to point out that Government patronage cannot help influencing the arts, whether it will or no.

The basic Government concept is of art as a social service. Art will be deployed towards the community as a whole; the performance arts, especially music and drama, will continue to be heavily supported, not only because such patronage is an admin-

istrative necessity, but because these arts are manifestly directed towards the community. The non-performance arts, especially painting and sculpture, must similarly come to terms with the community. Public sponsorship of the arts must exact an eventual price: public involvement. This involvement need not mean total acceptance. It does, however, demand recognition by the artist that society is *there*.

Such a development will be reinforced by the growth of the Arts Centre concept, an idea now welcomed by certain civic as well as university authorities. An Arts Centre (an identifiable locus, embodied in bricks and mortar) both challenges and welcomes the public. It is impossible that the permanent dwellers in this Centre should be unaware of the surrounding society, their paymasters and audience. This circumstance, together with an increasing awareness of the proximity and relevance of the other arts, is bound to have subtle and profound consequences in the development of each art. Raymond Chandler's remarks on the writer apply equally to all artists:

> . . . no writer in any age got a blank cheque. He always had to accept some conditions imposed from without, respect certain taboos, try to please certain people. It might have been the Church, or a generally accepted standard of elegance, or the commercial wisdom of a publisher or editor, or perhaps even a set of political theories. If he did not accept them, he revolted against them (Chandler, 1962, p. 77).

The artist, of almost all kinds, can now look forward to generous and sustained help from society in contemporary Britain. The manner in which he acknowledges his debt will increasingly afford material for the sociologist, as well as the art historian, of the future.

REFERENCES

Art Collecting for Schools: Catalogue to the Exhibition at the Scottish National Gallery of Modern Art, 1963.

ARTS COUNCIL. 1965. *Policy Into Practice*. 20th Annual Report
of the Arts Council, 1964–5.

Chairman's Report. Calouste Gulbenkian Foundation, 1960.

Chairman's Report II. Calouste Gulbenkian Foundation, 1963.

CHANDLER, RAYMOND, 1962. *Raymond Chandler Speaking*.
London: Hamish Hamilton.

DORIAN, FREDERICK, 1964. *Commitment to Culture*. University
of Pittsburgh Press.

EMRYS WILLIAMS, SIR W. 1966. *Arts Bulletin*, 4. London:
Institute of Directors.

Ministry of Labour Gazette. January 1966. Vol. LXXIV, No. 1,
p. 2.

A Policy for the Arts: The First Steps. 1965. London: HMSO.
February 1965, Cmnd. 2601, para. 1.

Public Patronage of the Arts. 1965. London: PEP. November,
1965.

MICHAEL TREE

Industrial design

In Great Britain the words 'industrial design' are used to cover a wide variety of industries and include both two-dimensional and three-dimensional design. Some other European countries have found it convenient to make a semantic distinction, which has resulted in industrial design being regarded as something exclusively concerned with three-dimensional design. In this country, however, it is accepted that the graphic designer involved in a large print-order for a leaflet has something in common with the furniture designer producing drawings for a mass-produced chair. In Britain there has never been any doubt that 'industrial design extends to embrace all aspects of human environment which are conditioned by industrial production' (ICSID, 1965).

Twenty years ago it might have been easier to define industrial design and to trace a line of development from William Morris ('Have nothing in your houses that you do not know to be useful, or believe to be beautiful') to Walter Gropius ('artistic design is neither an intellectual nor a material affair but simply an integral part of the very stuff of life') and then on to Frank Pick ('design is intelligence made visible').

Nowhere has this history been better recorded than in Sir Nikolaus Pevsner's *Pioneers of Modern Design*, and in these terms it makes more sense to think of industrial design as naturally forming part of this present book in which many of the contributors are concerned with fine art. But in Pevsner's brilliant book readers will note that he refers to the effect of new materials on buildings and products and to economic developments, particularly to the rapid expansion of industry matched by increases in population

in the nineteenth century. It is clear that industrial design reflects much more than the intuitive objectives of industrial designers, but it may not always have been clear how much industrial design was or was not 'art' and how much it was a misleading expression coined at a moment in history, which ceased like all moments in history, leaving a phrase whose meaning had confined a subject within too narrow limits, words which mean some things to some men and nothing to others.

That this has happened is clear, for however difficult it may be to untangle the many contradictions that were expressed during a serious period of unrest in British colleges of art and design in 1968, what emerged for certain was the feeling that far too much time was devoted to training students in techniques and far too little to encouraging them to ask the question why? That far too much attention was paid to hardware and too little to concepts.

Such a period of unrest may have been inevitable, and that it may have owed its origins to many other causes not so relevant to this subject is true, but it is worth noting that those who still think of industrial design principally as an art form have been much slower than the fine artists themselves to accept radical experiments, frankly vulgar sometimes, and a frequently wild liberation from tradition. The painters were far ahead of the industrial-designer 'artists', who only later produced the artifacts that sold well in Carnaby Street and the King's Road.

It may not much matter whether industrial design is or is not something to do with art, but what does matter is the fact that at this moment of time no critic or practitioner can be certain that his own definition of the subject is not exclusive to himself. For here is a subject which spans the logical precision of Eliot Noyes's international operation for IBM and the intuitive sensitivity of Ettore Sotsass's work for Olivetti. Here is a range of activity which embraces the detailing of comfort factors in the Apollo space project and the production of jewellery in small backstreet studios. It is therefore not surprising that theories abound, that old attitudes take a long time to die, that new concepts are sometimes treated with suspicion. A designer in his thirties is caught bowing

to the Bauhaus and at other times enviously emulating the adulation of systems methods. A critic is not sure whether to wear his Oxbridge scholar's gown or to put on his Los Angeles tangerine-coloured spectacles, so that in this field at least journalism and scholarship achieve an uneasy marriage – an entirely Graham Greene type distinction between 'entertainments' in the form of articles and serious comment in the form of books.

The best that can be said for this state of affairs is that it has liberated industrial design from the mandarins, that it has done much to break down the artificially constructed professional barriers with their codes of practices, that it has made the world aware that industrial design, even though it cannot be closely defined, is something which concerns it.

There remain certain peculiarly British ideas about industrial design that are fairly constant. One of these is the vague but widely felt belief that things to do with art and design are morally good. Another is that such things are on the whole of interest to a specialist few who may be identified possibly by an inability to play games or by a kind of rare sensitivity that singles them out from the majority. The first of these ideas probably results from a national conviction that things should be judged from a pragmatic point of view. (To the English Church of the seventeenth century it was a far simpler matter to put their Prayer Book into English than for the Roman Catholics to adopt the vernacular in 1965.) We have adopted with more ease than other countries, and without overt compulsion, odd disciplines like walking on the left-hand side of an escalator but standing on the right. In short, as long as good practical reasons can be shown, we do not involve ourselves in philosophical arguments and so tend to think of higher standards of industrial design in terms of common sense, on the one hand, and a protection of the public, on the other. We are less likely to involve ourselves in aesthetic arguments about industrial products although, possibly because of this, more likely to involve ourselves in aesthetic arguments on fine art, for we still retain in a modified way an entirely eighteenth-century distinction between reason and 'fancy'.

This distinction has important effects by creating a wide variety of reactions to industrial design. The Design Centre in London is visited by nearly 4,000 people each day and there they see a selection of modern British products and can consult Design Index – an illustrated catalogue ten times larger than the display. To some of those visitors the products seem too carefully selected and of a kind they do not wish to purchase, to others the selection standards are too low, cautious, and even clinical, but the majority of visitors find both the display and the Index a useful practical shopping-guide and almost certainly do not seek to analyse their own reactions. But the fact that some manufacturers and retailers find the selection standards too rigorous, and that some architects and designers express an opposite view, suggests that general statements about 'raising standards of design' depend more on individual ideas of received taste than on the absolute standards which are sometimes implied in the writings of those pioneers of modern design who felt much more assured of their objectives, who were convinced that industrial design could be assessed as connoisseurs assessed works of art, as some critics assessed the outside elevation of buildings – in short as mandarins and amateurs of art.

That tradition lingers on, and in any discussion of the social context of art it is necessary to admit the deeply felt British suspicion that things to do with art and design are for the few – so that the subject gets pushed into the jargon of élitist circles or into the indignant moralizing of do-gooders, and the huge consuming and producing population feels itself alientated, described as philistine and secretly sure that what it's really got is common sense.

Some people are upset to be told that they are the actual 'I know what I like' group, but to all intents and purposes that is just what they are. 'That's good design', they say. 'Who says?' – 'We do.' And that is quite unanswerable. As long as industrial design is equated or compared with art it will always be judged in this way.

If we are on the verge of new definitions it is first necessary to

see what exists now – in the cloudy and ill-defined area of doubt which is revealed by all who create or write about design. There is the question of taste. There is the question of technology. Thirdly, arising from both, is the question vaguely referred to as the quality of life. Each of these elements raises its own problems and each of them is capable of setting off a field of hares to be chased, caught, or reluctantly allowed to escape.

The question of taste suffered a nasty knock when the Pop movement swept first the world of art and then that of industrial design. For a long time in Anglo-Saxon countries Scandinavia had set the pace for many who were interested in industrial design. (In passing, it may be noted that the strong moral tone adopted by protagonists of good design is virtually an Anglo-Saxon phenomenon. To Latin nations industrial design for consumers is often an élitist thing and the best of it – now in Italy – lacks any puritan inhibition, is frankly for the rich, and reveals astonishingly high standards of finish and price – most obviously in the top end of car design.)

Scandinavian design in post-war years was to many eyes the result of carrying the Bauhaus inspiration to its logical conclusion and at the same time taking enormous pains to bring the quality of craftsmen to mass-produced objects and to exploit to the full the commercial advantages of selling furniture, cutlery, glassware, and pottery exquisitely made, well packed, and in its way unique. This was, and is, a conception of industrial design based on craftsmanship and on a logical consistency. Although 'style' is rightly a suspect word, there is no doubt that Scandinavian style was a recognizable thing – extending to a particular range of colours dictated as much by local light factors as by aesthetic judgement, to an austere neatness and clarity, to a certain severity, and, as always, to careful standards of manufacture.

To many, Scandinavian design was something you could bite on. It was not always understood that the colours and the wood were dictated by local needs and supplies rather than by a special dispensation of perception but, that apart, the ideals were quickly adopted. This was it – and it showed itself in some – but not all –

of the designs made for the Festival of Britain and subsequently. It was clearly at work in many American designs for machinery and computers, it moved into Germany but made much less impact in Spain, Italy, and France.

Then came the Pop movement and the alarm in some circles was evident. Could it be that those neo-Scandinavian designs really were clinical, chilly Anglo-Saxon artifacts with snow on their surfaces as some philistines had earlier suggested? Could it be that 'good' design now had to mean stamping Union Jacks on plates and zipping up cheap trays with red and blue? Could it be that the throw-away fun things qualified for admiration? What had happened to William Morris? What would the Bauhaus have made of it? Just to confuse things, learned articles appeared in the press seriously discussing the designs on Californian surf-boards, the neon lights of Las Vegas, and the number of badges on London beatniks' leather jackets. These things were dealt with in the same reverent tone that earlier critics had adopted for Loos, Wells Coates, and to other pioneers of modern design.

But it was not quite like that, for, although some people thought that this admiration meant that the age of 'anything goes' in design had arrived, a closer examination soon revealed that the same critics who were clapping their hands with joy at the new-found liberation were in fact busy cultivating the new taste: these were new attitudes but they had been invented by others and in spite of all the joy these attitudes were still concerned with taste, although some pretended that what had actually happened was a revolt against taste.

There was, however, one important difference. In the past most ideas of received taste had percolated down from one social group, usually the upper middle class, to the others. This time it was a classless movement: a kind of city folk-art which started among the poorer sections of society, but the immediate attempt of the *cognoscenti* to cash in on the scene was as quick and thorough as the commercially inspired manufacturers' and retailers' anxiety to start marketing the new merchandise.

That taste entered into it all is certain, and although superfici-

ally the brash and ornate consumer demands reflected in Carnaby Street were of the same kind as the lowest vulgar kind of unthinking taste, much despised by the proponents of good design, in fact they were far more self-consciously done. An analogy might be found in the difference between the stage version of *Oh! What a Lovely War* and a slick American musical comedy. The first had a classless air about it and looked spontaneous but in fact was the result of arduous rehearsal, but the typical American musical of recent years has managed to look like a computer job. Carefully rehearsed spontaneity certainly shows itself in the mini-maxi fashions of the young and, incidentally, in the complicated recording techniques used to produce many chart-placed discs.

Some people today would like to claim that taste as a criterion of industrial design is no longer acceptable. To others, the avoidance of taste means that there is no longer anything to work towards. Both are extreme views and the former seem to have forgotten that there have been many versions of Pop Art before, which came and went, among them a fashion in France during the twenties for *le goût concierge*. Proponents of good taste, however, will always seek a recognizable standard, and they will not be put off their search simply because at some moment of time a kind of anarchy prevails. In one important sense they have both tradition and commonsense on their side: tradition because, throughout the history of Western man, questions of taste have dominated the production of objects whether for ornament or function, and commonsense because it is reasonable to presume that within any particular mode or fashion there are some designers who will aspire to and achieve heights of creative ability which single them out. For the advocates of good taste most of the Pop art 'anti-taste' attitudes are paradoxically the best advertisement.

But before leaving this question, it must be pointed out that, as society struggles hard to escape class distinctions, so it becomes increasingly antagonistic to any idea that any one group's notion of 'good taste' can apply to all people. Just as egalitarianism has even led some students to advocate the abolition of degree classes, so they dislike any suggestion that good taste is only recognized

by a handful of people. In short, we now must accept that taste depends on many factors – not least the social background of those who judge, who have now ceased to be an identifiable section of society.

The influence of technology has clearly always been of vital importance to industrial design. In spite of their art-orientated origin, the words themselves automatically imply a dependence upon materials, engineering, and production. But in recent years the rapid increase in technological achievement has re-emphasized the unfortunate and unhappy divisions that arose in the nineteenth century between those who knew how a thing worked and those who thought they knew what it ought to look like. Industrial design – in the terms that for some fifty years it has been understood – concentrated on appearance but added to that the more important factor of human needs. Thus the industrial-design aspects of machine-tool design are taken to mean both the overall appearance of the hardware and those aspects of its design which concern the operator – his comfort, the ease with which he can reach and understand the controls, and even the psychological effects of the machine upon him. The engineering design is taken to cover all the other functional and mechanical aspects of the machine.

Today, that rigid compartmentalizing is obviously outdated and the present intentions of replacing the twenty-five-year-old Council of Industrial Design with a Design Council that would embrace both engineering and industrial design marks an important and official step towards ending an unnecessary and positively harmful division of responsibility. For it is now clear that all the factors involved in industrial design lead to the inescapable conclusion that products should be designed, produced, and marketed as the result of teamwork between all those involved. If the specialist techniques were not so complicated it might be possible for the engineer to acquire the expertise of the industrial designer or vice versa, but that may be hoping for too much. What, however, is a present necessity is for each to recognize the other's contribution and, above that, for each person involved to ask a

number of radical questions before embarking on a project that may lead to the production of many thousands of objects, whether they are in the consumer or the capital-goods markets.

But the effects of technology have been more far-reaching than this, particularly in Western society. On the one hand there are those who see in it the salvation of mankind: his liberation from drudgery; his ability to predict his needs through refined computerized systems methods and a consequent radical relook at how we live. Do we need offices or could we work at home with elaborate communication systems? Do we need fixed homes or should we nightly pitch our moving living-pod to a plug-in city? Should the city be designed or redesigned for the car or the car for the city?

Such questions and many more profound theories occupy the minds of a lively group of futurists in Britain and America. To them, many of the protests made about modern technology are at too low a level – not least the preservation of buildings and the conservation of older ways of living. For them, the gasoline station has replaced the cathedral as the nucleus of urban living.

But side by side with these lively, and literally forward-looking attitudes there has grown up a vociferous demand that we should examine the pollution, the chaos, the ugliness, the brashness of so much modern living. Often these protests come from those who believe in taste, but also from scientists who view with alarm the unthinking headlong rush to apply each piece of knowledge and each discovery without considering its results. So we find American professors hoping in some vague way that the underdeveloped nations will not pass through industrial society but will emerge into post-industrial society by leaping over the chaos that Western nations have created. It is a forlorn hope, but the efforts of those who wish to propagate intermediate technology deserve attention. They are doing a greater service than the conservers and preservationists, who often talk as if there was a golden age way back in the past, and they do not mean Eden – more often they are looking to the eighteenth century.

Technology coupled with mass-production and mass-

distribution methods obviously influences industrial design and has led many people to abandon the conception of those words as meaning anything other than 'industrial production'. Certainly less confusion might have resulted from avoiding all distinctions between function, appearance, and purpose. To have seen industrial design as a process rather than as the production of artifacts might have helped avoid such curious contradictions as motor-car pollution both physically and chemically in cities. It might have led to properly planned systems of supersonic aircraft, and the unloading and loading and ground transportation of passengers from jumbo-jets. It might have rationalized domestic heating systems, created many industrially-produced buildings, encouraged radical and disposable and inflatable solutions to many problems, instead of allowing so many of these decisions to be the focus of too much debate and too many defended positions.

The compartments into which the sociologist, the engineer, and the industrial designer have shut themselves are now revealing themselves to cause dangerous isolationism; and probably architects have realized quicker than most that their concern for 'professionalism' may have been an error when they are now so closely involved with engineers and, increasingly, with a vociferous public clamouring for participation.

But as far as industrial products are concerned, technology has led to the way of making quantitative judgements in place of subjective 'I know what I like' assessments. Today those criteria which for long bedevilled the subject – taste, amenity, appearance – can only be considered after the factual analysis has been made. Ergonomics, strength of materials, durability, maintenance and cost factors are rightly examined even in comparatively humble products, and the work of the Council of Industrial Design and of two national consumer protection societies has played a part in achieving this. The consumer needs to be aware of qualities which in the past he might have taken on trust.

For side by side with the increasing realization that design is not a 'way-out' activity to be shared by a few, has developed a closer appreciation of measurable elements. In the past, many

people would have judged the products of mass manufacture much as they would have examined *objets d'art* in a museum. They would not have had the benefit of the years of research that have been, and are now being, undertaken into user requirements and needs, and they would have been without the results of studies in standards, particularly as they affect anthropometric needs; for increasingly what are known as the ergonomic elements in design have become an essential factor in making an assessment. Thus judgements must be based, first, on whether a product works in the functional sense; second, on whether it works in terms of the psychological and physiological needs of the user, or, in the case of a machine, the operator; third, on a consideration of the material out of which the product has been made; fourth on a consideration of the cost. Only when all these factual elements have been assessed is it possible to make a subjective judgement on its appearance. That judgement will be as subjective as ever it was and individual opinions will vary, but as industrial design comes to depend more on advances in technology and on the sensible use of new materials, so the measurable elements in an assessment increase and to some extent the subjective elements decrease. It will not necessarily solve the problem of choosing a textile, but since ours is not a totalitarian system, it remains desirable that there should be a wide range of choice, and to shirk the subjective judgement is in fact to suggest that there are absolute standards of industrial design. All that can be hoped for is that, in making subjective judgements, neither the manufacturer nor the user will base judgements on personal opinions until they have assessed those elements which can be measured.

Similarly, more attention is now being paid to scientific principles as they may affect graphic design, for hitherto judgements on graphic design have frequently been arbitrary and purely subjective and yet there is here a wide field for research into legibility factors, identity factors (what does the eye single out in a single letter?), in sizes, typefaces, and colours. It seems likely, therefore, that as more research is undertaken into what may be called the quantitative elements of design, the area for subjective

disagreement will grow smaller but will be none the less conten-
tious. It is too much to hope that at the moment these considera-
tions are widely understood by the public at large, but they are
certainly more and more understood by industrialists who are
correspondingly less inclined to make arbitrary decisions without
the facts and without discussion with designers.

The third question which all discussions on design seem to
raise is that which politicians are now promising to all who vote
for them – 'the quality of life'. Like definitions of design, there is
so much doubt about the phrase that anybody using it is almost
certainly conjuring up his own answer.

It has already been said that industrial design, as understood
in this country, embraces practically the whole of industrial
production, and it is also true that it takes account of some
elements of architecture, particularly interior design, and some
elements of civil engineering – for example in the layout of under-
ground railway systems. Industrial design is, therefore, by its
very nature part of the social context, although it may not always
be consciously understood in this way. The suburban housewife
flicking through the pages of *Vogue* is willy-nilly making design
assessments, and her husband strap-hanging in the underground
is forced to consider certain aspects of design, although he might
be surprised to hear them described as such. Design of this kind
affects all individuals most of the time. Although they may be
more conscious of this when they act as shoppers or contract pur-
chasers on behalf of other people, they are in fact making hundreds
of design judgements every day, often when they are frustrated by
design deficiencies. Thus industrial design is something at the
centre of life and poses very different problems from the influences
of fine art. However desirable it may be that people should learn
to appreciate the benefits of painting and sculpture, the majority
will not be so easily convinced of their value because they do not
see these things as an essential part of their lives. When these same
people have to consider heating appliances for their own houses
and chairs which they will have to sit in for ten years or more,
they are immediately struck by the practical nature of the decisions

that confront them. It is not with any starry-eyed consideration of 'the good life', or with any feeling that there is something thrilling about making aesthetic decisions, that they make their choice.

In one way or another, therefore, design decisions creep into most people's lives. The more conscious they are of the factors involved, the better their judgements and decisions will be. They cannot avoid the decisions, nor can they pass them to somebody else, and in this respect industrial design differs from architecture. In architecture a client provides a brief almost always for a single building; in industrial design the manufacturer provides a brief almost always for mass production. In other words, the design decisions that are taken affect not just one client but potentially the whole of the shopping public and because of this the most complicated problems occur. The nature of mass production ensures that the designer, who by his training will wish to adopt high standards, must take account of marketing considerations. He cannot work in a vacuum. He differs markedly from the sculptor in his studio, for decisions that he takes today may affect millions of people.

Clearly, one of the dangers of mass production is that it will result in a boring succession of standardized products. This danger was recognized very early by Gropius at the Bauhaus, and its possibility is increased today by the fact that prefabricated buildings will possibly be equipped with prefabricated furniture units. The problem is, therefore, to avoid so much standardization that individual choice is restricted to limits that will be found intolerable. The designer does not regard this problem as a defeat but as a challenge. He could all too easily try to escape from the effects of mass production, but to do so would be to commit intellectual suicide, for, however much mass production and prefabrication may be deplored, the fact remains that they are here to stay for the foreseeable future. It is, therefore, all the more important that the designer's contribution takes account of people's needs.

Many of the criticisms made about modern design contain

words like 'clinical', 'cold', 'austere', and this is possibly because designers have sometimes been too anxious to regard the product as a personal contribution, so personal that it has ceased to be of use to those for whom it is intended. As a writer in the magazine *Design* has pointed out (Saltmarsh 1965), it was once fashionable for design-minded people to make jokes about electric-log fires, but it is possible that in many better designs for heating appliances the psychological needs of the user have been ignored. The electric logs were fulfilling a need not fulfilled by more sensible appliances.

This simple example does, however, draw attention to the important fact that man as a consumer is vitally linked in Western society with industrial production. He has a right to be heard: he has a need to be understood. Relatively few people can commission their own architecture, but nearly all have to make choices about products. If they make a certain choice – for example that all families will have two cars – they at once start a chain reaction of other design problems. They create traffic: they need more roads.

If they all decide to abandon high-rise high-density housing, they require new solutions to town-planning. The interdependence of these choices is seldom understood and there are times when the easily predicted results still come as surprises to those who should know better. But discussions on the quality of life are full of pitfalls. There is a large number of critics today busily lamenting the modern city in architectural and industrial terms. The motor-cars, the street furniture, the offices, the flats, the gadgets, the noise, the hurly-burly are all decried. A surprising number of these critics cheerfully go on lamenting these things from their comfortable flats in the down-town area of the world's cities and nothing on earth would make them move to the country, where, among other things, their means of communication would be too limited: their message just would not be heard.

Sometimes it seems that all this is merely a question of age. To those who remember with a deep romantic feeling what they believed to be a calmer, more elegant life – maybe back in 1910 or

even later – there is something shocking about preservationists trying to protect buildings and bridges which in their day they were trying to have pulled down. The disciples of taste now discover that graphic designs they lamented in their youth are at the peak of fashionable acclaim today. It has even been said that there is a need to restore 'lyricism' to life, as if the neon lights, the sun glinting on cars, the hooting of horns, the throbbing of transistor radios, the telephone, the television, the washing-up machine, and children's mechanical toys did not possess a magic of their own.

Another school of thought looks at the modern shops on the Left Bank in Paris, sees furniture, pottery, and textiles at fine-art prices, and assumes that the quality of life would be enhanced if all homes had these things. The élitist view is the most difficult of all because it is quite unlikely to be achieved except by the rich. One of the most obvious factors in the design of consumer goods is that it depends on acceptance, and in capitalist system that means on market acceptance.

Here there is a real dilemma, because the operation of a free market system first exposes the consumer to a welter of objects which he may not actually want and secondly forces the most conscientious industrial designer to consider factors which he may find distasteful. Whether he likes it or not, the designer in the Western world is a servant of the system. He can protest about it; he can demand integrity, moral purpose, and higher ideals, but in the last resort he either lives or starves. It is not so easy for those involved in industrial production to decline work as a limited number of architects is still able to do. It is certainly absurd for designers in industry to pretend that they can 'do their own thing' and always get paid for it.

In America this has never been so much of a problem for the industrial designers, and indeed the engineering designers have accepted without too much philosophy that they are as much part of the sales force and the marketing team as they are of the production team, and much less philistine than some would like to believe. In Europe it is different. In Italy one or two large

companies have patronized industrial designers in return for some services rendered but allowed them considerable freedom to experiment, but it is a paternalistic approach and unlikely to become a pattern throughout the Western world. In Britain industrial desingers are still uneasily poised between the desire to create a 'profession' on architect lines and the realistic assumption that in fact they are part of industry and, with the exception of a few craftsmen, might do better to acknowledge the situation. In Scandinavia industrial designers are still named, acknowledged, and admired but rather in the way that fine artists are in other countries.

Engineering designers suffer similar problems. In France, for example, they are highly regarded. In Britain only a few achieve proper acknowledgement, and the majority are concerned about their status. As we move towards broader definitions of industrial design, it seems certain that all designers must face the possibility that the anonymity of teamwork will be their most likely fate. But in questions which concern the quality of life and the important possibility of radical change remains open to all designers. In the free market systems some things are wrong. In some parts of America it looks as though concentration of private enterprise has starved the public sector. Late in the day some American cities are discovering that design in the public sector – in transport, state housing, and medical care – is far too scarce, piecemeal, and unplanned.

In Britain there is a more reasonable balance between private and public enterprise, and, in spite of odd class-conscious inhibitions, the public sector has often led the way – in housing, in domestic appliances, in transport, in medical equipment, in government-sponsored research and development programmes. This has resulted in a noticeable increase of public participation and in the future the consumer will certainly want to say more about his needs, as far as he understands them. In a free-enterprise or mixed economy this could lead to more acceptable design solutions. There is so far no evidence that state-controlled systems can produce industrially designed products to better standards –

oddly enough, Eastern European countries all too often painfully imitate yesterday's Western products – but all the countries of the world face the same basic problems and crudely – but without any implication of taste – the question remains: 'What, oh what, is good design?'

So now it becomes necessary to attempt to assess whether there is or is not any clear definition of industrial design that makes sense or is likely to make sense in the future. 'Man', say the conservers and the anti-pollutionists, 'has become very clever but is still not very wise.' If they are right, and all the evidence is on their side, those who are in any way involved in industrial production carry enormous responsibilities – far greater than the basic aims of consumer protection societies and yet embracing those aims of safety, efficiency, and reasonable cost. If industrial design can in the future be considered not only as the process by which all products are conceived, produced, and distributed but also as embracing the interdependence of all those products on one another and hence on people, it will have gone a long way to rid itself of the narrow and do-goodery attitudes with which it has for too long been lumbered.

If designers, and in particular those who in the future will call themselves industrial designers, would more often concern themselves with asking the question Why? as well as the simpler How? they could do much to impress on industrial producers the true nature of the responsibilities they carry – responsibilities which affect millions of people, which contain the possibility of easing world poverty, world hunger, and world neurosis, but all too often make all those things worse.

There is no going back to imaginary golden ages: the élitist and mandarin approach, whether it is directed towards the expensive or the throw-away end of industrial design, is always a limited attitude, inward-looking and inclined to assume that what it finds attractive today the others will have tomorrow ('Do your own coterie thing'?). Strong Anglo-Saxon moral purpose is probably misplaced: it is realism and humanity that count and moral purpose can too often lead to dogmatic assumptions that

hold back changes and create either false adulation of technology or worship of hand-made objects.

Designers on their own, of course, cannot alter the situation for, as Sir Gordon Russell (1965) has written, 'unless they are men able to appreciate the broader implications of their work and the work of others, changes will be made on a haphazard basis and the environment will be one of the worst sufferers from any piecemeal development. Equally, unless there are deep enough roots of appreciation and understanding throughout society, any attempt to achieve higher standards will be meaningless.'

REFERENCES

Economist, The. 1964. Article, 26 December.

ICSID. 1965. Report of a seminar of industrial designers organized under UNESCO by the International Council of Societies of Industrial Design.

PEVSNER, SIR NIKOLAUS. 1960. *Pioneers of Modern Design.* Harmondsworth: Penguin Books.

RUSSELL, SIR GORDON. 1965. *The Architectural Review*, August, p. 89.

SALTMARSH, J. A. 1965. Investigating the consumer. *Design*, November, pp. 53–4.

STANLEY REED

The film-maker and the audience

The struggle waged by poets, painters, and composers with the critical establishment of their day, with their patrons, and with the public is a familiar theme in the biographies of artists of most periods. Mozart defies his Archbishop, to the dismay of his father, Schoenberg overprints his concert tickets with insults, Blake wages ceaseless war on the philistines, Whistler throws his pot of paint in the public face, and Manet outrages the frock-coated by bringing a nude to the picnic. The dilemma of the artist was summed up by Peter Ustinov when he remarked that the dealers doubtless told Leonardo, 'Stick to that smile, Leo – they like that'.

The dilemma is particularly acute for artists working in the mass media, above all the cinema. There are several reasons for this. The film-maker, like other artists, needs to be free to establish his own disciplines to realize a personal conception; but he works with elaborate and expensive tools, and must depend on commercial patronage to provide them. Further, his art is a collective one, with creative contributions probably more genuinely shared than in the other performing arts, say theatre, or even opera, so that he is dependent on talents other than his own. The question who is the 'author' of a particular film, as for example between the writer and the director, is often a nice one. Finally – and here lies the root of his dilemma – he works for an audience immensely larger than that with which any previous

artist, or the artist working in any other field today, even including television, is confronted. Moreover to call this a 'mass audience', as though it were one man multiplied many times, begs the most important question confronting the film-maker, for the mass audience ranges over virtually all ages, is drawn from a wide variety of classes, cultures, and degrees of education, and speaks a hundred languages. Worst of all, it is an almost anonymous audience; and such inklings of its reaction as the film-maker obtains are either hopelessly untypical and misleading, as in the case of the critics or personal acquaintances, or come in fragmented and imprecise form over a considerable period of time by way of the box-office returns, which indicate no more than an overall response for or against and leave the film-maker to guess at the reasons.

The strong commercial orientation of the feature film industry, the sector in which most original and creative film-makers aim to work, is so formidable for the artist that its operation needs to be explored. Without the patronage of commerce and enough public success to ensure its continuance, the film-maker cannot go on working, and although it might be held that in the last analysis the same is true of most artists in other fields, the threat is in no other case so immediate and so compelling as to the man who wants to make feature films. The poet or novelist may starve – in practice no longer very likely – but with the rarest police-state exceptions can hardly be stopped from writing. So too with the painter. The composer may waste his best energies in teaching, or providing jingles and background music for television, his serious works may never be performed, but no-one is likely to stop his composing them, any more than the dramatist is prevented from writing plays that no one will perform. But the case of the film-makers is more extreme, as a brief consideration of the circumstances in which a feature film comes to be made will make clear.

A major feature film today may cost, say, half a million pounds in Britain, rather less on the continent, more in America. Some films, as their promoters proudly proclaim, cost a great deal more; on the other hand, a good many cost less and many directors

would happily work with smaller budgets, in exchange for more freedom in operation, perhaps in the matter of choice of actors and more flexible union practices; but despite occasional and quite exceptional instances of feature films made for £15,000 or £50,000, or some other figure sensationally modest enough to catch a journalist's eye, it cannot be sensibly denied that the normal cost of a feature film made in commercial circumstances and with any hope of a successful launching on the world market is certain to be reckoned in hundreds of thousands of pounds. Few directors can themselves command this sort of money, nor indeed can many producers outside the American majors and the state-financed industries of the communist countries. Most independent producers themselves borrow money, or resort to a consortium of interests. Either way the director, writer, or writer/director, is at the mercy of those who put up the money, and who almost inevitably want to have a say in the way in which it is to be spent. Changes may be called for, in the script, in the location, in the cast; the director may not be free to pick his own technicians, or he may find himself saddled with an unsympathetic producer. The film-maker must decide whether or not to accept these demands: he usually fights for an acceptable compromise, rather than abandon his chance of making the film, but he fights with no ultimate weapon, for although he can say no, only those who command the finance can say yes. The decision is final; the defeated film-maker cannot retire to his garret, poet-fashion, for without a studio, apparatus, staff, and money he is as helpless as a poet without a pen or a painter without paint.

The situation of the artist, as so far described, seems a classic one: the creative genius, forced to earn a living, seeks patronage, which from stupidity or commercial caution may be denied him. Seen thus, the picture is incomplete and less than fair to the commercial backers, whose problems deserve also to be examined. For the men in the film industries of the world who say yea or nay are not in the position of Renaissance Popes or eighteenth-century aristocratic patrons, concerned only to have produced and to own beautiful objects by fine artists, for prestige or personal

pleasure. They can finance nothing for its own sake, or for the gratifications of patronage; they are engaged in making an investment of other people's money in an extremely risky and unpredictable business. Given good luck and judgement, they may achieve a fair proportion of successes – a picture which the public takes to its heart can earn fabulous profits – so that they can afford, and must expect, a number of failures. Money-men in the film business are apt to point out, with more or less truth, that they finance four or five losers for every winner that comes up. But to invite failure by taking bigger risks than those which normally beset this chancy business is likely to bring one's career, and perhaps one's company, to a disastrous end.

The fact is that the investor, no less than the creative artist, lives or dies by the whim of the mass audience. The dilemma of the artist derives only in minor part from the obduracy or greed of his commercial sponsors, although there are plenty of stupid and grasping men in the film business; the villain, if villain there is, lurks behind the front office in the form of that many-headed multi-tongued monster, the world cinema audience.

Until the present century few artists in any field could count their audience in millions. True, the great geniuses, Dante, Shakespeare, Beethoven, and many lesser men have got through to many millions over the years, but they did not depend on this audience in their lifetimes. Success or failure for them depended on a few thousands, fairly homogeneous in kind. Eighteenth-century composers wrote for people ranging from skilled amateur musicians to fashionable chatterers, but in terms of social, educational, and cultural experience they were roughly of a kind. Shakespeare, Sheridan, and Shaw wrote for audiences of one nationality and a common culture. The Renaissance painters, the Netherlanders, the nineteenth-century French, even the painters of today, expect to interest only a quite small minority of like-minded people, and though they may have challenged the traditions of their time, at least those traditions were shared with those to whom the challenge was addressed. These bridges, links of common culture and interests, scarcely exist for the makers of

commercial feature films, who operate of necessity in a world market, for few feature films can be expected to recover their costs within their countries of origin. The ubiquitousness of the American cinema, whose social and political consequences cannot yet be appreciated in their historical perspectives, is a twentieth-century phenomenon; other countries of smaller ambition and resources can afford even less to ignore the world market. Feature film-making, for simple economic reasons, is of necessity international. It has been estimated that *The Bridge over the River Kwai* was seen by over three hundred million people in practically every country of the world, and other films have probably exceeded this total. Such films must have certain qualities of universal appeal, and it is as fascinating as it is hopeless to try to identify them: in the present state of our knowledge these qualities are too subtle and elusive for scientific isolation and test, for we must bear in mind that what might seem to be the obvious staples of popular entertainment, such as sex, violence, identification with glamour, luxury and success, the triumph of the under-dog, and so on, are present in hundreds of films, of which only a few, apparently selected by caprice, capture the imagination and the cash of the world audience. The men in the business have little but instinct to guide them: try as they will, and do, the formula remains as elusive as ever and he who discovers it will rapidly become the richest man on earth.

Until the dawn of that alarming day, the film-makers and film moguls have to be content to examine the returns and speculate. Wardour Street men talk of hunches, of flair, of having a nose; more often, they admit ruefully that they will never understand the public. They are at last beginning systematically to compile information and statistics, but in spite of the consumer research, the psychological consultants, and the computers, the instinct of the impresario, though pathetically inadequate, probably remains the best touchstone of public taste.

The chain of cause and effect which leads from the seemingly fickle tastes of a public embracing Paris or New York sophisticates, factory workers in Stoke-on-Trent, and African farm labourers,

to the decision of an American producer to make or not to make a particular movie need not be followed through in detail. Between the customer at the cinema and the producer come one or more distributors, the wholesalers of the film trade, and the exhibitors. The machinery which brings the films to the public is of interest in our present consideration only in so far as the fact that distributors and exhibitors have a financial stake in the success or failure of films induces them to demand a say in the sort of films made. The distributor, particularly in countries such as Britain where the success of a film depends very much on the willingness of one or other of the 'circuit bookers' to play it in the chain of houses for which he is responsible, can play a major part in the discussions which precede the making of a feature film. Where the circuits are strong, a distribution guarantee is a virtual necessity before finance can be raised for a native production. State bodies, too, such as the National Film Finance Corporation in Britain, who are frequently approached for 'end money', can also influence decisions, as also in varying degrees in various countries can censorship offices. Thus the creative artist, armed with his idea, his talent, a script, and probably a tentative cast list, goes into battle not with one man, but several. The pressures are cumulative, but all stem from the same basic cause, a concern with the likely public reaction to the film proposed for them: whatever the errors or the timidities of commercial or governmental intermediaries, in the end the film-maker faces his public, a vast conglomerate audience, unpredictable and largely unknown.

In seeking to come to terms with his audience, the film-maker, who may be fired by an inner vision or, at the other end of the scale, may merely be looking for a fat living, reacts variously to the challenge. Some go frankly commercial, making routine pictures to tried formulae, leaning on their stars, attractive locations, glittering sets, one or other of the half-dozen age-old stories, and the current set of clichés. The basic trick, as in most popular entertainment, is to give the familiar a new twist. Thus, for example, staple boy-meets-girl, which served the unsophisticated early cinema for a decade or two, was given a new

twist when Frank Capra made *It Happened One Night* in the thirties. In Capra's picture boy (Gable) met girl (Colbert), but did not fall in love. Boy hated girl, girl hated boy: they fought all through the picture, until love finally overcame in the good old-fashioned way and led to the good old-fashioned clinch. The formula was scarcely new; it was *Much Ado* in modern dress, with ancestors going back to Greece and beyond, but it suddenly caught the fancy of the cinema audience. The amendment, as it were, became the substantive and the cinema had a new formula which still flourishes. Such formula-based films are not by any means all bad; they can be very good of their kind, even brilliant, as was *It Happened One Night*. Nor, of course, do they constitute a clearly defined category, but show widely differing degrees of originality, inventiveness, and style, sometimes moving indisput-ably, even if unwittingly, into the territory of art. If they have a common characteristic it is in consciously playing safe, in so far as the hazardous entertainment business permits; they go for predictable responses and count heavily on packaging, that is a glossy exterior and brand names.

At the other extreme are film-makers who consciously with-draw from their audience as far as their strength of will permits; some claim, I have no doubt with complete sincerity, that they are utterly indifferent to the spectator, but it is improbable that any film-maker, in shaping a scene, in recording a line of dialogue or a gesture, can entirely exclude from his mind the expected reaction of those who will ultimately see the film on the screen. Nevertheless, there certainly are film-makers, of whom Robert Bresson is perhaps the supreme example, who work with almost complete detachment. Bresson is capable, for instance in *Journal d'un Curé de Campagne*, of shooting whole scenes, in this case, if I recall aright, a scene in which the young curé faces his parishioners in church and another in which he is called to account before his superiors, which would undoubtedly have seemed to most audiences the dramatic highlights of the film, and then of deliber-ately rejecting them because, in his words, 'they did not fit in with the action'.

To state the two extremes is not to condemn either. The concentration of artists like Bresson on their work, to the virtual exclusion of audience considerations, in no way implies arrogance or contempt for the people on whom they ultimately depend; on the contrary it may reflect a deep faith in the audience, a respect for its judgement, and an unwillingness to seek deliberately to influence it. Contempt for the audience is more likely to be found among those whose ideal is 'to give them what they want'. On the other hand, those film-makers who work with the image of the mass audience constantly in their minds are not necessarily to be dismissed as opportunists. They may be talented men with a genuine and shared delight in the response of the mass audience, such as the breed of accomplished and intelligent film men who kept Hollywood in the forefront for decades; they also include some of the very greatest men of the cinema, Griffiths, Ince, Mack Sennett, Keaton, Chaplin, and John Ford, who created new forms and carried them triumphantly to mass audiences all over the world.

This tyranny of the audience over the artist may not be new, and is less acute for artists working in most other fields than those of cinema and television, but it is nevertheless a central problem in any contemporary discussion of the function of art. Whatever the political and moral recessions of the turbulent twentieth century, the common man matters a great deal more than he ever has before; by and large he is better educated and has more leisure than in previous centuries. Moreover, thanks to advances in communication which amount to a revolution, millions of people are willy-nilly becoming connoisseurs of some forms of art, although not always thought of as art by those who absorb them, through simple familiarity. Art must always adjust itself to the developing social scene and today almost all artists are aware, though often only dimly and uncomfortably, of new and larger obligations. Society itself is also aware of these obligations, and the need to bring art to the people has become a commonplace, so that practically all governments make some efforts, on widely varying scales and from motives of varying purity, to achieve

this. The true nature of the problem, in my view, is too little examined and understood, and the methods used hopelessly enmeshed in thinking of earlier centuries and societies, but awareness of responsibility persists and grows. Artists themselves, except for those working in the rough and tumble of the entertainment business, rarely confront the problem squarely, or think out their own position. There are notable exceptions. Guillaume Apollinaire talked in the early days of the century of the 'need to reconcile art and the people' and prophesied that Marcel Duchamp would do it. The prophecy has not been fulfilled; Duchamp virtually abandoned art in 1923 in favour of chess and his name is unknown to the man in the street. But it was a perceptive remark, none the less, as the recent explosion of Neo-Dada and Pop Art, both highly derivative from Duchamp, shows. While it must be admitted that these artists, like Duchamp himself, have failed almost utterly to break through to the public, from whom they are at least as remote as their counterparts of earlier periods, they are perhaps thinking harder and more fundamentally than almost anyone else about the role of art in the twentieth century. Their failure only emphasizes the difficulty of the problem. Marcel Duchamp is at the centre of the argument, for that remarkable man, having made his derisive gestures against traditional European art and culture, producing his 'readymades', the fish slice, the hat racks, and the china urinal signed 'R. Mutt', in evidence of his belief that the object is more important than the artist, went on to argue that the spectator is more important too. So far from being the mere customer at the end of the production line, the spectator plays a vital part in the creative process, more important than that of the artist himself. For it is the audience, said Duchamp, that 'completes the cycle'. The artist is no more than a useful medium, scarcely aware of what he does; the work of art is meaningless until the spectator has interpreted it. He will, interpret it, of course, according to what he brings to the task, and this is the final creative act. 'It is posterity,' said Duchamp, 'that makes masterpieces.'

Duchamp's view of the artist as a 'medium' seems to be in

harmony with the attitude of those who, like Bresson, seek to ignore the audience as irrelevant to their part in creating the work, their concern being with the truth of the work to their revelation, not with the interpretation of it by the audience. But the film-maker is again caught in the extremes of this dilemma. Because he has to satisfy his audiences or fail, because irresistible commercial pressures ceaselessly push him towards giving the audience what it is believed to want, or at all events no more than it can be expected to take, he finds it peculiarly difficult to work in the pure isolation of the artist solely committed to the art object he is producing. On the other hand, he has little real communication with his audience, made up as it is of so many races and cultures, so many degrees of poverty or affluence, of education or ignorance, so many conflicting hates and loves and prejudices; it is overwhelming. He may be forgiven for feeling that there is only one thing to do; forget the audience, not from principle, but out of despair. He cannot be looking over his shoulder all the time.

Most film-makers, other than commercial hacks (of whom there are fewer than is often supposed) take a middle-of-the-road position; they neither ignore the audience nor capitulate to it. They could have no better apologist than Jean Renoir, talking to a National Film Theatre audience in 1967, who said:

If you want to persuade the public to accept a new point of view, to share in a discovery, you have to play the part of a prostitute, to put on a bit of make-up in order to attract . . . she may be wonderful inside, but if she doesn't put on a bit of make-up no one will follow her . . . you have to be a little bit dishonest, you have to give something the public will follow.

Ambivalent and disturbing to the puritan conscience as the tactic advocated by Renoir may seem, it can surely be argued that the cinema denies itself if it spurns the mass audience; its strength lies in its pervasiveness and wide acceptance by those for whom the traditional arts have no attraction. As art it must challenge,

136

and its challenge is addressed not to a minority élite, but to the public at large, who cannot be expected to follow into entirely uncharted lands. One might venture the generalization that the artist must work within forms sufficiently familiar to his audience for them not to be distracted from what is being said. If forms have to be modified they should not be too abruptly and impatiently changed. Russian experience in the early years of the Revolution, when art was thrown into the melting-pot with everything else, and the disillusion and tragic reaction which followed, has its lesson. But conservatism will not do either, for there are times when the public is ready for a breakthrough. Indeed, the unpredictability of the cinema audience can probably be traced to changing and developing tastes not revealed by the box office until something new suddenly and often dramatically uncovers a new, unsuspected vein of interest. At such times the audience may be ahead of the artists, or such of them as they are allowed to know. *The Birth of a Nation* came at such a time, and was the first great breakthrough to the mass audience, on a scale commensurate with the potential of the cinema, in its history. The gangster pictures of the early thirties were a breakthrough. Richard Lester's Beatles films were a breakthrough. So were *Room at the Top* and *Saturday Night and Sunday Morning*. So was *Bonnie and Clyde*. But not every film can take its audience forward with a bound, and the artist who counts his audience in tens of millions must know by a sort of instinct just how far he can go at any time and when the audience is ready for the next leap. In periods of equilibrium he can resort without damaging compromise to established forms. Perhaps his most certain device is that of telling a story. The story must be a good one, but does not have to be original. *Bonnie and Clyde*, though uncomfortably contemporary in its implications, is only a sort of *Romeo and Juliet*, and *Romeo and Juliet* in turn has many ancestors. But the story must be told well; it has to be respected.

The device, commonly used by dramatists and novelists, of letting a story work at two levels, is no less valuable in the cinema than in these other arts. Shakespeare used the trick

almost habitually; so did Swift, and so, of course, did Jesus Christ. Bergman, Antonioni, and Renoir all work in this way. Carl Foreman's *High Noon* was intended to be taken at two levels, as also was that other fine Western *3.10 to Yuma*. Playwrights on stage and television frequently employ this sort of two-pronged attack. The films of Bresson, the most perfect works, in my view, the cinema has yet produced, are parables almost in the Biblical manner, although more complex and enigmatical, more ambiguous.

One other generalization may be made on this problem of carrying ideas and new experiences to the popular audience. It is sometimes not that the audience cannot understand, but that they have become confused by the conventions of popular entertainment, by the stereotypes and clichés, so that what happens in a film is judged not by its truth or probability, but by what they have come to expect will happen in any given set of circumstances. It is not that the artist is saying something beyond their comprehension and experience, or remote from their daily concerns, but that they become unable to connect art and life. To the ordinary cinemagoer, a film is one thing, life another, and different codes and conventions of behaviour apply to each. It was Rauschenberg who said that the artist is not concerned with art or with life, but with 'the gap between the two'. Nor is art alone to blame for this confusion and misdirection. The habit of seeing things in cliché comes of course not only from entertainment in the cinema and on television, but from journalism and advertising, from ritualistic attitudes among parents, churchmen, and social groups, and from bad education. 'We are surrounded by clichés,' said Jean Renoir in the speech quoted above, 'and we each have a little chest of drawers with an answer to a question in each drawer.'

If bad education, like bad art, does harm, might not good education, allied to good art, do good? Can the teacher help? Formal education towards a fuller awareness and enjoyment of art is a task from which it is easy to shy away, and of whose results it is easy to be sceptical. There are those in the film trade, though fewer than there used to be, who frankly do not want a more

discriminating audience; they want a solid mass audience, with a common denominator of taste, and damn the minorities. At the other end of the scale are the élite-conscious intellectuals and aesthetes, who believe in a sort of artistic predestination; either you are capable of appreciation, or you are not. Conveniently forgetting their own usually privileged childhood environment, they disdain artistic education for others. For my part, I believe in it profoundly. It is true that education in appreciation of art, in the wrong hands, can become unbearably priggish and patronizing, like poetry in pubs. But I believe that the educators have a responsibility to the mass cinema and television audience, first to bring as wide a range of films, particularly important films of past decades, to as many people as possible; and, second, to do what can be done, within the framework of formal education, to help people to understand them. It is not a matter of explaining to a child in school what a film-maker is saying, much less of telling him, 'this is good; this is bad'. It is a matter of engaging his interest in what he might otherwise have passed by. We are back with Apollinaire's need 'to reconcile art and the people'. Jim Dine, who affixes objects such as a bath shower to his canvas and paints the water coming out, says he wants 'to make them aware, without handing it to them'. Most good teachers would accept the dictum. But David Wark Griffith put it best. 'My object,' he said, 'is to teach you to see'.

As far as our school system is concerned, progress is lamentably slow, despite much valuable small-scale experiment by adventurous teachers. In the seventies, when the nation spends much of its time looking at films, mainly on television, only a handful of our schools are making any attempt to encourage intelligent and discriminating viewing. Academic prejudice and a sort of wilful blindness to the facts of life, deriving perhaps from a genuine fear lest old standards and values be undermined, still afflicts education. The attitude, in its extremest form, led the headmaster of one of our most famous schools to attack the pernicious cinema at an educational conference in the twenties in the following terms:

The cinema is prejudicial to learning, exactly as is the reading of snippets of information in a halfpenny newspaper. Never is a young child's mind so severely strained as when looking at pictures. If the English people want to commit race suicide, they can do it by overtaxing the brain energy of the young; and never has human ingenuity invented a device more efficacious for this sinister end than the moving picture.

We can hardly expect the splendid madness of this utterance to be matched today; but we seem as far as ever from any serious attempt to educate the child and the mass audience to cope with the flood of visual stimuli which characterizes our environment.

Fortunately, education does not depend entirely on what goes on in our schools. An important process of self-education is taking place among film and television audiences everywhere. We all look and learn; that is we learn to discriminate, and I have little doubt that the mass audience today is not only more experienced in looking at films than it was twenty, ten, or even five years ago, but is more sophisticated, more discerning, more selective, and more adventurous. The cinema, as Griffith wished, is teaching us to see.

The increasing range and sophistication of the public is playing its part in a fragmentation of the mass audience of which the film trade is becoming slowly and reluctantly aware. The industry is beginning more consciously than hitherto to cater specifically for sectors of the total audience and minorities within it. There is the 'family audience', once preponderant, now a shadow of its old self; the 'X Certificate audience', which consists by no means exclusively of men in raincoats, but has a high proportion of sensation-hungry adolescents and a sprinkling of cinéastes in pursuit of some elusive foreign movie; there is, in Britain, the Saturday-morning Cinema Club audience with an average age of seven or thereabouts; London, like most capital cities, has its own West End audience; then there is a Sunday-night audience for one-night stands of films on opera and ballet, sometimes mediocre in quality, but which nevertheless bring in

many culture-hungry people who otherwise would never go near a cinema. Among these minorities, that of most interest to film-makers and with the greatest commercial potential is what the trade in Britain has come to call the 'specialized audience' or, in its earlier and more picturesque jargon, the 'carriage trade', to distinguish it from the 'cap and muffler' end of the business. Specialized audiences patronize specialized cinemas (in America, art-houses) and are also the mainstay of Britain's one to two thousand film societies. This minority audience, which tends to be young and which comes mainly from that one-fifth of the population which has had a grammar-school or equivalent education, is interested in foreign films and revivals. Because this audience exists, and is growing, in most countries where films are shown, we are approaching the point at which films of a more sophisticated kind than the mass audience will accept can become financially viable. Indeed many already are. A Buñuel, Antonioni or Truffaut, whose names guarantee maximum art-house distribution, with an occasional breakthrough into circuit release, have little difficulty in raising the money for the films they wish to make and can command a good deal of freedom from commercial interference. But returns from the art-house circuits are notoriously slow to come in, so that even the giants sometimes run into financial problems, while younger or lesser men often find themselves against insuperable obstacles.

Those who care most deeply about the cinema cannot but welcome the rapid growth of the minority audience and the proliferation of art-house cinemas and film societies. They must be no less enthusiastic about the increasing discrimination of the popular audience, for it should not be too easily assumed that the future of the film as art lies in the hands of the cinéastes. We should rather hope for the narrowing of the gap between the two film cultures. For when we speak in one voice of cinema as art and cinema as mass entertainment, we are implying a division which may not exist.

Looking back over the brief but crowded history of cinema, one must be struck by the dominance of the popular, not only in

the commercial development of the film as entertainment, but in the progress of the film as art. At every decisive phase in the realization of cinema's artistic potential, the instinct of the mass audience seems in retrospect to have been right.

In the earliest days of the despised cinematograph there were those who sought to give it seriousness of purpose. The Lumière brothers, who first produced a commercially viable machine, themselves saw it as a popular educator, and sent their cameramen round the world to film the Nile and the Taj Mahal for the edification of Paris audiences, rather in the style of nineteenth-century lantern lectures. But it was the showman Méliès, recruiting the talents of the girls of the Folies Bergère into his team, who proved the first artist in the history of the film. He also produced the first films to reach audiences on anything like a mass scale, though largely through the agency of those who shamelessly copied his work. In Brighton at about the same time, the close-up was discovered by film-makers engaged in the making of popular melodramas and comedies. In America, the foundations of film editing were being laid by Edwin S. Porter and, a little later, D. W. Griffith: they were not indulging their artistic theories, but turning out two pictures a week for the nickelodeons.

In the next decade determined efforts were made both in Europe and America to turn the cinema into art. A company known as *Film d'Art* was launched in Paris in 1907 with the express purpose of turning the audience, now growing by leaps and bounds, away from the chase films, comedy knockabouts, and rudimentary Westerns which they were coming to love, and to introduce them instead to serious drama and high comedy. The public, they thought – and all honour to their good intentions – needs must love the highest when they saw it. They engaged Sarah Bernhardt, Max Dearly, almost the entire Comédie Française, and the great Réjane. Regina Badet and La Belle Otéro were brought in from the Paris Ballet, and Saint-Saens was employed to write the music for their first great epic, *L'Assassination du Duc de Guise*. As for stories, instead of leaving the producer and his cast to make them up on their way to work, they went to

Sardou, Rostand, Hugo, and Goethe. In Britain, too, a cultural revolution was planned, with Shakespeare, as interpreted by the great actor-managers of the day, as the centrepiece. A few years later, Zukor launched 'Famous Players in Famous Plays' in New York, and James Hackett, Minnie Maddern Fiske, and Lily Langtry were among the dozens of famous and expensive performers engaged. These ventures attracted a good deal of patronizing approval from the better papers and brought some prestige to the cinema in quarters whose appreciation had no commercial value and whose artistic judgements in this area were worse than useless. Fortunately for the development of film art, the public quickly corrected the deviation; they voted with their feet. The films, it now goes without saying, were awful. Meanwhile, Griffith, between 1908 and 1912, in which he made some three hundred films, worked out the essentials of film technique and developed the first school of film acting. In 1915 his genius took the world by storm with *The Birth of a Nation*. Alongside him, from 1909 onwards, Mack Sennett was creating a new, wild, circus-derived, curiously surrealist art form with the Keystone Cops. When the history of twentieth-century art comes to be seen in perspective, Griffith and Sennett, Ince, Chaplin, Keaton, Mack Swain, Mabel Normand, and others of that extraordinary period will be seen as major figures. The nature of their achievement cannot here be examined; the point to be made is that they were despised and rejected by the intellectuals and the critics, and were idolized in the fleapits.

Much the same story can be told of the twenties, though in less black-and-white terms. After *The Birth of a Nation* things were never quite the same, and no intelligent person could fail to have some awareness of the true nature of cinema. Even so, the great films of the twenties are the American silent comedies, above all those of Keaton and Chaplin. Nor does the quality of these films depend entirely on the acting genius of the two performers; Keaton's *The General* is in structure an almost perfect work of art, and Chaplin's *Circus* runs it close. The intellectuals, particularly in the second half of the decade, when the film society movement

had begun, were not unaware of the quality of some of these works, though scathing about the run-of-the-mill Hollywood star vehicles, re-examination of which today reveals qualities unappreciated at the time, at least by the cinéastes of the day: they reserved their laurels for the French *avant-garde*, the German cinema, and the Russian epics. Of these three, always regarded as milestones in the development of film art, only the best of the Russian works really survive today as statements of first importance. The work of Eisenstein and Pudovkin, moreover, was aimed at the masses, and its strength derived from that fact; they directed their appeal uninhibitedly to mass emotions, in the manner of Griffith, on whom they modelled their style. As for the Germans, *Caligari*, *Waxworks*, and *Niebelungenlied* seem almost irrelevant to the cinema of today, while the lively and fascinating experiments of the Dadaists and Surrealists in France were less original works of cinema than experiments in the application to cinema of theories worked out in other fields of art. The public were untouched by them; they were watching Mae Marsh, the Gish and Talmadge sisters, Stroheim, the Barrymores, Chaplin, Langdon, Laurel and Hardy, Lloyd, and Keaton, and on the whole they were probably right.

And so it was in the thirties. Sound film arrived, and both the theory and the practice of film-making were shaken to their roots. The cinéastes, almost to a man, displayed a bitter conservatism. Their *avant-garde* theories of the new visual language seemed in danger. Some grudgingly admitted that sound might have a complementary function, though actual speech was hardly to be tolerated – 'natural sound' was better – and argued that silence must remain an element as important as sound, which could only be effective if used with restraint. The root-and-branches swore to remain faithful to the true art of silent film. But the mass public at no time had any doubts at all. In a matter of months the silent film was no more than a dusty survival; within a couple of years it had disappeared. As for the film-makers, Pabst in *Kameradschaft* and Pudovkin in *The Deserter* made genteel gestures towards the 'imaginative' use of sound, Clair captivated

the film-society audience with charming musicals, but the giant steps forward were taken not in Europe, but in Hollywood, with the shattering gangster pictures and loud musicals. Comedy in that period ranged from W. C. Fields, Mae West, and the Marx Brothers to William Powell, Myrna Loy, and Lubitsch, not to mention Mickey Mouse and Popeye. Few of the art-house films of that time survive with the same force, for they rarely had the same vitality. A revaluation of the whole of film history is now beginning. Ten years ago *Cahiers du Cinema* discovered the American second feature and today the intellectual film magazines are forever finding new heroes among the unregarded commercial directors of the forties and fifties. There is indeed a danger lest what should be a serious revaluation based on close examination of particular periods should become instead a cultist hothouse. But the general conclusion emerging seems to me inescapable; it is that the public has generally been right.

Thus baldly put, the argument needs qualification at many points. We cannot ignore Bresson, Ozu, and Godard because the public do. To attempt to apply all down the line the criterion of public acclaim as the clue to greatness will hardly do. Is *The Sound of Music* a masterpiece? Or *Thoroughly Modern Millie*? The National Film Theatre has rediscovered Will Hay, and the turn of Jerry Lewis will undoubtedly come; but Gracie Fields? Norman Wisdom? What will the future critical historians of the British cinema have to say about Anna Neagle, Diana Dors, and the *Carry Ons*? The Board of Trade has made an award to the Christopher Lee Hammer Horrors for export performance; already Hammer have their supporters among the cinéastes, though it is an ultra-sophisticated taste; will the film historians of the future rediscover Hammer, as Feuillade has come to be acclaimed after half a century? I am too mistrustful of accepted critical canons to pronounce glibly even on such questions as these: in any case I am not contending that the public is infallible and every box-office winner a major work of art; I merely point to the evidence of film history, in so far as we understand it, or even know it, to suggest that the art of the cinema may well prove

to be deeply and genuinely rooted in the responses of the mass audience, and that in seeking to reach the true aesthetic of film the instinct of the mass public may offer the most important single guide. The audience may be the tyrant of the film-makers, but it does not follow that it is the enemy of good cinema.

© Stanley Reed 1970.

EDWARD ADAMSON

Art for
mental health

Creative therapy is a broad term to describe the therapeutic use of artistic self-expression. Art forms such as music, drama, movement, pottery, sculpture, drawing, and painting are employed to assist the cure of both physical and mental ailments. For the purposes of this paper, I intend to concentrate mainly on the therapeutic effects of drawing and painting in the sphere of psychiatry. I shall begin with a brief historical background to creative therapy generally, and outline the development of the subject in this country. I then wish to examine the role of the artist in a psychiatric hospital and the contribution that creative therapy can make to mental health. Finally, I shall examine the claim that the creative expression of psychiatric patients is 'true art', and from this I shall seek to differentiate such works from the paintings of professional artists.

The therapeutic aspects of music enjoyed recognition in Old Testament times:

> Thus it was that David met Saul and entered his service . . .
> And whenever Saul was taken with this evil mood of his, David
> would fetch his harp and play; whereupon Saul was comforted
> and felt easier, till at last the evil mood left him.
>
> 1 Kings. 16:14-23 (Knox version)

We are also reminded by Shakespeare that music's charms can 'soothe the savage breast', but it was not until the end of the

147

nineteenth century that the therapeutic use of artistic expression received any serious scrutiny. Although many doctors had commented upon the unusually prolific output of drawings and graffiti from schizophrenics, the phenomenom was generally regarded as a mere curiosity, and such accounts as there were, were descriptive rather than analytical. Max Simon recorded his comments on schizophrenic art in 1879, and an Italian psychiatrist, Cesare Lombroso, followed with an attempt to codify the drawings of schizophrenics. He produced an elaborate but unscientific set of conclusions based on the supposed relationship between genius and madness. It was not until the 1920s that the subject came of age: Hanz Prinzhorn published his famous work *Bildnerei der Geisteskranken* in Berlin in 1922. This was a comprehensive, well-illustrated study in which, among other things, Prinzhorn commented upon the aesthetic value of many of the works. This was a period, incidentally, in which a new interest was being demonstrated in art generally. The impact of psychoanalysis, through the work of Sigmund Freud, added a new dimension to the study of art, particularly in relation to the concept of the unconscious mind. This aspect was elaborated by Freud himself in his famous study of the artistic achievements of Leonardo (1909–10). He postulated that there was a considerable latent content of unconscious sexuality in artistic endeavour. C. G. Jung was already using art in a more dynamic way with his patients. In the same year that Prinzhorn's book was published, the brothers Moreno opened their first 'therapeutic theatre' in Vienna. They used a technique known in present-day hospitals as 'psychodrama', in which patients are encouraged to act out their problems in a group situation.

Between the wars it was mainly the followers of C. G. Jung who used the therapeutic aspects of drawing, painting, and clay modelling. In Great Britain the subject was slow to develop, although there were notable exceptions such as the Withymead Centre. Serious attention to psychotherapeutic art was also shown by Dr Guttman and Dr Maclay, who started to collect the drawings and paintings of psychiatric patients at the Maudsley Hospital,

London, in 1936. The development of creative therapy in Britain after the war was by no means immediate. It was well established in America, and the Continent maintained the lead it had pioneered. An International Society of Art and Psychopathology had already been established, organizing conferences in various capitals of the world. The aftermath of the war was an inauspicious time for drawing and painting to be included in the treatment programmes of British psychiatric hospitals, which were already undergoing considerable reorganization as a result of the inception of the National Health Service. It was just at this point, in 1946, that Millicent Buller, of the Red Cross Picture Library, invited me, as an artist, to assist her scheme by touring various British hospitals to discuss with the patients pictures that had been lent to the hospitals. In the course of this tour, I visited Netherne and Fairdene Hospitals, Coulsdon, Surrey, where I met Dr Cunningham Dax. He subsequently invited me to join the staff of his hospital, as a practising artist, to open an art studio for the patients. I believe that this was the first time that such an appointment had been made on a full-time basis in a state hospital. Subsequently difficulties in the way of establishing the role of an artist in a welfare-state hospital became considerable. The National Association for Mental Health lent considerable assistance by paving the way for the inauguration of the British Association of Art Therapists.

The first national public exhibition of 'Schizophrenic Art' was held in the galleries of the Institute of Contemporary Art in London. Opened by Kenneth Robinson, M.P. (subsequently to become Minister of Health) it afforded, in addition, a social commentary on art and mental illness in 1955. For some of the British lay public, lack of exact knowledge and fear of the true facts of mental illness (let alone of art itself) were given revealing expression in the rationalizations of the popular press when the exhibition opened. Labelled by one influential columnist as an unwarranted eavesdropping on the sufferings of the insane, the exhibition was regarded by some as unsuitable for the general public. This, incidentally, was at a time when statistics demon-

strated that nearly half the hospital beds in the country were occupied by mental patients. Nevertheless, the publicity given to the exhibition resulted in a large attendance. There were generally expressions of incredulity at the graphic competence of the works, especially because the majority of the patients who produced them were entirely untutored. The intellectual element among the spectators were stimulated to review Expressionism, Dada, and Surrealism in the light of many apparent similarities to the psychotic products in the exhibition. When a similar exhibition organized by the National Association for Mental Health was held at the Institute nine years later, it was greeted with universal enthusiasm. The most recent exhibition, at the Commonwealth Institute, August 1968 (Adamson, 1962, 1964, 1968), was more didactic. It illustrated childrens' work, as well as a pictorial reflection of the 'open-door' movement which had taken place in psychiatric hospitals since Prinzhorn's day. It demonstrated the therapeutic use of painting, and contained an international section. This exhibition was visited by 24,000 people.

A significant aspect of this exhibition was that it reflected the work of artists engaged in the teaching and treatment of difficult children. Since the war, art teaching in schools had undergone a revolution from the narrow confines of object drawing, towards a new freedom of expression. When this freedom was introduced to the maladjusted child, it became evident that here was perhaps a means of preventing deeper disturbances in later life.[1]

Specific training in creative therapy is now included in London University's course for the teachers of maladjusted children, held at the Institute of Education, London, where there is now being planned a more comprehensive course of training in remedial art teaching. Art is becoming more generally recognized and used in child guidance clinics, and in schools and hospitals for the disturbed child. More generally, art is now recognized, not as a

[1] The exhibition included a fascinating series of 'apple pictures' painted by a boy of nine for his teacher, John Timlin. They illustrated how a child, previously thought to be educationally backward, revealed his anxieties through painting and subsequently achieved a normal standard of work.

mere diversion, but as a dynamic agent in the active pursuit of mental health.

The position of the artist in schools had long been established. For the artist in the psychiatric hospital it was quite a different matter. Often his role was confused with that of the occupational therapist, although in many cases his training was considerably longer. At any rate, the official salary rates of 'art therapists' recommended by the Ministry of Health were lamentably inadequate.[1]

I have no wish that my remarks should be interpreted as the slightest denigration of the very worthy role of our colleagues in the occupational therapy departments; on the contrary, I wish to establish that the artist in a hospital fulfils an entirely different role, owing to the fact that he is, first and foremost a professionally trained artist.

He [the artist] is responsible for getting the patients to paint the pictures by his encouragement, stimulation, and the creation of an atmosphere sympathetic to self-expression and persuasive to production. The fact that he is an artist, a professional and not an amateur, that he can speak with knowledge and authority and that he is in charge of the studio is important.

E. Cunningham-Dax (1953)

Dax was particularly interested in expanding the work of creative expression.[2]

The insistence that the creative therapist should be a professional artist is again asserted by Professor Plokker in his work *Artistic Expression in Mental Disease* (1964). It is vital that anyone

[1] The British Association of Art Therapists has on its files the case of an artist who, it was thought, could be promoted to a more lucrative position on the establishment of a hospital by having his role designation nominally changed to that of refuse collector.
[2] This particular development is expanded in his book. The results proved both revealing and efficacious, but the genius of Dax was not sufficiently recognized in this country. He subsequently left to take up a major appointment in Australia.

who is permitted to encourage the artistic self-expression of others should have a professional background. No well-meaning amateur, unacquainted with the subtleties of abstract and figurative expression, is really competent to encourage something of which his knowledge is incomplete. Since it is important to encourage creativity, one must have a creative catalyst. Unless this is so, there may be a danger that art activity becomes a means of keeping the patient out of mischief, or that an occupation such as 'painting by numbers' results.

When patients are encouraged by psychotherapists to produce paintings, the results often demonstrate a desire to please on the part of the patient, which results in Freudian phallic symbols or Jungian signs as the case may be. The psychotherapist can unconsciously stimulate such manifestations without realizing the true content of the products.

What then is the role of creative therapy or, in this context, remedial art treatment? I can best answer this question by describing the workings of my own department. Patients are referred to the department when the psychiatrist feels that creative activity might be particularly effective as a form of concurrent therapy. Painting constitutes the largest part of the total activity, although we have departments for pottery and sculpture as well. The department comprises five studios, and has a painting gallery and archives of over 60,000 paintings which are visited by an average of 700 people annually. The artist in charge does not give any positive direction in the choice of subject-matter. He merely provides a sympathetic atmosphere in which work can take place. He is there for guidance where need be, and can provide the occasional expert advice in the choice and use of media. This account may seem deceptively simple; it is not always so. The patient arrives in hospital with the veneer of pre-conditioned attitudes to art, which often reflect the ethos of role stratification. Many patients resentfully regard the activity as a return to the confines of the schoolroom. Others take refuge in their inability to master a representational technique. To compensate for this, however, some patients are mercifully relieved

by their illness from conforming to such a rigid pattern of behaviour. Their illness has the effect of releasing them from any cultural role-expectations, and they paint naturally and spontaneously without any inhibitions. It must be emphasized at the outset that this art activity is not merely a distraction or diversion for the mental patient; it is not occupational therapy; neither is it art instruction. It does contain elements of these activities, but it goes far beyond them to produce a unique contribution to the establishment of mental health.

Art activity for psychiatric patients offers considerable positive benefit. At its simplest, it confers the benefits of an *occupational* activity: it detaches the patient from the deleterious effects of idleness and self-absorption; it imposes a discipline involving concentration and decision-making, and cooperation with and reaction to the limitations of the artistic medium. Finally, it gives the patient satisfaction in the fact that he has created something. *Created* is the operative word in the dynamic area of art, where one is required not to reproduce but to re-create, and where the satisfaction is surely more profound.

Art requires its author to make a statement. The creator must study, analyse, and reinterpret to produce a final synthesis. Applying this activity to the shattered imagery of the schizophrenic is an attempt to establish a system where previously none existed. It is, perhaps, a first step in reassembling the fragments of a disintegrated personality.

Art externalizes the inner world of its exponent. The patient can view his work and see his imagery *objectively*. He can see his work at a distance, physically, which is a step towards viewing it mentally in the same manner. In this way the patient is encouraged towards an objectivity which may in time allow his sanity to reassert itself.

For other patients, the *self-exploratory* aspect of the activity is helpful. The patient's work is an aspect of his own personality which meets with no disapproval. Art allows him to day-dream or investigate at will. Furthermore, it permits the necessary rationalization that he is merely painting; that it is the painting and not

himself, and therefore he can afford to be more eloquent without a fear of imagined reprisal. Often a patient will carry out a complete self-analysis on paper, depicting, exploring, and phantasizing on the unresolved conflicts of his life.

Art can be cathartic in other ways. For the patient whose symptoms are manifested in uncontrollable aggression, painting provides an outlet for these feelings and a means of purging them on paper. Often the painting is a tachiste explosion of red weals, with words emblazoned across the paper. This form of *cri de coeur* permits an explosively destructive emotion to be expressed without damage to anyone. It also frees the patient from the destructive aftermath of guilt and the fear of retribution.

A more subtle form of this phenomenon is apparent in the *magical* quality which painting can possess. Under this aegis, a constituent of early cave-drawings, and the black magic rituals of witchcraft and of primitive peoples' art, the creation assumes an almost physical identity, which can be modulated by its artist. This is an aspect often used by children when they draw. The child, usually to the accompaniment of his own sound-effects, draws his aeroplanes, which in turn drop their bombs and are shot down by a quick scribble of dashes from the enemy plane, or a red-crayoned explosion from an anti-aircraft shell. In a psychiatric hospital a patient might draw, perhaps, a woman. Underneath he might write the words 'mother-in-law' and then slowly eradicate the drawing with a rubber. Obsessional and compulsive acts are frequent in many patients' symptoms. These range from the familiar walking on pavement cracks, or the tapping of lamp-posts, to the uncontrolled compulsions of the sick mind. One of my patients had been a farmer. When he arrived in hospital he was convinced that it was his duty to produce enough food to feed the world daily. He came to the studio regularly and meticulously drew the daily wheat and root crops for his task. Another patient imagined that she was married to me. Our entire courtship, marriage, and honeymoon were enacted on paper. She even laboriously drew a market garden so that we need never be hungry!

Some types of mental disorder rob the patient of the ability to speak, describe his feelings and symptoms, or make any form of contact with the outside world. Art is a valuable means of *communication* for some of these patients whose inability to communicate has hindered their treatment. Psychotherapy can be of benefit only when contact is established. Many patients who were mute or incoherent were often quite uninhibited about painting, which in turn provided an avenue through which they could learn to express themselves more fully.

Painting is a very *personal* activity. Psychiatric hospitals are by their nature institutions. For the patient this can sometimes result in the loss of individuality, and this in an environment where ego-identity is needed. There are nearly two thousand patients in our hospital, each in some way seeking an identity. For many, art is one means of achieving it. By what may seem a paradox, painting can help to integrate the patient into the group situation. Experiments that we conducted with a group of long-stay schizophrenics illustrate this point. A common art activity, such as the painting of a mural, can often unite antisocial personalities by giving them a common aim. Patients who had been quarrelsome and obtuse joined with a group of similar patients to produce about five large murals. While they were at work they displayed an amazing amount of cooperation and completed the murals successfully.

Art products have a contribution to make to psychiatric *diagnosis*. The paintings of mental patients often resemble their dreams. Psychiatrists can therefore find in them a fertile source of data. Paintings do possess distinct advantages over half-remembered dreams; they are palpable and permanent records and so can provide information for diagnosis as well as prognosis.

Readers acquainted with the methods of psychoanalysis may more readily appreciate how accurate interpretation can be made from the patient's phantasies and dreams. The latent content of a picture is readily discernible by the well-trained psychiatrist. Often a painting can cut short a laborious question-and-answer session, which takes much time, especially within a crowded

hospital. Often the psychiatrist can, through a painting, obtain a clue to a diagnosis which otherwise might have taken much longer to discover. There is a danger here, however, that paintings might be too readily analysed on the slenderest of evidence and divorced entirely from the other symptomatology of the patient. There might even be a possibility that some paintings, far from throwing light on the patient, might act as a projective test like the Rorschach test (ink-blots used for diagnosis) and reveal more about the unconscious mind of the spectator who is analysing the work.

Pictures by psychiatric patients have often served as an *early warning system* of a future event. One of my patients, whose outward behaviour gave no rise for concern, painted an emotionally impregnated picture of a graveyard. A great white dove with wings outstretched hovered over this macabre scene. The picture made such a powerful impression upon me that I immediately showed it to the psychiatrist handling the case. She recognized the symptoms of suicidal depression. Instructions were given to the nurses in charge to give this patient special surveillance; as a direct result of which an attempted suicide was successfully averted. In recognizing the emotional intensity of the painting, the artist can provide a diagnosis of concern which the doctor, with his specialized knowledge, can translate into action.

I have emphasized that the artist does not suggest the subject of a patient's work. Nevertheless, there are some occasions when this is necessary, particularly when the patient seems unable to progress. Painting can therefore be used in *direct psychotherapy*. Strictly under the guidance of a psychiatrist or psychotherapist, the *development* of a painting may be suggested to the patient, or implanted in his mind, in order to facilitate the lowering of a psychic barrier. For instance, one patient, an inhibited middle-aged woman, produced an endless succession of paintings of a posy of tight crocus buds. Her psychiatrist finally suggested that it would be interesting if the crocus petals might open just a little. The patient obliged, and as the petals of her flowers opened, she paralleled this by opening out her own shut-in personality. She

subsequently revealed the conflicts which had been buried deep within her, and which had previously impeded her recovery.

Paintings have a unique merit in revealing *data* on a patient's state of mind at a moment in time. This is of particular value to research workers in the field of psychology and psychiatry. Readers of Dr Dax's *Experimental Studies in Psychiatric Art* see the patient's work as evidence for a medical hypothesis. Dr Robertson (1952) did some valuable correlations of patients' colour choice. On other occasions, paintings may accurately record data on a patient's imagery before, during, and after an experimental situation or a new course of treatment. The effects of the operation of leucotomy have been studied in this manner. A psychiatrist can also obtain information about a patient's conception of his own identity. Often when patients are asked to draw pictures of themselves, they depict a disjointed image. One patient drew herself in the centre of a block of ice. Another, a man, when he tried to paint himself at home, found that he could paint the sitting-room where he lived, but was unable to draw himself within this setting. Often hirsute middle-aged women draw themselves as sophisticated filmstars, and one man in his forties drew himself as a baby.

In child guidance clinics it is also important to obtain data on a child's conception of himself. Emotional retardation can readily be diagnosed by the way a child paints. For the very young, the body is a large circle from which protrude the arms and legs. As maturation progresses the idea of the body-image develops also, and any retardation or psychosis can often be spotted by asking a child to draw himself.

In our discussion of medical research one inevitably meets the sceptic. It has been stated that some patients might easily have recovered without assistance from the hospital artist. A controlled experiment is suggested for two groups, only one of which is receiving intensive creative therapy. The results could then be compared at the end of a specific period. This point of view is limited, and is structured in terms of the result. Although the experiment has not, to my knowledge, been carried out, it would

be impossible to quantify, qualify, and control all the variables. In addition, creative therapy has never claimed to be a sole or independent cure for mental illness, nor is its usefulness seen in treatment alone. It should be used alongside all the other medical and therapeutic aids available in a modern psychiatric hospital; it is complementary rather than competitive.

It was thought at one time that the introduction of physical methods of psychiatric treatment would soon relegate the hospital artist to the status of an interesting anachronism. Treatment by surgery and by insulin are by this time on the wane, but electro-convulsive therapy and chemotherapy have produced a dramatic improvement in the recovery rate in hospitals. It is contended by some that these methods often suppress symptoms but do not touch the underlying cause, which it is the aim of psychoanalysis to discover. This argument has been challenged because doctors are now using paintings to illustrate the dramatic changes in their patients' symptomatology after drug treatment.

The British Association of Art Therapists instituted a survey of psychiatric hospitals and special schools, and the replies to their questionnaires indicated that there are some eighty artists employed as creative therapists, and nearly as many vacancies. It seems, therefore, that the artist has a unique and valuable role to play as a therapist in our society.

Let us now consider the utility of exhibitions of schizophrenic art, and this may serve to preface the larger question whether these paintings are true works of art? Why, in fact, do we hold art exhibitions of this type at all? There are many reasons for this, the least important of which is that the organizers value their aesthetic content. The other reasons are mainly didactic.

For the psychiatrist, the nurse, and others engaged in the work of mental health, the painting can illustrate something of *what it feels like* to be mentally ill. The term 'paranoia', used to describe a state in which delusions of persecution (or of grandeur) pre-dominate, certainly becomes clearer when the spectator is allowed to share the visual images of a paranoid patient; an ordinary hospital bedroom may then be transformed into a phantasmagoria

of horror where human eyes peer from walls and electric light bulbs, and where wallpaper patterns writhe with hidden menace. For the psychiatric nurse to understand that this is the daily 'reality' of her patient's existence is a forward step towards greater sympathy, understanding, and tolerence. For the psychiatrist in training, one picture can illustrate a schizophrenic's state of mind, and a series of paintings can accurately chronicle a course of treatment. It was principally for this purpose that the gallery and archives of schizophrenic art were established in my own hospital in 1956.

Not only psychiatrists and other professional workers but also many lay people have been educated in a area in which much tolerance and understanding are needed. The emotions expressed in the paintings are often very recognizable. Insecurity is a common sensation, and is frequently depicted: a man precariously balanced on a tightrope high up in the roof of a circus tent, or a girl clinging by her fingers to the brink of a cliff with the sea below. For spectators to determine the precise borders of sanity thus becomes more perplexing. Pictures are one graphic means of illustrating the fact that mental patients are often grappling with situations which we ourselves have experienced, but have been fortunate enough to resolve. In addition, mental illness is removed from the damaging influence of the horror film, and from the image of the figure of fun. Even today there is considerable confusion between mental sickness and subnormality, or low inteligence. I am continually being asked, 'How can *these people* paint such pictures?' as if the questioner had removed himself from those he criticized. It is perhaps not the unintelligent who readily succumb to psychiatric illness so much as the intelligent and sensitive.

We must now consider another area of common confusion: can a schizophrenic painting be regarded as a work of art, and to what extent does the work of established professional artists reveal any affinity with the work of psychiatric patients?

The first question hinges on the term *art*. That the creative expression of a patient is an art form, there is no doubt. Whether

one dare go further and maintain that these are works of art is debatable. To maintain this position would be to side with the irate father who says that his daughter of six can paint as well as Picasso. Child art is in a position similar to schizophrenic art in this respect. Children's paintings and drawings have a rare accidental quality of beauty, but they cannot be equated with the works of established professional artists. The purpose of a creative therapy department is not to produce artists. In every instance it is the subject-matter of the pictures that is of paramount import-ance, and not the style. A true work of art depends upon the *conscious modulation of style*. It requires qualities in the artist of judgement, ecclecticism, reintegration, the knowledge when to stop, and when to accept the chance effect. The artist is in control throughout, but the sick mind does not normally possess these qualities. Creative therapy may be one means of achieving them in the end.

It is this inherent sensibility of the artist that is so often con-fused with the *sensitization* of a patient as a result of his illness. It is as if 'the doors of perception' (to quote the title of Aldous Huxley's famous work [1959]) had been opened to the patient, and as if this increased awareness had lent a graphic but uncontrolled dimension to his work. In addition, the illness often liberates the patient to paint spontaneously, like a child.

It cannot be denied that the artist is motivated by the un-conscious levels of his mind. It is essential to realize that this is mainly in the area of subject-matter. The fact that Leonardo painted the Virgin and St Anne because he was intimately con-nected with both his mother and his nurse when he was a child, is incidental to the manner in which he painted the picture, and it is this for which he is famous. It is a fact that professional painters who become mentally ill usually lose their power to paint. This is because they have lost the very powers which differentiate their work from schizophrenic art. One symptom of an artist's recovery is that he wants to paint again.

The lives of professional artists are often cited to substantiate the fact that they exhibit a high degree of insanity. Names such

as Van Gogh and Goya are quoted, and on the basis of this minority a hasty generalization is sometimes made. This was the idea in the forefront of Lombroso's mind when he attempted to equate genius with madness. This view is on the level of that of the uninitiated layman who, faced with an example of abstract art, feels there is a decision to be made about the sanity of either the artist or the spectator. Few would deny that the healthy artist possesses deeper sensitivity and perception than the average person. His awareness is much greater; he is allowed to tread upon the very brink of perception's precipice and look down; he then returns and gives society a vision that can be appreciated and shared. The mental patient has fallen over the precipice, and he can neither return nor control the images he sees. The artist and the psychotic are both attempting to establish a personal statement, but for the artist it is both personally and universally valid, for he has modulated his style so that these who look at his work are drawn into full participation in his vision. A spectator of psychotic art is the voyeur of an isolated experience.

REFERENCES

ADAMSON, E. 1962. Darkness into light. *Observer*.

ADAMSON, E. 1964. *Art and Mental Health*. London.

ADAMSON, E. 1968. The madness of Vincent Van Gogh. *Art and Artists*, Vol. 3, No. 9.

ADAMSON, E. and FREUDENBERG, R. K. 1968. Development of creative expression in hospitals. *Art and Mental Health*.

CUNNINGHAM-DAX, E. 1953. *Experimental Studies in Psychiatric Art*. London, Faber.

FREUD, S. 1909–10. *Leonardo da Vinci*. London: Hogarth, 1951.

HUXLEY, A. 1959. *The Doors of Perception*. London: Chatto and Windus.

PLOKKER, J. H. 1964. *Artistic Self-Expression in Mental Disease*. London and the Hague: C. Skilton.

PRINZHORN, H. 1923. *Bildnerei der Geisteskranken*. Berlin.

REITMAN, F. 1950. *Psychotic Art*. London.
REITMAN, F. 1954. *Insanity, Art, and Culture*. London.
ROBERTSON, J. P. S. 1952. The use of colour in the paintings of psychotics. *Journal of Mental Science*.

H. R. KEDWARD

Modern man
in search of
his art

In a lecture delivered at the opening of an exhibition at Jena in 1924, Paul Klee remarked:

> While the artist is still exerting all his efforts to group the formal elements purely and logically so that each in its place is right and none clashes with the other, a layman watching from behind pronounces the devastating words 'But that isn't a bit like Uncle'. The artist if his nerve is disciplined thinks to himself 'To hell with Uncle. I must get on with my building . . . This new brick is a little too heavy and to my mind puts too much weight on the left; I must add a good sized counter-weight on the right to restore the equilibrium'.
>
> <div align="right">Klee (1948, p. 31).</div>

Not only does this passage show Klee's humour at its most typical, not only does it create the atmosphere of the Bauhaus by its analogy of painting and building, but it also expresses in concentrated form the essence of the art revolution of the twentieth century. Between the Cézanne retrospective exhibition of 1907 and the mid-twenties, many artists relinquished matching for making: visual reality as the necessary model of art was discarded and the breakthrough was consolidated despite public opposition and incomprehension. As a result, much of modern art can be

called not the art of illusion but the art of object-creating:

> The aim of life is living creatures
> The aim of art is living creations
>
> Josef Albers

Not all modern art makes such constructionist claims: an expressionist tradition, particularly in Germany, produced figurative paintings, often, as in Beckmann, in reaction to the growing assertion of abstraction, but even here the distortion of colour or line necessary for heightened expression has removed art from the tradition of orthodox academic painting derived from Renaissance perspective and realism.

It can be said, therefore, that the first three decades of this century saw modern art established as a new way of seeing and feeling. But while confounding the layman's comfortable reliance on natural, visual reality as the subject matter of painting, artists of pioneer movements went further and produced their new realities backed by impressive intellectual pretensions. Modern art became a new way of thinking. By both paintings and pronouncements art was carried into areas which are shared and disputed by theology, metaphysics, psychology, and even politics. When for example the Futurist Marinetti cried 'We sing of war, the only cure for the world' or when Kandinsky wrote that 'after a period of materialist temptation the soul is emerging refined by struggle and suffering', they threw art into the whirl of modern intellectual debate.

The result is not entirely in the interests of perceptive and accurate art appreciation as this essay attempts to show. One perceives the ease with which philosophical or ideological statements by various artists become the prey of certain systems of thought which seize on the new realities in modern art and vigorously adapt them to their own world view. In the process the changes in seeing and feeling become subordinate to the change in thinking, and modern art is made into a systematized intellectual statement on the condition of twentieth-century man.

I would like to illustrate this process in two ways. Artists of this

period can be found stressing firstly the dehumanization of paint-
ing and secondly transvaluation of art in quasi-Nietzschean terms.
Both concepts pushed the artist into claims which go beyond
questions of style. For this reason they have been pliable material
for subsequent theorists. By examining these two popular areas of
theorization it can be seen that evidence is provided at the begin-
ning of the century for intricate ideas on the modern European
mind and condition which leave the reader enmeshed in intel-
lectual speculation but often far from the realities of the new art.

I. In looking for a meaning behind the rejection of orthodox art
and the creation of new art forms which bewildered and alienated
much of contemporary society, it is easy to single out the word
'dehumanization' as both a description and a philosophy of art
from Cubism to full abstraction. In the biographies of many
influential painters of this period there is at least one reference to
the artist's disenchantment with either nature or the human being
and his growing conviction that some form of distortion, frag-
mentation, or abstraction is necessary for the life of art. Frequently
the expressions of this disenchantment go beyond the purely
aesthetic repudiation of redundant art forms. 'Quite early in life,'
said Franz Marc, 'I began to feel that man was hideous; beasts
seemed far more lovely to me. Yet even in the beast I found so
much that was ugly and repulsive that an inner urge instinctively
caused my representations to be more and more schematic and
abstract.' Marc, before World War I which was to cause his death,
had come close to complete abstraction, and the sketches made in
his notebooks during the war – itself a climax of dehumanization –
show his steady move towards a full imaginative autonomy of
construction. Klee would seem to have summarized Marc's
position when he wrote in 1915, 'The more horrible the world (as
it happens to be in our day) the more abstract art becomes . . .'
Both statements of Marc and Klee suggest that more than
aesthetics were involved in their new art forms. Already in 1907
Klee had been bored with nature ('Perspective makes me yawn')
which he tended to identify with the tasks of the unimaginative,

the conformist, and the complacent. His reception of Schönberg's 'Pierrot Lunaire' was his own challenge to orthodoxy. 'Burst you stuffed shirt, your knell is ringing' – a challenge to convention which was not without its social overtones.

At the same period Cubism was scandalizing the public. 'Rubbish cubed' was the staid reaction of that otherwise revolutionary Russian Marxist, G. V. Plekhanov – an opinion widely shared when their major exhibition was held at the Salon des Indépendants in 1911. Apollinaire, in his poetic study *The Cubist Painters*, turned the tables on the derisive critics: 'Those who mock the new painters are actually laughing at their own features', and he consolidated the break with tradition by the aphoristic statement that:

Artists are, above all, men who want to become inhuman. Painfully they search for traces of inhumanity, traces which are to be found nowhere in nature. These traces are clues to truth, aside from which there is no reality we can know.

Apollinaire's study appeared in Paris in 1913. A year earlier another intellectual statement of the aims of modern art was published in Munich, the second European centre of art revolution. Written by Wassily Kandinsky and called *Concerning the Spiritual in Art*, it was less polemical than Apollinaire but equally insistent that a breakthrough in art was of more than aesthetic significance. He claimed that 'the freer the abstract form the purer and more primitive the vibration' and his intention was to shatter the soulless artificiality of modern life and release an inner reality through the medium of abstract, or as he termed it, 'absolute' art. It was an art, critical of materialistic civilization and the blindness it engendered.

From these expressions of aim and theory and from paintings which move towards abstraction, it would not be difficult to construct a theory of modern art as an assault on the human form and popular values. When the Spanish sociologist Ortega y Gasset produced his study on the *Dehumanization of Art* in 1925 he appeared to have crystallized the central revolutionary fact of

modern art in precisely these terms. He claimed that it no longer represents the 'lived reality' which was part of the everyday world of the masses:

'Modern art will always have the masses against it. It is essentially unpopular: moreover it is antipopular.' When a man's dislike for a work of art is 'due to his failure to understand he feels vaguely humiliated'; he realizes that he is an 'average citizen, a creature incapable of receiving the sacrament of art, blind and deaf to pure beauty' (Ortega y Gasset, 1956 edn, pp. 5–6).

The psychological perception here is striking and Ortega's analysis has gained wide intellectual acceptance, particularly among sociologists, who encounter constant public antipathy to abstract art, and historians who can point, for example, to the way that the Nazis found it easy to mobilize public prejudice against the Bauhaus. Indeed, Ortega's presentation of the unpopular art could be substantiated by the actual claims of some artists and the wilful social withdrawal of others. The theme of the alienation of the modern artist from society has many intellectual champions. But Ortega's thesis, contrary to many second-hand sources, does not stop at this broadly defensible point. His further aim is to demonstrate that this popular dislike of modern art is a necessary result of the division of society into the 'illustrious' and the 'vulgar'. As an apologist for élitism, Ortega approves of the esoteric appeal of dehumanized painting though he does not feel that the paintings themselves have yet achieved a high level of excellence. They are however on 'the royal road of art' which he defines in this way: He says that nineteenth-century art was serious: as weighty as life itself. It was almost sacred. 'At times – in Schopenhauer and Wagner – it aspired to nothing less than to save mankind. Whereas the modern inspiration is invariably waggish . . .' Art's 'mission is to conjure up imaginary worlds. That can be done only if the artist repudiates reality and by this act places himself above it' (Ortega y Gasset, 1956 edn, pp. 43–5).

It is here that his intellectual system asserts itself at the expense

167

of his earlier analysis. It is possible to challenge Ortega's presentation of dehumanized art by the continuity of the human figure in the work of the expressionists, but it is generally acceptable. By the end of his article, however, one has discovered that he is really interested in making modern art fit his schemata for an *élitist* aesthetic. We are left with a picture of art as intentionally anti-popular, of waggish inspiration and seeking worlds of fantasy beyond reality. The floating forms of Kandinsky, the linear contortions of Klee, the collages of Picasso and the harlequinades of Miró might all appear both waggish and fanciful, but this is to underestimate the seriousness and experimental dedication of the artists concerned. If one examines for example compositional or synthetic Cubism – the period when Picasso, Braque, and Gris moved from the dismemberment of the natural figure to a more autonomous construction of shapes and planes – there is no suggestion of flights of imaginative fiction. The paintings, *papiers collés*, and collages are formal demonstrations of the way objects can be composed. They are passionless and in many ways without meaning. The deliberate intention to dehumanize a natural object by distortion was certainly part of the cubist intention, but it was fragmentation in the interests of perception and construction, not in the cause of fantasy. In Mondrian and Malevitch, where dehumanization was total and orthodox reality in art eliminated, the elements of an imaginary world are even fewer than in cubism. Mondrian exhorted artists to create pure form, unrestrained by subjective feelings and ideas. 'Behind changing natural forms there lies changeless pure reality.' His rigorous obedience to his own precepts produced pictures in which colour and space were tightly governed by line – a lyrical purity which has none of the impudence diagnosed by Ortega as the mark of modern art. In Chagall and de Chirico, as in the surrealist tableaux of Ernst and Dali, the illogicality of dream imagery provides more substance to his definitions, but in many of their paintings dehumanization is far from complete.

It might be argued that these qualifications to Ortega are slight and that his basic analysis of dehumanization is untouched.

This is not quite the case. Because of his limited understanding of both the aims and achievements of modern painters, his prediction of an inevitable gap between modern art and the masses is weakened. To say that dehumanized art is inevitably unpopular is to freeze the artistic awareness and habits of the people at a given uncomprehending level. This could be justified perhaps if one agreed that the aim of the dehumanizing artists was to remove art from everyday reality and lose it in an *élitist* world of fantasy. On the contrary, their aim was frequently to accentuate these realities in a new and dynamic way or to penetrate to a new and deeper reality that would enlarge the experience of the spectator. Fernand Léger was one who worked strongly against the potential *élitism* of his own art by demanding that it serve contemporary interests. In his murals for various buildings including, much later, the church of Assy, he tried to create colours which satisfied a basic physical need as well as a taste for decoration. Nor did Klee, despite his irritation with the insensitive layman, cultivate an antipopular art. He ended his lecture with the words:

> We have found parts but not the whole: we still lack the ultimate power for the people are not with us.
>
> Klee (1948)

Klee would be out of sympathy with a finalized division of men into the categories Ortega put forward. So too would Kandinsky, whose efforts to publicize the new art in revolutionary Russia derived from a conviction that it was universally communicable. Between 1917 and 1921 he created in Russia twenty-two new provincial museums, a museum of pictorial culture, and an Academy of Aesthetics. Working under a government that recognized only objective values this was a considerable achievement for an artist preoccupied with inner reality and certainly does not suggest that Kandinsky was intentionally antipopular.

It is true that Kandinsky failed to awaken people to his inner meaning or even to the excitement of his symphonic colours. It is equally true that the Bauhaus was forced to move from Weimar owing to public hostility. But even as the visual realities of the

169

once deplored impressionists have come to be respected, so it is not inconceivable that the objects and shapes created by modern art will come to be widely seen as both pleasing and interesting. Ortega y Gasset, by investing modern art with his own *élitist* aims, has produced a brilliant but static analysis. One of his conclusions runs:

> All [the modern artist] does is to invite us to look at a piece of art that is a joke and that essentially makes fun of itself. For this is what the facetious quality of modern inspiration comes down to. Instead of deriding other persons or things – without a victim no comedy – the new art ridicules itself. And why be scandalized at this? Art has never shown more clearly its magic gift than in this flout at itself. Thanks to this suicidal gesture art continues to be art, its self-negation miraculously bringing about its preservation and triumph.
>
> Ortega y Gasset (1956, p. 44)

Whatever certain artists wrote about dehumanization, however unpopular their paintings, there would be few, outside Dada, who would have appreciated this distortion of their theories and their art.

II. From the earliest breakthrough by modern artists there were attempts to assess the new position of art and to philosophize on the role and nature of the new artists. A new set of values seemed to be involved which stretched beyond the actual form and content of the paintings and established itself in areas removed from, or tangential to, aesthetics. The most intensive illustration of this is the extent to which art was related to the philosophy and psychology of Nietzsche. During the period under discussion the view of modern art as pervaded by Nietzschean values was given a firm foundation. Those since then who continue to subscribe to it talk of the art of the overman or speak aphoristically about the artist and eternity, the need for disharmony in art, or the psychology of destructive art. It would appear that those who have a deep knowledge and understanding of Nietzsche's work tend to

regard most applications of Nietzsche to twentieth-century culture as based on perversions of his actual writings, but they admit at the same time that Nietzsche lends himself easily to such misunderstandings. Certainly, in the thirty years following his death, his influence, particularly in France and Germany, was dynamic; his name occurs frequently in explicit acknowledgements and his ideas are widely discernible, though often in distortion. Perhaps the most direct inheritor in the art world was the metaphysical painter de Chirico, who felt intuitively the poetic contribution of Nietzsche which has been more recently assessed by Erich Heller (1952). 'Schopenhauer and Nietzsche', wrote de Chirico, 'were the first to teach the deep significance of the senselessness of life and to show how this senselessness could be transformed into art . . . the dreadful void they discovered is the very soulless and untroubled beauty of matter.'

It was for this exposé of the void and the absurd that Camus later admired Nietzsche, and de Chirico, with his attempts to suggest a depth beyond and beneath the unreality of his stage-set paintings, had drawn close to the genuine spirit of Nietzsche. More distorted were the Nietzschean claims of the Futurists in their evocation of force, conflict, and dynamism, but they did reflect his contempt for both nineteenth-century bourgeois capitalism and nineteenth-century international socialism. At Trieste in 1909 Marinetti, the leading Futurist spokesman, announced:

> We are as far removed from international and antipatriotic socialism . . . that ignoble exaltation of the rights of the belly . . . as we are from timid clerical conservatism symbolized by the bedroom slippers and the hot water bottle. We sing of war, the only cure for the world . . .
>
> (quoted in Joll, 1960, p. 141)

It was a rationalization of Nietzsche to make him a mentor of aggressive nationalism: his arguments with Wagner and his criticisms of Bismarckian Germany are too consistent to leave any doubt about his scepticism, but in the overcharged atmosphere

of prewar Europe his call for a transvaluation of values and his allusions to blood and heroism were easily transferable into both politics and art. The manifesto of Futurist painters in 1910 demanded a destruction of all orthodox and academic art, including the portrayal of nudes, and a turn to the art of the present and future: one of movement, dynamism, and synaesthesia. The sensation of movement was captured by cinemascopic renderings of successive stages of motion, dynamism expressed by lines of force cutting through the plane of the picture and the synaesthetic explored by Boccioni and Carra, in particular, who painted noises, sounds and smells. The transvaluation explicit in this call to the future pulled art away from its own sphere and threw it aggressively into politics: both Marinetti and Boccioni welcomed the war of 1914 as the concrete realization of their philosophy.

In England similar dynamic aims were embodied in the vorticist movement originating from the explosive journal *Blast!* first published in June 1914, edited by Wyndham Lewis, and proclaiming vortex as 'the point of maximum energy'. It was a forceful reaction against the aestheticism of Beardsley and, like Futurism, it was quickly identified with the romance of war. Wyndham Lewis's painting 'Plan of Campaign' made up of parallel lines and blocks of colours to express divisions of armies in combat, was an expressionistic portrayal of war obsession in the months before its outbreak in 1914. The point to be made here is that Vorticism and Futurism, whatever their precise relationship with Nietzscheanism, identified art with the forces of destruction and assertion that had become equated with Nietzsche's philosophy.

Even Cubism was endowed with a Nietzschean blessing. Apollinaire, in *The Cubist Painters*, wrote:

Greek art had a purely human conception of beauty. It took man as the measure of perfection. But the art of the new painters takes the infinite universe as its ideal, and it is to this ideal that we owe a new norm of the perfect, one which permits the painter to proportion objects in accordance with

the degree of plasticity he desires them to have. Nietzsche divined the possibility of such an art:

'O divine Dionysius, why pull my ears?' Ariadne asks her philosophical lover in one of those celebrated dialogues on the Isle of Naxos. 'I find something pleasant and delightful in your ears, Ariadne: why are they not even longer?' Nietzsche in relating this anecdote puts into the mouth of Dionysius an implied condemnation of all Greek art.

The single sentence 'Nietzsche divined the possibility of such an art' could well be used as a summary for the attitudes so far expressed on the position of art in the early twentieth century. The position and role of the artist was also credited with a Nietzschean ring, especially in the case of the German Expressionists. In *Form in Gothic* (1912) the young German art critic Wilhelm Worringer portrayed the nature of Northern, in particular German, art and in the process produced a typology of the Northern artist which coincides remarkably with Nietzsche's description of the Dionysiac artist whose experience is suffering and isolation. Worringer set the Northern scene with these words:

Behind the visible appearance of a thing lurks its caricature, behind the lifelessness of a thing an uncanny ghostly life, and so all things become grotesque . . . Common to all is an urge to activity, which being bound to no one object loses itself as a result in infinity.

Worringer (1927 trans., p. 75)

This compares in atmosphere to Nietzsche's lines:

Thus all joy wants eternity
Wants deep deep eternity

which, as Heller (1961 edn, p. 116) indicated, is 'an eternity not of joy but of the world with all its sorrow, transfigured in the act of willing it'. Worringer's picture of the artist in this state of inspiration is one of loneliness, introspection, and suffering, and there are artists like Nolde and Munch who, with Van Gogh, are close examples of the artist isolated by temperament, environment, and

his own depth of perception. Van Gogh's masochism, Nolde's morbidity, the tormented world of Munch, and Nietzsche's obsession with suffering, form a psychology of distortion and torment which only art could adequately express.

On the evidence of these selected views of art and artist held in the early decades of the century there is reason for suggesting that aspects of modern art have involved a 'transvaluation of values' of little less than Nietzschean dimensions; that there emerged artists and art illustrating conflict, disharmony and a heightened sense of the individual, or group of individuals, fighting against the surrounding world. As far as it goes this interpretation is instructive. But when it is projected on to the whole of modern art and extended into a theory on the state of the twentieth century it ceases to have validity. One might protest that such a generalization could only be the work of an obsessive, but obsessives are often widely read for the very clarity of their single-minded explanation. This is true of Hans Sedlmayr's *Art in Crisis*.[1] In modern art, Professor Sedlmayr writes,

> war is declared, not only on man and nature but on light, on the intellect, and on composition. The attraction that is exercised on the artist by the extra-human, and the extra-natural darkness, unreality and the subconscious, by chaos and nothingness, has about it all the qualities of an enchantment.

This enchantment, he continues, illustrates a crisis in modern man. Rootless, godless, and adrift in the chaos of disintegrating values, man turns against himself and employs the powers of the monstrous, the dark, and the savage against the forces of order, enlightenment, wholeness, and beauty. Paintings and buildings have lost their top-bottom, front-rear orientation: man has lost

[1] (English edition 1957; translated from the German, *Verlust der Mitte*.) Professor Hans Sedlmayr was until recently Professor of Art at the University of Munich. The ideas reproduced here were first expounded in a set of lectures between 1941 and 1944. He has written extensively as art historian and critic.

his God-human perspective. The result is an art of darkness.

> We must admit that we have before us a perversion that is serious and deeply rooted, for it is monstrous that we should admire a spirit that humiliates and torments the human soul under the guise of art when we can still resent such insult and humiliation of man in reality.
>
> Sedlmayr (1957, pp. 159–60)

It is not that Sedlmayr is ignorant, nor that he abuses the thinkers and critics he calls to his support, but that he refuses to look dispassionately at the aesthetic of modern art. Encouraged by statements on art and artist not dissimilar to those quoted above, and armed with a knowledge of Dostoevsky, Nietzsche, Strindberg, Baudelaire, Spengler, and Ernest Jünger, he pulls art into a philosophical framework in which a twisted line is equal to a twisted mind. Nietzsche provides much of the commentary for the processes of transvalued art which he describes. 'Man is a bad habit that must be overcome' is one of his quotations from Nietzsche, used to summarize the descent of art into the inhuman; and throughout the book there is an unquestioning identification of paintings, buildings, and sculptures with the most destructive philosophy which appeared relevant.

In certain cases this does not distort – for example, Marc, Barlach, and Grosz are not misrepresented by their pithy statements even when Sedlmayr reproduces them in a vacuum.

> 'Quite early in life I began to feel that man was hideous' (Marc), 'man is one of nature's experimental failures' (Barlach), 'man is a beast' (Grosz). They are all variants of Nietzsche's 'Human all too human'.
>
> Sedlmayr (1957, p. 159)

But when Klee's words, 'Our beating heart drives ever deeper towards the ultimate ground of things' are also used to exemplify the art of unreality and nothingness, one is aware that Sedlmayr has no discrimination in either art history or art criticism. From the philosophizing of certain artists he has derived sufficient

material to buttress a preformed religious world view which bears little resemblance to the realities of modern art. There are some truths in his thesis: it is not entirely groundless but by its very systematization it does injustice to the complexities of art. In detail his evaluation of modern art in Nietzschean terms is vulnerable at two points.

First, Nietzsche's advocacy of conflict had its own source in the twin claims that 'God is dead' and 'Man is a sick animal'. Not all philosophizing artists in this period who spoke of conflict shared this position. Striking exceptions were Klee and Kandinsky. Kandinsky retained his faith in the Orthodox religion and presented his inner reality, which his paintings explored, as deeply religious and spiritual. When he spoke of disharmony and conflict, he used the musical idea of counterpoint. 'Harmony today', he wrote, 'rests chiefly on the principle of contrast', and to illustrate the kind of colour conflict that interested him he cited the reds and blues of popular religious carvings in Germany. If Kandinsky had philosophical affinities, they lay not with Nietzsche but with Bergson, whose ideas on intuition as a source of knowledge paralleled Kandinsky's own notions of obtaining spiritual knowledge through art.

Paul Klee is even less relevant to either Sedlmayr's thesis or Nietzscheanism. His insight into life was almost purely aesthetic, despite the philosophic ring of certain phrases. Feininger captured the essence of Klee when he reacted to some of Klee's drawings: 'Quite wonderful . . . does Klee *paint*? I should like to know. That he plays the *violin* is certain, if to conjure up a world of sounds from four strings is equal to conjuring up a world view with penlines, crosses and triangles.'[1] Klee's 'ultimate ground of things' was a reference to the forms of the creative process itself, and in his search for these he demonstrated a cultural width and receptivity which made him alive to forms as distinct, in time, as Zeppelin aircraft and ancient Egyptian hieroglyphs. Will Grohmann summarized the work of Klee with the acute observation, 'Klee experienced things real and imaginary as formal images

[1] Letter to Kubin, 1913. Quoted in Hans Hess (1961, p. 68).

which are at the same time glimpses into the universe'. Klee's intention to distort and compete with nature must be seen in these terms, and not put in a quasi-Nietzschean mould. The emphasis on form is the dominant throughout. It is his major key.

Secondly, Nietzscheanism, however distorted, accentuated the responsibility of the individual himself to realize the new life made possible by the death of God. If the artist is to be the 'over-man', overcoming the limitations of man and fulfilling himself by his own achievements, then art and life must be so inextricably bound that they are interchangeable. Merely to be a great painter is insufficient. This heightened individualism and merging of life and art lay behind Worringer's stereotype of the Northern artist and as we have suggested it was not an uncommon feature of early modern art. But it was far from universal. Alongside the revolutionary artists who made principles of life and art coextensive were those whose single-minded aim was the service of art and who attempted to sink their individuality in the pursuit of perfection. Piet Mondrian exemplifies this position and any examination of his life and work will place him at the opposite pole to the ebullient or the introspective expressionists of the Boccioni or Munch variety. Mondrian was a painter of infinite patience who saw his art slowly advancing towards the perfect line relationships he envisaged; the pure tension of rectangular construction. The discipline and humility of this approach demonstrated a dedication to a cosmic perfection which he believed existed independently, but which could only be given expression through the individual insight of the artist. In the first number of the new magazine *De Stijl*, October 1917, he concluded:

The new plastic approach is dualistic in composition. By virtue of its exact plastic appreciation of cosmic relationships it is a direct expression of the universal. By virtue of the rhythm and the material reality of its plastic technique it is an expression of the subjective consciousness of the artist as individual. It is thus a revelation of universal beauty without however implying any negation of the general human element.

177

There is little of either genuine or popular Nietzscheanism here. The only connection would be through the word 'Apollonian', Nietzsche having divided art into the ecstatic and demoniac (Dionysiac) and the disciplined (Apollonian). Emile Langui has taken over these terms for his essay in *The Sources of Modern Art* (1962, p. 133), paraphrasing Nietzsche in the following way:

> After 1884 two main currents dominated modern art, until our own day. One of these cherished the rule that corrects emotion, the other the emotion that breaks every rule. The first current may be called Apollonian, so directed is it by the desire for order, clarity and harmony. The second . . . is given up wholly to exaltation of instinct, spontaneous impulse, even the raptures of the tormented soul; it is Dionysiac.

In the brief history that follows, it is not surprising to find Mondrian as the definitive Apollonian along with Malevitch and the Cubists, confronting the main Dionysiacs from Van Gogh, Gauguin, and Munch to Chagall and the Dada movement. Had Sedlmayr entertained even such an elementary categorization as this he might have moderated the all-pervading misanthropy and individualistic aggression that he found in modern art. Not that Langui's definitions are always helpful: the Futurists fit unhappily into the Apollonian side, and Klee is out of place among the Dionysiacs, while Miró, with his bright colours but formal arrangements, makes nonsense of the distinctions altogether. But at least here is an example of Nietzschean terms used to promote understanding of art rather than a spurious philosophy of the twentieth-century artist.

There is one further interpretation of modern art that makes extensive use of Nietzsche as a point of departure. It can be found within C. G. Jung's edited book *Man and his Symbols* in a well-documented thesis by A. Jaffé.[1] It ranges wider than Langui; it is

[1] Aniela Jaffé, Jungian analyst and close colleague of C. G. Jung in Zürich, edited his *Memories, Dreams, Reflections* (1958) published in English translation in 1963. Her article in *Man and his Symbols* (1964) is entitled 'Symbolism the Visual Arts'.

far more intuitive than Sedlmayr. Because it involves a psychological interpretation of the form and content of carefully selected paintings, it is difficult to refute, although an intellectual unconverted to the Jungian system rebels against the enormity of the claims.

From a presentation of recurrent psychological symbols in art Madame Jaffé turns to modern art in a section called 'The Retreat from Reality'. Her thesis is this. Nietzsche's 'God is dead' was a profound recognition that the mask of society – its 'persona', in Jungian terms – had fallen and that individuals were thrown back on their basic selves in the search for a new orientation, a new life of reconstructed values. In this period of individual and psychological anarchy, when the various sides of the psyche disputed for predominance, it was the dark unconscious side, previously muted by the power of the persona, that asserted itself in violent, disturbing, instinctual and destructive symbols which can be clearly seen in the imaginative art of the early twentieth century. The very psychological depths from which these symbols spring are the depths not only of the individual but also of collective humanity. The goal of modern imaginative artists, she continues, was the centre of things. Art became mysticism – but mysticism of the dark unconscious, of the shadow, of the mercurial rather than the heavenly spirit. On its own this inspiration is dangerous and destructive, but balanced by the light of conscious awareness it can be creative: in fact recognition of these dark forces is a precondition of wholeness and fulfilment (Jungian individuation) providing that it is in the control of the conscious. The thesis ends on a note of optimism, that after the dark, unbalanced art of de Chirico, Kandinsky, Klee, and the Surrealists, there are signs of the true balance in the art of Manessier and Soulages in which light colours are seen breaking through the dark criss-crossing bars of the unconscious. Individuation is in sight. Not that it had been lost entirely: Chagall, for all his fantasies and expression of the unconscious, kept a human control on life through his Jewish Hassidic beliefs.

Much of Jaffé sounds like a different version of Sedlmayr.

But her debt to Nietszche goes further. Jung himself was immensely impressed by Nietzsche's psychological observations, and his theory of individuation has strong similarities to the concept of the overman, while his earthly, mercurial, or chthonic spirit echoes Nietzsche's Dionysius. By applying Jung to modern art therefore, Madame Jaffé can safely use the evidence of Nietzscheanism among early modern artists which we have seen was an actuality. Only once in this respect does she show fundamental misunderstanding. In considering Kandinsky, she treats the words 'God is dead', which occur in *Concerning the Spiritual in Art*, as coming from Kandinsky himself, showing his affinity with Nietzsche. We have already challenged this interpretation with reference to Sedlmayr. Jaffé's case is no stronger since Kandinsky used these words to express not himself but the views of certain sections of society 'which call themselves Jews, Catholics, Protestants, etc. Really they are atheists and this a few of the boldest, or the narrowest, avow. "Heaven is empty"; "God is dead"' (Kandinsky, 1947, p. 30). These people he saw as the embodiment of materialism – the evil he and his art were determined to overcome. Apart from this mistake, most of Jaffé's imaginative theories make excellent reading and provide an unusual intellectual stimulus. In the end the strength of her essay is relative to one's belief or disbelief in the validity of Jungian psychology. In many ways the arguments of E. H. Gombrich (1957) against the use of psychoanalysis in art criticism apply here also. We learn nothing of the aesthetic qualities of either the artists or the paintings which are discussed. But Jaffé has countered this in advance by disclaiming any intention to examine the aesthetics. She is interested only in the content of paintings, which reveal symbolically the deep realities of the psyche. This delimitation of subject matter appears to have made her ideas invulnerable; but is this really so? Presumably the point of such an essay is not an exercise in psychological gymnastics but intends to say something true about modern art since she is deeply concerned with both motivations and the actual forms of expression. To reach any truth, all available evidence should be studied. When one examines Jaffé's

evidence one finds that her selectivity is at some points alarming. She uses the writings of Klee, Kandinsky, Mondrian, Malevitch, Marc, and others with a view only to substantiating her systematic thesis. Thus for Marc the goal of art was 'to reveal unearthly life dwelling behind everything . . .'; Klee in his own words is 'more concerned with formative powers than formal products'; Kandinsky is quoted as saying 'Form, even if it is quite abstract and geometrical, has an inward clang'; and Mondrian is found accusing the Cubists of not pursuing abstraction to its logical conclusion, 'the expression of pure reality'. All these extracts are held to demonstrate the presence of dark mercurial mysticism in modern art. This mysticism, Jaffé (1964, pp. 263–6) declares,

> was alien to Christianity, for that 'Mercurial' spirit is alien to a 'heavenly' spirit. Indeed it was Christianity's dark adversary that was forging its way into art. Here we begin to see the real historical and symbolic significance of 'modern art'. Like the hermetic movements in the Middle Ages it must be understood as a mysticism of the spirit of earth and therefore as an expression of our time compensatory to Christianity.

And later she says of 'anyone who has ever walked open-eyed through an exhibition of modern art' that

> However much he may appreciate or admire its formal qualities, he can scarcely fail to sense the fear, despair, aggression and mockery that sounds like a cry from so many works.

What is surprising both here and in the whole of her article is that little standing is given to aesthetic and formal interests as motivating forces in modern art. The revolution in thinking has been taken as the central feature in the changes of the early twentieth century and all other aspects have been undervalued. 'To prevent any misunderstandings', Jaffé states again in the middle of her thesis, 'it must once more be emphasized that these considerations have nothing to do with artistic and aesthetic values but are solely concerned with the interpretation of modern art as a symbol of our time'. But this argument is insufficient. In the

writings of almost all the painters whom she quotes there is extended reference not only to their 'mysticism' but also to their preoccupation with form as an art motivation in itself. Malevitch said of his black square on a white ground:

> The square that I had exhibited was not an empty square – it was the sensibility of the absence of any object . . . suprematism is the rediscovery of pure art which in the course of time had become hidden by the accumulation of objects.
>
> Malevitch (1927)

The belief of Malevitch was that art could be placed in a realm of pure aesthetic sensibility by the use of the square. In the case of Mondrian it is surely *de rigueur* to link his search for purity with the astringency of his formal discoveries:

> The truly modern artist is consciously aware of the abstractness of a feeling for beauty: he consciously recognizes that a feeling for beauty is cosmic and universal . . . The new plastic approach cannot therefore take the form of natural or concrete representation . . . it cannot appear clothed in those things which are characteristic of particularization, that is in natural form and colour. It should, on the contrary, find its expression in the abstraction of all form and colour, in other words in the straight line and clearly defined primary colours.
>
> Mondrian (1917)

For Kandinsky and Klee, spirituality in art was certainly an important concept, but others were of equal significance. Pictorial anatomy, harmony and contrast, musical composition, linear expression, tonal values, rhythm, absolute construction, and colour in motion were all phrases which both expressed and inspired their aesthetic experiments. The formal teaching at the Bauhaus should not have been overlooked by Jaffé as a source and model for much of modern picture and object-making. Like many of the art innovations of this century it took its rationale from the bankruptcy of representational art and not from the 'Death of God'. The two phenomena may have arisen concurrently, and

there is probably some significance in this, but they should not be compounded and confused. If Nietzsche was the prophet of one, the camera was the agent of the other: both demand careful and separate treatment before any far-reaching synthesis can be made. Such a synthesis is unlikely to prove as simplistic as Jaffé's explanation, for all its persuasiveness.

Through examples such as these it is possible to see the danger of using art for a systematic statement on twentieth-century man. The liberation of art form, the diversity of technique, and the emphasis on experiment and the autonomy of expression, make the task of the intellectual systematizers impossible. The ingenuity of their theses does not compensate for the distortions involved. Ortega, Sedlmayr, and Jaffé fail to convince because they have failed to select, or have selected in the interests of a world view which is itself open to serious questioning.

The social and intellectual context of the twentieth-century artist is multiform and complex. Even where a common environment is shared by a number of artists, this is no guarantee of unity of inspiration, style, or meaning. Chagall and Soutine both lived at La Ruche, near the slaughter-houses in Paris, but whereas Soutine fiercely probed the subject of carcass and bleeding meat, Chagall painted the flying resurrected bodies of the dead cattle. Feininger and Moholy-Nagy both taught at the Bauhaus, but the former said of the latter's stress on the technical in art, 'I reject it with all my heart – this misconception of art is a symptom of our time. The demand to couple the two movements is nonsense in every respect.' The proliferation of schools of artists, art programmes, and manifestos accentuates this diversity of modern art: it is not surprising that it defies the systems criticized above. Art both provokes and feeds on intellectual ferment and in the ferment of the early twentieth century, artists can be found to stand for almost all contemporary ideas. Degas was an antisemite, Boccioni a militarist; Feininger an egalitarian socialist, Rouault a believing Catholic, Nolde shared the rejuvenated religious spirit of the prewar generation; Kandinsky welcomed the Russian

183

Revolution. The 1918 Novembergruppe in Germany greeted the end of the war with a dynamic optimism, 'Our voices say yes to all that is growing and developing'. And the Surrealists took up a blatantly social position against bourgeois values. The close interaction of art and ideas is thus undeniable, but there are no ideological schemata which do justice to the diffusion of art inspiration and achievement. Still less can art which concentrates on the formal elements of composition be encompassed by intellectual structures which derive not from aesthetics but ideology. For this reason the Marxist judgements in Ernst Fischer's *The Necessity of Art* (1959) are as tendentious as the totally different condemnations in Sedlmayer. Their mistake is to believe implicitly that all art is either symbolic or symptomatic of man's condition. Such a belief is defensible at a general level but it is more vigorous to admit that some art symbols and symptoms lead not outwards but back into art. Mallarmé's celebrated statement is an example of this: 'The ideal poem would be silence . . . the poem of nothing but white,' a judgement near to the spirit of Malevitch, and echoed by Kandinsky's prose-poem *White Horn*:

> *A circle is always something*
> *Sometimes even very much*
> *Sometimes – rarely – too much*
> *As a rhinoceros is sometimes too much*
> *Sometimes it – the circle – sits in com-pact*
> *violet. The circle the white circle.*
> *And grows unquestionably smaller.*
> *Even smaller.*
> *The rhinoceros bends its head, its horn.*
> *It threatens.*
> *The com-pact violet looks angry.*
> *The white circle has grown small –*
> *a little point an ant's eye.*
> *And twinkles.*
> *But not for long. Again it grows –*
> *the little point (ant's eye)*

It grows in growing.
In growing the little point (ant's eye) grows.
Into a white circle.
It quivers once – and only once
Everything white.
Where has the com-pact violet gone?
And the ant?
And the rhinoceros?

(Paris, May 1937, trans. by Ralph Manheim)

This is the world of the Chinese artist who stepped into his picture and disappeared, and the art it suggests cannot easily be understood in terms beyond the aesthetic.

There is a need therefore for sensitive caution in the intellectual approach to modern art. But such caution should not sap imagination and it does not invalidate the search for meaning. What is unlikely to emerge is a coherent picture of twentieth-century man, for there is no such coherence in his art.

REFERENCES

APOLLINAIRE, G. 1913. *The Cubist Painters*. Paris.

FISCHER, ERNST. 1959. *The Necessity of Art*. Trans. by Anna Bostock. Harmondsworth: Penguin Books, 1963.

GOMBRICH, E. H. 1957. Psychoanalysis and the history of art. In B. Nelson (ed.): *Freud and the Twentieth Century*. London: Allen & Unwin.

HELLER, E. 1952. *The Disinherited Mind*. Harmondsworth: Penguin Books, 1961.

HESS, HANS. 1961. *Feininger*. London: Thames & Hudson.

JAFFÉ, ANIELA. 1964. Symbolism in the visual arts. In C. G. Jung (ed.): *Man and his Symbols*. London: Aldus Books.

JOLL, J. 1960. *Intellectuals in Politics*. London: Weidenfeld & Nicolson.

KANDINSKY, W. 1914. *Concerning the Spiritual in Art.* New York: Wittenborn, 1947.

KLEE, PAUL. 1948. *On Modern Art.* London: Faber & Faber.

LANGUI, EMILE. 1962. The visual arts, 1884–1914. In Jean Cassou, Emile Langui, and Nikolaus Pevsner: *The Sources of Modern Art.* London: Thames & Hudson.

MALEVITCH, KASIMIR. 1927. The non-representational world. In M. Seuphor: *Dictionary of Modern Painting.* London: Methuen, 1958, p. 97.

MONDRIAN, PIET. 1917. The new plastic approach to painting. In M. Seuphor: *Dictionary of Modern Painting.* London: Methuen, 1958, p. 100.

ORTEGA Y GASSET, J. Y. 1956 edn. *The Dehumanization of Art.* New York: Doubleday Anchor.

SEDLMAYR, HANS. 1947. *Art in Crisis.* London: Hollis & Carter.

WORRINGER, WILHELM. 1912. *Form in Gothic.* English translation by Herbert Read. London: Putnam, 1927.

CHRISTOPHER CORNFORD

Letter to Jean Creedy

1 December 1968

Dear Jean,

You have asked if I would contribute to a symposium that you are editing about the arts today. I think that's what you said it was called. You wanted something along the lines of 'Ideas of Change in Art Education' – and you wanted it quickly. This suggested to me the expedient that over the weekend I should simply write down without premeditation or literary decorum such thoughts as I have on this topic; and that, in order to emphasize the hasty and non-authoritative nature of my piece, it should take the form of a personal letter to you. After all, one can write a letter on the spur of the moment, but such is one's reverence for the printed book that, if asked to write or contribute to one, one's normal cycle is to think about it for weeks, then if one accepts, to take several months reading up sources and making notes, then during the ensuing months or years, do the actual writing. But we (and by we I mean all of us concerned with and involved in art education) are in the middle of a crisis, so we can't afford such a long process of gestation: statements must be made boldly and at once or not at all. Thus I am writing these words the very day after your request, and without preparation or research of any kind: I have to stress these circumstances in the hope that any sloppiness in the thinking or writing will be forgiven by your readers.

Where had I better start? Perhaps with what is most immediate in my mind, namely the events of last summer. I mean the events at Hornsey and Guildford, which can't, I suppose, be thought of in isolation from the student movement in general.

Obviously there is going to be in the next few months a perfect avalanche of articles and books describing and explaining the international student revolt, most of them written by people much better qualified than I am. So you won't want another set of diagnoses from me. One thing I would say, though: when all the books and articles come out, they will *all* be true. That is, the revolt of the students in particular and of the young in general is so immense and so deep a phenomenon, there are so many convergent causes of it, that anything anyone can throw into the stockpot of explanations is likely to have its rightful place there.

If you want to know in a nutshell what I personally think about student activism in general, I think it is among the few hopeful things that have happened in my lifetime. Why? Well, firstly, because it asserts, in the face of all pragmatism and worldly calculation, the values I believe in (liberty of the human spirit and body, the importance of education, creativeness, mutual concern, social and economic justice, opposition to the commercial exploitation and pollution of our planet, to name only the principal ones) and secondly because – largely owing to the great numerical and economic weight of the young today and to the availability of the mass media – it asserts these values to some effect. The people in power simply have to take notice, reforms become inescapable, things actually get *done* (sometimes). It wasn't like that when I was young in the 1930s. Protest then was only a squeak among the rising rumble of the tanks and planes. It's true that we have nowadays the problem of the intransigent revolutionaries for whom violent political action is the ideal way of life. Possibly there are nihilists too: young people so comprehensively despairing of the human condition that only total negation and destruction seem to them an appropriate response. But even these people – perhaps these most of all – start with a motive that is essentially moral. Moral revulsion against a lifeless, greedy, vulgar, environmentally reckless, surreptitiously or overtly oppressive social ethos was what got them out on the streets in the first place. So one shares with them (if one happens to be a member of the intelligentsia) a lot of moral assumptions and socially critical

attitudes – even if one thinks, as I very strongly do, that violent political action is no more a satisfactory way of life than neat disinfectant is an agreeable and wholesome beverage.

Art students are only a special case of young people in general: that's why one has to think about the whole phenomenon of student revolt before one can understand what's going on in art colleges or speculate about their future. But art students are nevertheless in one respect non-typical, it seems to me, among students in general in that they are a good deal less politically minded. One reason for this may be that they don't go in for analytical and rational thinking as much as students in ordinary academic disciplines. For each art student who reads Marx and Mao Tse-tung there would I imagine be dozens who read R. D. Laing, and in Laing's philosophy the revolution is mainly an interior occurrence. Another reason may be that they're so taken up with the desire to make things that political activity seems, in the ordinary way, a tedious irrelevance. So if they do act politically it's all the more impressive: you can reckon that they were more or less goaded into it. And it's characteristic, to judge by Hornsey and Guildford anyway, that when they do take matters into their own hands their thinking is from the word go constructive, just as their actions are typically non-violent. Anyone who gets as far as reading these words must know that for days and weeks during both sit-ins the students were earnestly and tirelessly debating not only the detailed problems of their education and how it should be run, but also the most far-reaching social and philosophical implications of art and design activity. From this a pile of documents many inches thick arose, only a few of which, I regret to say, I've yet got round to reading. Nor was I present at either sit-in, as again I much regret: you know how it is, one is always hard-pressed at that time of year, but I must say I wish now that I'd dropped everything and just gone along, as several of my colleagues did. It may well be a long time before that degree of excitement, inspiration, and sense of creative collaboration gets generated anywhere in this country again. Still, I did get to the Round House conference early in July, called by the

Movement for Rethinking Art and Design Education (herein-
after MORADE) and there I managed to collect enough docu-
ments and talk to enough people to get a pretty fair grasp of the
ideas that had been hammered out during all those preceding
weeks of talking. (I also got a heady whiff of the excitement of the
sit-ins. People's faces shone, as the saying is, and there is no sight
in the world more beautiful than this. Some people also shouted
and tub-thumped and scurried about with sheaves of paper as in
shots from movies about Petrograd in 1917. But the violence
was all in words, and goodness knows there was cause enough for
bitterness – but that is another story). Anyway, what I write here
is bound to rely very heavily on Round House material because
this is where all current ideas of change in art education (this is
my theme, you remember) became generally available. A week or
two after this memorable conference I wrote some notes to my
colleagues trying to summarize compendiously the policies that
MORADE was putting forth at that time. The best plan would
be for me to reproduce these notes here. But first I'd like to try,
ambitious though it seems, to give an encapsulated version of the
background story of art education – or rather of what I happen
to know and think about that very big subject. That way the lay
reader, if there should happen to be one, will get some notion of
what led up to last summer's explosions.

There was no significant public expenditure on art and design
education in Britain until 1837, when the government set up a
School of Design in London to improve the standard of British
arts and manufactures. This institution later divided itself into
the Royal College of Art (so named since 1898) and the Victoria
and Albert Museum. But, starting in the early 1840s, provincial
schools were set up in the manufacturing centres of the North and
Midlands, and later on in some country towns; missionary out-
stations, as it were, sent into the field from South Kensington.
There were 60 such schools in being by 1856; 91 in 1864; by
1885 the number had risen to 198 schools teaching 37,000 pupils,
which is about the same volume of further education in art as we
have today – though thousands of the pupils involved were

probably industrial apprentices on day release or doing evening classes.

These schools were not until very recently at all effective in improving the standard of design for manufacture. This was partly because the manufacturers were too complacent and short-sighted to use the graduates of the schools, and partly because the schools themselves became more and more taken up with fine art activities, teacher training, and handicrafts. They progressively lost touch with industry, in so far as they ever had it, and the gap did not begin to close noticeably until after Robin Darwin re-formed and re-equipped the Royal College of Art in 1949.

Nearly a hundred years earlier, a major landmark was the take-over of the whole system in 1852 by that very capable official Henry Cole, who, operating from South Kensington, devised a gruesomely disciplinarian course of graded instruction in drawing which he succeeded in imposing on every publicly financed school in the country, starting at primary level. Beginning with straight parallel lines, the consummate achievement in the advanced stage of the course was a meticulously shaded drawing of a plaster cast of a piece of Roman ornament, which could take you a mere three months full time but a year or more working only part of the day. If you pushed this through industriously enough you got a national scholarship to the Central School in South Kensington and were thus on the road to the headmaster-ship of one of the provincial schools.

This massive and dismal industry devoted to the production of the dullest kind of pedagogue did not finally disappear until the First World War, though the impact of the Arts and Crafts Movement brought a little life to it from the turn of the century onwards. Immediately before and after the 1914–18 War, Henry Tonks at the Slade School was the dominant influence in art education, and though the Slade, being part of London University, was outside the public system, the Tonks approach and the Tonks aesthetic pervaded a great many art colleges up and down the country. In brief it was English Impressionism, i.e. a kind of realism which licensed fogginess of contour without burdening

itself, like its French original, with any rigorous colour theory. Great stress was laid on anatomical accuracy and truth of tone, which meant the kind of tone relationship you see if you screw your eyes up. It was a discipline of a sort, but it became progressively more bloodless, timorous, and academic as time went on. And of course it failed ludicrously to recognize or accommodate what was happening on the Continent, to wit, the Modern Movement, which was then at the height of its heroic age. It didn't just fail to cope with developments since Cézanne: it couldn't cope with Cézanne himself, or even in any intellectually valid way with Impressionism in the French sense. However, perhaps I shouldn't be too snooty about the Slade. Tonks must have had some kind of personal gift, because in fact his school produced nearly all the best painters of the first few decades of the century. The needful counterstatement came from Roger Fry and the Bloomsbury Group in their role (better late than never!) as sponsors of Post-Impressionism this side of the Channel. Not long afterwards came Herbert Read as apostle both of abstract art and Surrealism. The correlative of Fry and Read in the realm of child art and art teaching was Marion Richardson, about whom more in a moment. I am talking now about the 1930s and it was around then that, as the saying is, I came in. So I am beginning to recount from first-hand experience. I was at Chelsea School of Art between 1934 and 1937. Chelsea was, under the inspired principalship of Harold Williamson, too good a school to be considered typical – were not Graham Sutherland and Henry Moore, not to mention Robert Medley and Raymond Coxon, members of that remarkable staff? Abstract or surrealist art would certainly have been countenanced and even encouraged: but those of us who wanted to be teachers had to take the official examinations of the Board of Education, first in drawing, after two years study (or was it one?), and then in painting after another one (or was it two?). Your life painting more or less had to be in the Tonks manner, unless you were temperamentally anti-impressionist and opted for a more conceptually modelled affair, a sort of latterday Signorelli. Then there was still life (I guess

Fantin-Latour would have been a good safe model to bear in mind) and the big Comp., which you did in your own time before the actual exam, and which had to have a minimum of so many human figures not smaller than so high. You can probably imagine the results: Anglo-academic stodge would fairly describe them.

I don't seem to be alone in my estimate of the woeful provinciality of the British art world during this epoch. In the course of a well-earned tribute to Bryan Robertson, contributed to *The Times*, Sir Kenneth Clark wrote as follows:

> In 1910 and 1912 Roger Fry organized the post-impressionist exhibitions at the Grafton Gallery and disturbed, for a generation, the insularity of English taste. Gradually the English were converted to Matisse and Picasso (although there were anti-Matisse demonstrations at the Victoria & Albert Museum as late as 1946) and we all settled down in the cheerful conviction that we were in the movement. Like Roebuck Ramsden in *Man and Superman* we could say 'I am as advanced as I ever was'. The movement meant Paris. Even an exhibition of Paul Klee at the National Gallery in 1945 didn't convince advanced men that there was any serious art outside France. By 1952 we were back in the same torpid isolation that had made us so happy before 1911. In that year Bryan Robertson became Director of the Whitechapel Art Gallery.

What about Design all this time? Strange to say, nobody much used the term. There was something called Commercial Art (posters, packages, typography, layout, etc.) which we fine artists and intending teachers regarded with a tinge of snobbish disdain. And you could do what we nowadays call Textile Design, but was then called Fabric Printing – large lino cuts, backed with wood and banged on to lengths of cloth with a lead mallet that produced a highly antisocial noise. At the Central School of Arts & Crafts and at some large provincial colleges like Birmingham, a much wider variety of craft courses was available.

From all this people *did* get jobs in the real world of design,

partly because already the work of Frank Pick and Jack Bedding-
ton was beginning to have its effect: in other words, there were
beginning to be some potential patrons of 'commercial art' whose
aesthetic standards were not lethally debased. Herbert Read's
tireless advocacy of higher standards in industrial design must
also have made some just perceptible impact around the middle
1930s.

But I was going to talk about Marion Richardson. As I said,
she achieved, among other things, the importation of a post-
Impressionist aesthetic into the teaching of art to children. In fact
she did more. She set in motion reforms in the training of art
teachers that finally broke up the last relics of the Henry Cole
system, and not before time. For, strange as it may seem, as late
as 1937, when I myself went to West Kensington Central School
as a student teacher, I had to make the children copy truly deadly
cyclostyled line drawings of oak-apples and blackberries arranged
as ornamental borders. The art master whose temporary assist-
ant I was, looked and behaved like a Prussian drill-sergeant, and
the atmosphere was one of boredom compounded with terror. All
this kind of thing Marion Richardson brought eventually to an
end by promoting the notion of the child as the natural artist who
need only be given big hog-hair brushes, a large sheet of grey
paper, and a few descriptive suggestions to become a dangerous
rival to Vuillard or Matisse. It's true that her ideas of art teaching
later became known, among the Bauhaus-influenced generation of
young teachers, as the Woolly Knickers School. For by the early
1950s the complete lack of intellectual or theoretical backbone in
the Richardson method had caused it to degenerate into a half-
convinced permissive recipe which probably bored and frustrated
most of the children as much as it did some of the teachers. But
we shouldn't forget that, when it first came in, it represented an
enormous advance towards humanity, freedom, light, and colour
in countless battered backstreet schoolrooms.

The real trouble with the Richardson philosophy was that it
was 'arty' in the bad sense as well as the good. The good sense of
'arty' is 'loving art', which in my view befits any civilized person.

194

The bad, the *boring* sense is 'separating off the cultivation of artistic sensibility from other human faculties and activities and kinds of experience, and thus rendering it more or less unreal, precious, or twee'. In the particular case of school curricula, the separation was between art activity and more or less any other kind, largely owing to the fact that 'art' was conceived of almost entirely in pictorial terms – for one never got much further from this than doing a spell of puppetry now and again. No connection was made with, for instance, the mathematics class (through shared concern with solid geometry, topology, or proportion theory) nor with the sciences (through shared study of natural structures) nor with geography (through a shared interest in the graphic presentment of information) nor with the humanities (through an intelligent cultivation of historical and critical analysis) nor with the wood or metal or electrical workshops (for the development of what Tom Hudson calls 'creative technology'). In a word, Richardson just hadn't caught up with the twentieth century, and the more the century advances the greater the misfit is seen to be, by the younger teachers especially, between her approach and the realities we live among.

Are you wondering why I'm talking so much about art teaching in schools? Aren't I supposed to be talking about *art* schools, not ordinary primary and secondary ones? Well, my brief doesn't say so: it just says *art education*, and in terms of sheer numbers of pupils involved, what goes on in the primary and secondary schools outweighs what goes on in art colleges by several thousands to one. The art class in schools doesn't get the same publicity as the art college because it's comparatively unglamorous and noncoloursuppworthy. But in fact it demands attention. I'll write that again big. IT DEMANDS ATTENTION. I want to know why it is that although ever since Henry Cole's time we've been spending huge sums each year on art classes in our public education system, and on training teachers to give them, we seem to have so very little to show for it. Millions of children attend art classes. Why, when they grow up, do they allow themselves to be enmeshed and oppressed by such huge complexes of ugliness and

worthlessness in the environment? Indeed why do they mostly become enthusiastic consumers of the ugly and the worthless? In Henry Cole's day the answer would have been obvious, to wit that the 'art' teaching wasn't to do with art at all (Cole explicitly said that it shouldn't be) but was just a training in copying and manual dexterity by way of preparation for some dogsbody job in industry. But nowadays art teachers in training colleges are given a most enlightened course, for which I'm perfectly certain that Fry and Read would be on the obligatory reading list. Why doesn't this good, wholesome, highbrow visual culture get through to the masses *via* the art class? Could not the reason be that the theorists of art pedagogy have got some vital connection wrong or missing? Is it perhaps that they feel it their duty (as I know I did in my student teachers days) to purvey to the children a set of middle-class cultural *answers*, instead of getting the children to frame a set of non-middle-class cultural *questions*? Shouldn't the art teacher try to start much more from where the children themselves live, what they know, are affected by, can see? Any bit of supermarket packaging, for instance: one could do written and drawn and painted projects based on this which could lead progressively to almost anything, including conceivably the whole content of middle-class highbrow culture (which, so far from despising, I belong to and live by). This is in fact just the sort of new approach that, along with brilliant improvisations in the use of the scrap and detritus of urban civilization for constructive purposes, has been pioneered by workers like Peter Green of the Hornsey Education Department. All I'm trying to do here is to give their work a boost and hasten the day when it will penetrate the teacher training colleges everywhere – though of course that carries the risk that the new methods may degenerate into just another pedagogical recipe or mindless rule of thumb, the way the Richardson method did, and perhaps all inspired innovations must tend to.

There is, however, a new force to be reckoned with, at least in the secondary schools, which will certainly act against ossification and sclerosis of this or any other kind. Today's *Observer* carries

a news item about the formation of a national union of secondary school pupils, having as its purpose the active critical participation of the children in running the schools and their curricula. Three cheers for that! Of course one can see conflict ahead in so far as the school-teachers may feel insulted or threatened by this offered collaboration, and may strive to suppress it. This would be a pity, for surely education must proceed better to the extent that it resembles partnership rather than subordination.

I must get back in a moment to my miniature historical commentary. But just one or two more thoughts before I leave the children. Surely it's just as much the business of art colleges to interest themselves in the early stages of art education as it is the business of universities to think about sixth-form curricula. And shouldn't art colleges, as producers of designers in need of an enlightened market, also take cognizance that the art class in the primary and secondary school could have the function of nourishing such a market and extending it? In short, shouldn't art colleges stop being so snobbish and aloof as many of them now are with respect to the total art education system of which they are the summit? Shouldn't they try to see it *as a total system*? Isn't this what the twentieth century is trying to teach us all the time – to see things as wholes and not as little specialist enclaves? Well then, let's make a start by creating within the art colleges a new climate of opinion. Up to now a fine-art student on graduation has tended to have the following rank-order of aspirations: (1) Make it with some West End gallery and become a Name. (2) Teach part-time in an art school. (3) As an absolute last ditch, teach children. I think these priorities could with advantage be turned upside down, in the sense that students could be encouraged to think of teaching children as an admirable and interesting kind of job. And this good cause would be markedly advanced if some arrangement could be made for a regular liaison and interchange between staff at secondary level on the one hand and at professional level on the other. In this way, art colleges could be kept aware of what courses their potential recruits were involved in, and at the same time secondary-level art teachers

197

wouldn't feel that they were cast out for ever from the art school world. Eventually the pre-Diploma or foundation course might, as a result of this liaison, become the regular responsibility of the secondary school, which would enable the professional college to diagnose the nature of incoming talent at an earlier stage.

It would surprise me if some or all of the reforms I have been suggesting were not in fact already in hand here and there, because there are, I'm glad to say, already established within certain major art colleges (I've already mentioned Hornsey) and a handful of universities, departments devoted to art-educational studies. I myself am in touch with only one of these, which happens to be in a new university. I welcome its existence as an enriching and diversifying element in that context: but I'm markedly inclined to think that departments of this kind will work at their best in the heterodox and ebullient atmosphere of the art college proper. I'm told the government wants to get them all tidied away into colleges of education – a bureaucrat's solution as neat and logical as it is deathly.

Monday 2 December

I'd better get on with that historical survey, which had just about reached the 1939–45 War. Soon after it, the national system changed: the old Board of Education Drawing and Painting Examinations were superseded by the new Ministry of Education's National Diploma in Design (hereinafter NDD). This was still centrally examined, but was a good deal less academic than its predecessors in terms of subjects, as well as much wider in terms of art and craft activities catered for. The old exams in anatomy and perspective were dropped, thus signalizing the fact that the Ministry of Education had finally bidden adieu to the Quattrocento. Specialists in painting or sculpture now had to do a 'craft' as an additional minor subject, but if you were a craftsman or designer you could take one of a wide variety of specialized courses as your main study, with a bit of fine art work on the side. The requirement in terms of written work was minimal, and there was no specification about having GCE 'O' levels in your

pocket on entry. Any college that cared to could run the course, and just about all the 190 or so, however one-horse they might be, did. It was in two parts, the Intermediate (superseding the old Drawing Exam) after two years; and the Diploma (superseding the old Painting Exam) after two more. To qualify as a specialist art teacher, you would have to do another year's pedagogical course, just as you did under the former arrangement. Almost exactly contemporaneous with the setting up of this new system was the conquest of aesthetic supremacy by the Euston Road school. The chief luminaries of this were William Coldstream, Victor Pasmore, and Lawrence Gowing, who had originally run a small private art school in the Euston Road for a year or two before the Second World War broke out. There they had developed a new doctrinal variant of English Impressionism, differing from Tonks' approach in insisting on an unprejudiced observation of *what you saw* ('looking' was cardinally enjoined) rather than what, according to anatomy or perspective or any other adduced principle, you might expect to see. Somehow corollary to this was a kind of puritanical rigour both of iconography and of pictorial construction. Degas, *via* Sickert, was canonical. Sincere efforts were made to accommodate Cézanne, but they only proved once again that you can no more serve Cézanne and Degas than you can God and Mammon. It was Cézanne who took second place, with the result that the Euston Road movement effectively isolated itself (this is becoming something of a refrain, isn't it?) from the mainstream of twentieth century art – whether you reckon that as being School of Paris or Bauhaus or a bit of both.

Anyway, during the years immediately after 1945, Euston Roadism proved an eminently teachable method – in fact it soon became an academic recipe with its own infuriating mannerisms, such as nudes with legs painted lilac because they'd gone lilac from sitting still, and you must paint what you see; or little crosses drawn with a rigger brush and left exposed among the flesh tints in order to show how judgematically you'd marked out the whole design before hand; or multiple outlines in a drawing

to show how conscientious you'd been in changing your mind repeatedly as to the thickness of a leg or the whereabouts of a chimney stack. This multiple outline eventually found its way into the ads and onto the cereal packets: there were pictures of Dad helping Son to Wheat Scrumpies while bits of his hair, face and jacket seemed to float off into the surrounding space . . . But one oughtn't to blame poor Bill Coldstream for that – everything gets vulgarized in the end.

So, to get back to the narrative, there we all were, exhorting our students to observe keenly and record with exactitude the spaces between bottles on trestle tables or between the belly of some blowsy model and the leg of the Camden Town-type washstand we'd picked up in the local fleamarket – when all of a sudden along came some Young Turks with names like Richard Hamilton, Tom Hudson, Harry Thubron, Roger Coleman, William Turnbull; and in their midst a formidable apostate from Euston Roadism in the person of Victor Pasmore. These people had been studying twentieth-century art in general but particularly abstraction and the Bauhaus; from bases in Newcastle and Leeds they began propagating pedagogical techniques derived from the Bauhaus preliminary course, and the theories and methods of such schools as Constructivism and de Stijl. Under the banner of Basic Design, their influence spread like a forest fire among the younger and more open-minded teachers. There was a great sense of excitement – justified surely, in that for the very first time in its history British art education was being brought into relation with the modern consciousness and the Modern Movement: was being, if you like, deprovincialized – albeit twenty years or so behind the times.

Two more developments must be noted, and then we're practically up to date. In 1949, during the heyday of the Euston Road era, Robin (now Sir Robin) Darwin took over the Royal College of Art and set about reorganizing and re-equipping it, with the ferocious effectiveness for which he has since become famous. To recount in detail this labour of Hercules would take too long: in the simplest terms, his primary objective was to

rededicate the College to the purpose of its original foundation in 1837, namely that of helping industry and hence the economy by training designers realistically in terms of the processes and professional techniques actually required by the industries in question; and doing so in close consultation with the industrialists themselves. By way of teachers Darwin engaged some of the best young or youngish practising designers, under whose guidance the students would frequently carry out commissions from outside bodies in a fully professional manner, so that their transition to practice after leaving should be as nearly seamless as possible. That the policy achieved the results intended is common knowledge: one needs only to walk round the Design Centre and note how many labels on the exhibits bear the initials DesRCA to be convinced of it.

As far as the fine art departments were concerned, his policy on staffing was the same: to collect together the most gifted and successful young artists available. But the teaching programme was different: it was that of *laissez-faire*. The College had no doctrine or aesthetic of its own. It took in graduates from the NDD or Vocational Courses, and in effect said to them: 'Here are studios, materials, advice if required. You have three years' grant to support you. Go ahead and develop your talents, *be* someone!' The Bratbys and Tilsons and Dennys and Rileys and Hockneys of this world are there to prove that this policy likewise worked excellently, at all events for those strong spirits who could survive the ferocity of the competition and the direness of the self-confrontation involved.

The last major change we need consider is the advent of the Diploma in Art and Design (hereinafter DipAD). This new national qualification, designed to supersede the NDD, arose from the deliberations of a Council under the chairmanship of William Coldstream, appointed by the Minister in 1959 and issuing its first Report in 1960. Since so much recent history stemmed from the situation created by the DipAD, I had better tabulate as concisely as I can the recommendations which the Council made and which the Ministry subsequently adopted:

(a) 'The aim should be to produce courses conceived as a liberal education in art in which specialization should be related to one of a small number of broad areas or, to put it in another way, that a subject that is principally emphasized should always be studied in a broad context.'

(b) The four 'broad areas' to be: Fine Art; Graphic Design; Three-Dimensional Design (e.g. silversmithing, ceramics, furniture, product design, interior design) and Textiles/Fashion.

(c) Five GCE 'O' levels or the equivalent required for entry, except in cases of really outstanding talent, who would be smuggled in without them.

(d) Diploma courses to last three years beginning at 18. (You could start the NDD at 17.)

(e) One year's pre-Diploma or foundation course to precede the Diploma Course. (Purpose: to acquire fundamentals and diagnose which area a student might best specialize in.)

(f) History of Art to be studied throughout the course, and examined at the end. A pass required as condition of the Diploma award.

(g) 'Complementary Studies' also to be pursued throughout the course, but not necessarily examined. (These studies defined as 'any non-studio subjects, in addition to the history of art, which may strengthen and give breadth to the students' training'. Choice was left to the colleges: in practice such subjects as philosophy, psychology, anthropology, social history, literature, the mass media were typically offered. The most intelligent programmes were, or rather are, those which refuse to make art-historical studies into a separate and insulated area, but on the contrary cross-relate them with the sort of humane studies I have just mentioned, treating the whole lot as the continuum which in truth it is. In such cases, of course, the prescribed examinations would simultaneously cover History of Art *and* Complementary Studies.)

(h) About 15 per cent of syllabus time to be devoted to History of Art and Complementary Studies.

(i) Examination leading to the Diploma to be internally run, with external assessors in attendance. (This was perhaps the most important single provision and the most progressive. It gave academic autonomy to the art colleges for the first time in their history.)

(j) The Diploma to be regarded as equivalent to a university first degree. (Tricky one, that: it led to difficulties, as we shall see.)

(k) An independent body to be set up to inspect colleges wishing to run DipAD courses, to give or withold licence to do so, and to approve new courses. This was a Council under Sir John Summerson's chairmanship, and known by his name.

In the upshot, by 1966 forty colleges were recognized to give DipAD courses in one or more of the four 'areas': Leicester headed the league with ten courses in four areas, and Winchester came at the bottom with one course in one area.

The Coldstream Committee subsequently produced two more reports, of which only that concerned with Vocational Courses needs to be discussed here. These courses in fact constitute a very large sector of further education in art colleges and demand notice for that reason alone.

(i) The idea was to give shape and status to the many trade-orientated design courses already in being at virtually all art colleges; to serve local industry by providing technically trained recruits, in such skills as typography, cabinet-making, embroidery, millinery, technical illustration, display design, etc. Also to make available an alternative educational channel for aspirant designers who could not muster the requisite GCE qualifications for entry to DipAD.

(ii) Vocational courses to be practical and industrial in emphasis but to contain an element of 'general education in art and design' as well as of Complementary Studies.

(iii) Age of entry to be between 16 and 18 inclusive.

(iv) Courses to last three years normally, sometimes two.

(v) Examinations to be internal. Local or regional certificates to be awarded.

(vi) It should be possible for a student to cross over into DipAD on proving his suitability.

(vii) There should be facilities for day- or block-release vocational courses for students unable to attend full-time.

As you can see, the Vocational Course is very much in a cap-touching relationship to the gentlemanly degree-equivalent DipAD. Yet some of the best talent probably found its way into the Vocational swim, for the simple reason that young people with a gift for art design very often came from schools where GCEs were hard or impossible to pick up. Coldstream was certainly trying to be realistic in providing this alternative, but it begins now to look as though any such deliberate stopping-short of the full possible educational process is bound to create anomalies and resentments in practice.

However, it's important not to undervalue the achievements of the Coldstream Council and the measure of advance represented by the DipAD. To begin with, limitation on the number of centres recognized for the new courses ensured a high concentration of teaching talent in them, even though it also caused a fearful scramble for the available student places. Then Local Authorities whose colleges earned the coveted recognition tended to be very generous with premises and equipment. Best of all, academic autonomy meant that the dreary routines imposed by the centralized exam system could be dropped, and experimental courses set up. Meanwhile, the History of Art and Complementary Studies departments, though they had their problems and zones of friction within the colleges, brought in their train libraries, lectures, exhibitions, and other cultural facilities, the general effect of which was to raise markedly the level of student intelligence, cultivation, awareness, and sophistication. Indeed, it seems likely that these thought-stimulating and question-encouraging agencies were in a sense influential towards last summer's sit-ins. Once train people to ask questions and it's odds on they'll ask at least some which are inconvenient for the institution; but of course any institution that is wise and in good health will welcome this as a

symptom of vitality and as a potential means of self-renewal through the impact of fresh ideas.

Anyway, the first DipAD courses started in the newly recognized colleges in 1963, so that the first graduates rolled off the line three years later in 1966. Nobody, I suppose, is in a position to know fully how successful or otherwise the courses were, nor how enterprisingly the principals and staffs interpreted their new brief. Presumably these factors varied very much from school to school. The outcome proved, however, that within this renovated framework still newer ideas were generated; and that these ideas, meeting with incomprehension and actual repressiveness on the part of some authorities, set up tensions powerful enough to cause sit-ins in two colleges and sympathetic turbulences everywhere else.

What were the rubs, what were the discontents and misfits? I can set them forth most compendiously, if you'll forgive me doing so just once more, by means of another tabulated list: compiled this time, after attending the Round House conference called by MORADE between 8 and 10 July 1968. (N.B. When put between inverted commas the items below are quotations from Round House and Hornsey documents. The remainder are formulations by me. Where I have wished to make my own comments, they are put in parentheses and in italics.)

A. *Educational Philosophy and Policy*

1. 'Conference agreed that the purposes of art education are the creation of awareness, to allow potentially creative people to develop their attitudes, to encourage questioning, to promote discovery, to develop creative behaviour.'

2. 'Our field of concern is the whole of art education, including primary and secondary . . .'

3. 'The relation of art to society needs explanation and redefinition. The body set up by this Conference will have the responsibility for exploring this situation.'

4. 'All conception being based on perception, we feel that attempts to introduce conceptional thinking at too early an age tend to dull sensory perception without improving the individual's ability to deal with the information thus perceived. We therefore demand that the fundamental emphasis be placed on perceptive training.' (*I suspect this means something but I am not clear what. If it means the re-education of all the senses, as advocated by McLuhan, count me in. I think he's right.*)

B. *Critique of Coldstream Policy*

1. Coldstream made a mistaken attempt to confer academic respectability on Art and Design courses by postulating degree equivalence for DipAD, and by introducing 'academic irrelevancies' like GCE requirements on entry and examinations on the History of Art.

2. In DipAD there is also excessive emphasis on specialized and narrowly technical studies designed to fit students into pre-established 'slots' in industry and commerce.

3. Boundaries between, e.g., Painting and Sculpture, or Furniture and Interior Design, are being eroded by the course of events; as is also, to some extent, the distinction between Fine Art and Design. The DipAD structure perpetuates these boundaries.

4. Another obsolete, invidious, and academically snobbish distinction is that between Diploma and Vocational courses.

C. *Admissions*

The five 'O' level requirements should be dropped. Other selection methods should be devised, possibly based on the findings of experimental psychology. (*Yes, but if the GCE requirements went, wouldn't mandatory grants go with them? And do art schools want Prof. Eysenck telling them whom to admit?*)

D. *Courses*

1. Courses should be framed autonomously by Colleges and not be dependent on approval by an outside body. They should be

planned jointly by staff and students in consultation, and should be subject to review by joint staff/student bodies.

2. They should not be 'linear' i.e. framed with a view to producing graduates highly specialized in fulfilling certain existing but possibly obsolescent roles ('slots').

3. They should be based on the 'network' idea, whereby a switch from one type of activity to another is reasonably possible.

4. They should aim to equip students to be problem-solvers in a wide range of activities and give them the mental flexibility and initiative whereby they would be enabled to solve problems that have not yet arisen. They should be 'training in self-education'.

5. There should be more emphasis on group work and projects and less on individual performance.

6. The present divorce between theory and practice should be healed. Any subjects other than professional ones studied should be, and be seen to be, related to the profession (e.g., complementary or general studies). There should be livelier and more searching critical dialogue.

E. *Assessments*

Examinations should be based on what a students has done throughout the course in however many fields: not on his 'success' or 'failure' as aspirant for a particular preconceived role. Invigilated examinations in art history should be discontinued: all written work should be assessed cumulatively for the entire course.

F. *Staff-Student Relations*

1. These should be on a basis of friendly partnership and continual dialogue. The 'Us' and 'Them' situation must be circumvented.

2. Social and cultural facilities should be shared: there should not be separate canteen facilities, etc. (*Shouldn't there be some separate facilities for staff and students, in view of age and culture differences, as well as some shared facilities?*)

3. There should be an Association in each College consisting of all staff and students 'to serve the best interests of the membership from an educational, social, recreational and cultural point of view'.

G. *College Government*

1. There should be adequate representation of students on Faculty and Academic Boards and also on the Board of Governors.
2. Colleges should be run by an Executive Committee jointly elected by staff and students. (*This sounds impossibly cumbersome to me.*)
3. 'Any college or department must be entirely free to establish its own academic and organizational terms of reference.' (*Shouldn't the body that provides the cash have any kind of a look-in?*)

H. *Finance*

1. 'Art colleges should have direct grants from a central body similar to the UGC' and be removed from the financial control of LEAs (*Isn't there a danger that a single central grant-giving body could be much more niggardly than a multiplicity of LEAs?*)
2. 'Students' grants should be paid nationally, not by LEAs. No deductions should be made on account of parents' contributions, which should be recovered by the authorities.' (*Same comment as on preceding point.*)
3. All students accepted should receive a full grant. (*To me this is not self-evidently just.*)

I. *Research*

Research activity should be promoted and encouraged at all colleges and not merely in some favoured centres. Incorporation into Polytechnics militates against this, since research does not form part of their brief.

Some of these proposals may subsequently have been modified or dropped and others may have been added. But they give a fair

enough idea of the general lines of criticism and suggested reform of the DipAD structure which MORADE stands for. My own points of dissent are comparatively minor: the academic and organizational reforms seems to me not only sensible but positively urgent. Perhaps the two matters of most central importance are, first, the abolition of obsolete specialisms and departmental insulation; and, second, the need to let the student have the fullest practicable measure of initiative and responsibility in the running of his course, particularly in its later stages, and also in the running of the college itself. Of course both these desiderata involve considerable difficulties. Insulated departmental structure is administratively convenient: conversely, it is an administrator's nightmare if students are free to surge back and forth across departmental boundaries. But administration is for people, not vice versa, so those whose task it is will have to put their heads together and devise the requisite enabling machinery. As for student initiative and academic self-direction, to foster these in due measure as each individual becomes ready for them, is an art and not an unvarying prescription. Clearly, students should be given direction when they need it, but the continued aim should be to withdraw it as the students' initiative develops. It can best be ensured that this initiative shall flourish throughout a college if the students are present in person on all the decision-making committees, including the highest. College authorities should not be concerned to resist this development: they should rather be worrying about how best to bring forward and nurture talent from among the students for this kind of shared responsibility.

Thursday 5 December

. . . If that last statement seems politically *risqué* today, I wouldn't mind betting that it'll look positively platitudinous by the time it appears in print. Times are changing with apocalyptic speed, and there are signs that at least some art college authorities are intelligently aware that this is the case. It seems to me that we're confronted with a change in the *Geist*, in the social and

cultural dispositions of young people, so enormous as to amount to a sort of mutation. The phrase 'storming Heaven' keeps reverberating in my mind – isn't it the title of some Russian film? Why are our students storming Heaven? Marshall McLuhan's writings provide a great deal in the way of explanation as well as of predictions which prove truer every day. It's a pity that he is habitually spoken of so slightingly: is it that people acquire their opinions of him without going to the trouble of reading what he writes? But I sometimes wonder whether what we are witnessing may not also have something to do with the World Wars. The 1914–18 one cut such a frightful swathe through the males of this country that the 1920s and 1930s were doomed to a kind of debilitation. But far fewer people – British people, that is – were killed in 1939–45, and anyway that war has receded more than two decades into the past. This respite in the rhythm of slaughter has allowed to grow up a new crop of young humans who give me a feeling of remarkable genetic vigour and a rich variegation of talent.

Along with all this there has also been a mutation in art media. Just think: it's only about a dozen years since the word *art* meant spreading Messrs Winsor and Newton's coloured pastes across rectangles of woven flax. Or making mimetic statues out of wood, stone, clay, bronze, plaster. These well-tried techniques continue to be practised, but they have been added to and modified, amplified and overlaid, interfused and cross-connected, by so many unprecedented materials and processes, not to mention the further dimensions of light, sound, and movement, that the old classifications of Painting, Sculpture, Printmaking, Stained Glass begin to sound as archaic as the titles of medieval guilds. The art school of the future, it is fairly evident, will be organized not on the basis of traditional materials and techniques – though for my part I hope these will continue in active use, and the traditional crafts like pottery and weaving along with them – so much as on *responses-to-felt-needs*, whether social needs or the imperatives of the individual psyche, or any combination of the two. Otto Hahn's description of the twentieth-century artist as 'le technicien

de la pensée' hits the mark: especially if you add in the phrase '*de l'imagination*': for the art school of the future will also, it seems safe to predict, be very much more scientific and technological in tendency than hitherto. I don't mean *technocratic*; that is, besotted with a worship of machinery and electronics for their own sakes. I mean that, in the course of their problem-solving, their response-to-felt-needs, the coming generation of artists and designers, many more of whom will (one hopes) have had good mathematical and scientific grounding at school, will naturally reach for materials and processes which only technology can provide. I believe that in the coming decades the always deplorable mutual dislike and mistrust traditionally subsisting between art students and students in science and technology will wither away. Their respective cultures are already drawing together in certain not insignificant ways: if you stand outside the buildings of the Imperial College of Science and Technology you will notice (as you would not have done five years ago) many students passing in and out who, in point of personal *décor*, would be hard to disting-uish from art students – while up the road at the Royal College of Art you will find a number of research workers for whom it is habitual to use a computer.

The corollary of all this, it seems to me, is that we have to question every one of our assumptions, however long-standing, about educational method and academic government in art colleges. Some of these assumptions may survive reappraisal, but it cannot be guaranteed that any particular one will do so . . . All that *is* certain is that the dealers in Securicor guards, Alsatian dogs, spikes, alarm-bells, barbed wire, arc-lights, loyalty oaths, and vindictive dismissals will recede into oblivion beneath a pall of fathomless contempt.

I have a feeling I've run on much too long. But may I say just one more thing, please. I've been writing so far as though it were universally and axiomatically agreed that art colleges are good and necessary establishments. Personally I think they are, but suppose I were challenged to say exactly why I think so, and in particular what the taxpayers get in return for the substantial national

disbursement per annum on what must look to many of them like hotbeds of dangerous unconventionality and social dissent – how would I make the case for the defence? It wouldn't be at all difficult in the case of design departments and their students, because one could easily show that design skills earn money both for their practitioners and for the country, so that the taxpayer is indirectly reimbursed. But what about all these painters and sculptors and so forth? Well, a few of them each year will become potentially important makers of those art objects whereby the community is shown something of its own predicament and aspirations. This in itself is a social function of great though not widely recognized importance. Others will join the teaching profession. But if the quality of art education is what it should be, then *all* the students involved, fine artists as well as designers, mediocre as well as brilliant, will have benefited in common from a prolonged practice of what is nowadays called 'creative behaviour'. I write these words with a touch of embarrassment because they sound so like phoney educationists' jargon. But I believe they mean something interesting. They don't mean just a high output of objects of art or design, though such objects would in our context be the most typical results of 'creative behaviour'. What I have in mind is a comprehensive attitude of inventiveness towards everything that comes to hand, a joyous enterprisingness, an ungovernable cross-connectingness of mind such that possibilities of making are scanned with a quite new width and in unforeseen combinations. I believe that the capacity for this kind of behaviour exists in many more people than is commonly supposed, but that all too often it gets withered up by dull disciplinarian teaching at primary or secondary level, much more often the latter. The art school, perhaps better than any other kind of higher educational *milieu*, can reanimate and develop this capability, and so put forth a kind of essentially educated person that the community is going to need more and more urgently as the age of the blinkered specialist and 'vertical thinker' (to borrow Edward de Bono's term) draws to its close.

This point is so urgent (in fact it lies at the heart of the crisis I

wrote of right at the beginning of this letter) that I'd like to reinforce it by a quotation or two. *That society desperately needs its artists* is a proposition which seems to recur in nearly every book or article I pick up: but here is a selection of passages to this effect that have caught my eye in the last few weeks:

> The artist is always engaged in writing a detailed history of the future because he is the only person aware of the nature of the present.
>
> <div align="right">Wyndham Lewis</div>

> Among the most rigid vertical thinkers are lawyers, doctors and to some extent business people, all of whom prefer things to be rigid, defined and orthodox, for it is only then that they can bring to bear their experience and technical training.
>
> It might be wondered where the artist comes in. In his search for new ways of looking at things, in his dedication to breaking down the old conventions of perception, is not the artist the supreme user of lateral thinking? In the world of art it would seem that lateral thinking is going on all the time under the more self-satisfying name of creative thinking. The artist is open to ideas, influences and chance. The artist seeks to develop an intense awareness. The artist tries to escape from the accepted vision of things often by deliberate use of un-reason. The cult of psychedelic experience is a deliberate attempt to heighten awareness in order to find more significant ways of looking at things. Are not all these the very essence of lateral thinking?
>
> <div align="right">Edward de Bono, *The Use of Lateral Thinking*</div>

> What we are getting is not the demise of art, but a transformation of the function of art. Art, which arose in human society as a magical-religious operation, and passed over into a technique for depicting and commenting on secular reality, has in our own time arrogated to itself a new function . . . Art today is a new kind of instrument, an instrument for modifying consciousness and organizing new modes of sensibility. And the

means for practising art have been radically extended. Indeed, in response to this new function (more felt than clearly articulated) artists have had to become self-conscious aestheticians: continually challenging their means, their materials and methods. Often, the conquest and exploitation of new materials and methods drawn from the world of 'non-art' – for example, from industrial technology, from commercial processes and imagery, from purely private and subjective fantasies and dreams – seems to be the principal effort of many artists . . . All kinds of conventionally accepted boundaries have therefore been challenged: not just the one between the 'scientific' and the 'literary-artistic' cultures, or the one between 'art' and 'non-art'; but also many established distinctions within the world of culture itself – that between form and content, the frivolous and the serious, and (a favourite of literary intellectuals) 'high' and 'low' culture.

Susan Sontag, in *McLuhan Hot and Cool*

Persuasive as they are, I don't think these quotations between them exhaust the list of specifications of the artist's role in society which make him so indispensable a palp or organ of the general consciousness, especially in an epoch of high-speed development and metamorphosis. But enough has been said, I hope, to establish that any diminution or closure of the art education system (such as I sadly fear is in the minds of many educational reactionaries and short-sighted pragmatists up and down the country) would be an act of dangerous collective self-emasculation – the falsest imaginable kind of false economy.

By what means we can in practice legislate for 'creative behaviour' in our art colleges without at the same time providing a general invitation to superficiality and sloppiness is admittedly a problem, but I don't think its insoluble. Nor do I think that we can, at least in principle, train too many fine artists, once they begin to see themselves as 'creative behavers' and problem-solvers rather than in such obsolescent and predeterminate roles as

'painters' or 'sculptors'. In fact such people, especially in so far as they are willing to teach, could be a major line of defence against social neurosis as the age of enforced leisure due to automation materializes, as we are told it will. People who have a relish for living and skills in making will, in such a situation, be as essential to mental health as doctors and nurses are to the health of the body. What is more, the activities these people can teach will be in especially acute demand if and when the proposed raising of the school-leaving age is implemented. I suppose if our country goes irremediably broke or is overrun by some hideous totalitarianism, new or old, these gleaming cultural territories one can glimpse ahead may never be reached. But if we manage to rub along somehow, and if the older and younger generations will pool the best of what each has got, the last thirty years of this century might well be, at least in the realm of education, a startling improvement on the first seventy.

I would like to end these rambling, unpremeditated, and decidedly fallible remarks with a quotation. It is the text of a poster emanating from post-sit-in Hornsey. Whether by art or artlessness I'm not sure, but at all events with a most touching completeness, it sums up for me the reasons why, despite all the black things that have happened, the summer of 1968 has been a season shot through with extraordinary pulses of hope.

TALK WITH US
Understanding is free
Understand us.
We are part of one another.
No more them against us.
Each one is indispensable
We create an education
Education means
A life time growing wiser
Is there anything more important?
Alive with feeling.

Wisdom equals thought.
What else can answer our questions?
The quiet noise of wisdom working
THAT IS THE REVOLUTION

> Issued by the Association of Members
> of Hornsey College of Art.

Spikes and barbed wire are powerless against such a movement
of the spirit as can be sensed here. It makes one glad to belong
to our profession, wouldn't you agree, Jean?

> Yours ever,
> *Christopher*

P.S. I've just thought of two thumping great issues which, if I
hadn't had to write this in such a hurry, would probably have
occurred to me earlier on and so got included in the appropriate
part of my text. The issues are (*a*) how should art and design
training relate to the new polytechnics; and (*b*) does it make
sense, after the shining example of the Bauhaus, that art and
design studies should be pursued in separate institutions from
studies in those other fields which are major determinants of
our physical environment, namely architecture and town and
country planning?

To answer the second question first: no, it *doesn't* make sense,
and one day our educational potentates will realize this, and do
something about it: though they've let this idiotic schizophrenia
go so far in organizational terms that it's hard to see what steps
they can take, in the measurable future, to mend it.

As to the polytechnic question, this is too complicated and
speculative for me to venture any generalization except the over-
obvious one, already sufficiently stressed, that integration is good
and separatism, in principle, bad. But the key words here are *in
principle*. In practice, and with respect to situations as they now
exist, the incorporation of art colleges in the new polytechnic
system could mean an access of strength: or it could mean virtual
extinction in a morass of dreary-minded and parsimonious

vocational training. Decisions would have to be *ad hoc*, but the people on the art college side of the table had better be vigilant and wary. What suits the tidy-minded bureaucrat doesn't at all necessarily cause the flowers of creativity to bloom: if anything, rather the reverse.

© Christopher Cornford 1968.